Art and Eloquence in Byzantium

Art
and Eloquence
in Byzantium

Henry Maguire

PRINCETON UNIVERSITY PRESS
PRINCETON, NEW JERSEY

Published by Princeton University Press, Princeton, New Jersey
In the United Kingdom: Princeton University Press, Chichester, West Sussex

Publication of this book has been aided by a grant from the
Paul Mellon Fund of Princeton University Press

Princeton University Press books are printed on acid-free paper and meet the
guidelines for permanence and durability of the Committee on Production
Guidelines for Book Longevity of the Council on Library Resources

Printed in the United States of America

Library of Congress Cataloging-in-Publication Data

Maguire, Henry, 1943-
 Art and eloquence in Byzantium.

 Includes bibliographical references and index.
 1. Art, Byzantine. 2. Christian art and symbolism—
Medieval, 500-1500—Byzantine Empire. 3. Art and
Orthodox Eastern Church—Byzantine Empire. I. Title.
N7852.5.M34 709'.02 81-47144
ISBN 0-691-03972-0 AACR2
ISBN 0-691-03693-9 (pbk.)

First Princeton paperback printing, 1994

10 9 8 7 6 5 4 3 2

To my family

The word is to the hearing what the image is to the sight.
John of Damascus

Contents

List of Figures

Acknowledgments

It is a pleasure to acknowledge here the help of many friends and colleagues whose aid made this book possible. In the first place I am indebted to my two thesis advisors, Ernst Kitzinger and Ihor Ševčenko, who were my initial guides through the fields of Byzantine art and literature, respectively. They have contributed to this book in many ways, both direct and indirect. I am also grateful to Aleksander Kazhdan and to Ann Epstein, who read parts of the manuscript and offered their valuable comments and criticisms. In addition, thanks are due to the anonymous readers of the Princeton University Press, who made suggestions that were very helpful to the author.

A large part of this book was written at the Dumbarton Oaks Center for Byzantine Studies. I owe an incalculable debt to the unique library of that institution, and to the unfailing helpfulness of its staff. Nowhere else could an interdisciplinary study on a Byzantine topic have been pursued with such facility. I am especially grateful to the librarian, Irene Vaslef, who has aided my research on so many occasions. The writing of the book was finished at the University of Illinois at Urbana-Champaign. Here, too, the excellence of the library's resources and the frequent assistance given by its staff members have greatly eased my work.

One of the special benefits provided by Dumbarton Oaks is the opportunity to meet with visiting Byzantinists from the United States and from abroad. During my stay at Dumbarton Oaks I was aided in various ways by many scholars, especially by Hans Belting, Anna Kartsonis, Inabelle Levin, Ioli Kalavrezou Maxeiner, and David Wright. I am also thankful to Slobodan Ćurčić, who has helped me in numerous particulars at the University of Illinois.

Several colleagues helped in the difficult task of obtaining good photographs. Here special thanks are owed to Ann Epstein, Doula Mouriki, Lee Striker, Kurt Weitzmann, and David Winfield. I am also indebted to Judith O'Neill, former head of the Byzantine Photograph Collection at Dumbarton Oaks, for assistance

on many occasions, and to Ann Terry, who made the drawings reproduced in Figures 47 and 49. Many of the photographs used in my research were purchased with the assistance of a grant from the American Council of Learned Societies.

Finally, I must thank my family, to whom this book is dedicated. I owe a special debt to the patience of my son, Gavin, who was taken to Greece for the churches instead of the beaches, and to the support and encouragement of Eunice, my wife and colleague.

Urbana, Illinois
June 1980

List of Abbreviations

Art and Eloquence in Byzantium

Introduction

The essential premise of this book is a simple one; it is that the sermons and hymns of the Byzantine church influenced the ways in which Byzantine artists illustrated narrative texts. Often the accounts given in the Gospels of important events are terse and succinct; Byzantine preachers and poets used their imaginations, and especially their training in ancient rhetoric, to fill in the details that the Gospels failed to provide. The literary embellishments of sermons and hymns in turn nourished the imaginations of Byzantine artists, and fundamentally affected the iconography and even the style and arrangement of their work. This book examines the influence of several rhetorical genres and techniques on the art of narration in Byzantine art and literature, particularly ekphrasis (description), antithesis, thrēnos (lament) and hyperbole.

There have been few cultures in which the influence of rhetoric has been as pervasive as in the Byzantine empire during the Middle Ages. In Byzantium the art of eloquence was one of the cornerstones of higher education, from the fourth through to the fifteenth centuries. For most of that period the prestige and impact of rhetoric was greater in the eastern empire than in Western Europe.[1] Some Byzantines went so far as to consider rhetoric the equal partner of philosophy. In the eleventh century the great scholar Psellos claimed that in his work he had succeeded in fusing together philosophy and rhetoric, so that each could enrich the other.[2] Conversely, in the twelfth century the historian Anna Comnena condemned the philosopher John Italus because: ''he had not 'tasted of the nectar' of rhetoric; for this reason his language lacked harmony and polish. . . . His language put on a scowl and reeked only of bitterness.''[3] In this century a distinguished Byzantinist suggested that the practice of rhetoric influenced not only the philosophy of the Byzantines but also their characters. In a study of the Hellenistic origins of Byzantine literature, Romilly Jenkins linked the Byzantine reputation for instability to two of the favored exercises of the schools, anaskeuē and kataskeuē, in which pupils al-

ternatively attacked and defended the same proposition, with equal ardor and persuasiveness.[4] The same writer characterized rhetoric as "the most powerful and pernicious influence of Hellenism on the mind of Byzantium."[5]

Whether rhetoric is seen as a blessing or a curse, there is no doubt that it was a strong current running through almost all classes of Byzantine literature at all periods, as modern scholars have repeatedly shown. But while the course of rhetoric in medieval Byzantine literature has been comparatively well charted, its influence on art has hardly been explored. Several recent studies have illuminated the relationships between art and rhetoric in Italy during the fifteenth and the sixteenth centuries, a period that saw a simultaneous revival of interest in both classical eloquence and antique art.[6] But, although the eastern empire had a strong and unbroken rhetorical tradition throughout the middle ages, modern historians have paid relatively little attention to rhetorical elements in medieval Byzantine art;[7] the Byzantines themselves, however, repeatedly spoke of the connections between eloquence and painting.

Since Byzantine rhetoric is a little-known subject to nonspecialists, I have attempted to provide in the first chapter a general description of the role of rhetoric in the Byzantine church. Besides a discussion of the Byzantine view of the links between oratory and painting, Chapter I contains brief accounts of the nature and teaching of Byzantine rhetoric, and of its relationship to the literature of the Greek church. This survey is intended to serve as a background to the four following chapters on rhetoric and painting, and makes no claims to completeness; throughout the chapter, I have naturally emphasized those features of Byzantine rhetoric that appear to me most pertinent to the visual arts.

The subject headings of Chapters II, III, IV, and V, on description, antithesis, hyperbole, and lament, are based on the categories contained in the handbooks of rhetoric used by the Byzantines themselves. My purpose is to show how particular rhetorical exercises and particular figures of speech influenced the decoration of Byzantine churches; these techniques of rhetoric passed from the schoolroom into the literature of the church, and from the literature of the church onto its walls. But, at the outset, it must be explained that I do not believe that Byzantine artists made use of these conventions with a consciousness of their place or of their names in the formal system of rhetoric. It is possible to speak intelligibly without knowing the terminology of the classifications of formal grammar; in the same way, uneducated or little-educated Byzantine painters could incorporate rhetorical techniques and structures into

their work without a knowledge of their names or their places in the academic curriculum.

The relationships between Byzantine art and rhetoric form a large and formidable territory, of which this book only attempts to map a small area. For the most part, I have concentrated on the Byzantine Middle Ages, that is, on the art created between the end of iconoclasm, in 843, and the fall of Constantinople, in 1453. A further limitation that I have placed on my enquiry is to restrict it to Byzantine religious as opposed to secular art, for the reason that the former has survived in greater quantity and is consequently much better known today. Moreover, I have not attempted to discuss the literary affiliations of every subject in Byzantine religious art, for to do so would require a work of several volumes. Instead, I have selected those subjects in art that appear to me most closely linked to literary eloquence, with the intention of showing how they were influenced by different categories of rhetoric. My aim has been to analyze a few subjects in depth, in order to prove that the relationships between Byzantine art and rhetoric are real and significant. If these relationships are accepted, they should open the way to a fertile field of research in Byzantine art and literature.

The relationship of art to literature in Byzantium may be said to present the historian with three separate questions. The first is the question of the texts that may have influenced a given image. The second is the question of the circumstances in which each text became influential. Did it, for example, acquire relevance on account of a theological dispute? Was it incorporated at a certain time and place into the regular liturgy? Or did it have an impact on the visual arts because of the personal preferences of a particular artist or patron? Finally, the historian faces the third question of the process by which the artist was made aware of the text. Did the artist himself have the occasion to hear the text, the literacy to read it, or the education to understand it? Or was the artist instructed how to illustrate a difficult text by a more literate employer?

For the most part this study will be concerned with the first of these questions; that is, to identify a number of non-Biblical texts, primarily sermons and hymns, that influenced the structure and imagery of Byzantine art. Where possible, I will also try to suggest answers to the second question by identifying the circumstances in which these texts may have come to influence Byzantine art. It will be shown in the second chapter, for example, that a fourth-century sermon by Basil the Great on the Forty Martyrs of Sebaste may have acquired a new relevance for Byzantine artists and their patrons as a result of the disputes

over iconoclasm. And in Chapter V we shall see how elements from the rhetorical laments were gradually incorporated into the liturgy for Holy Week, from the tenth to the fourteenth centuries. The third question, however, that of the process by which the artist understood the text, will receive less space in these pages. The reason for this comparative lack of attention to the artist is simply that there is very little information about him. Since medieval Byzantine artists, unlike those of the Renaissance, have left no written statements about themselves or their work, we know little of their thought processes, other than what the monuments themselves can tell us. Nevertheless, before we begin our enquiry, we must face the question of the artist's role, because the artist obviously was the essential link between text and image, and he cannot be left out of the discussion entirely.

The question of the part played by the artist in the transmission of motifs from literature to art centers on his education. How would the artist have been exposed to the sermons and hymns quoted in this book, and to what extent would he have understood them? The most likely occasion for a Byzantine to encounter these texts was in the course of church services. The more prestigious sermons, especially those of the Church Fathers, were incorporated into service books arranged according to the liturgical calendar, so that they could be read out on the appropriate day of each year.[8] Many of the hymns that we will quote could likewise have been heard in the course of the regular liturgy. But this still leaves open the question of the extent to which most artists, or other Byzantine churchgoers, could comprehend the texts, even if they could hear them. Many of the sermons were written in a highly complicated, affected, and archaizing style, which may have been as far from the everyday speech of a Byzantine in the Middle Ages as Chaucerian English is from the average English of today. The medieval preachers who continued to compose in this style were members of a tiny elite who had received their higher education in the schools at Constantinople. Their homilies may have been all but incomprehensible to provincial audiences, if they were delivered in the style in which they were written. Many artists might have been unable to understand the more ornate sermons, even if they had occasion to hear them recited in church.

In spite of this objection, it is still possible to suggest ways by which Byzantine artists could have absorbed the techniques of literary eloquence. In the first place, there is evidence that many artists were sufficiently well educated to write; they were literate, even if they had not received a higher education in rhetoric. This is proved by the prayers and signatures inscribed by Greek artists on the frescoes that they painted for foreign patrons in Serbia. In the

church of Our Lady at Studenica, for example, a Greek painter left a personal prayer in his own language, in a high and inconspicuous location under the drum of the dome.[9] Artists who possessed a basic literacy could certainly have understood the simpler passages of the liturgy, and may, indeed, have known some of them by heart. Thus a number of the rhetorical stuctures and images discussed in this book could have been familiar to artists through their knowledge of church services.

In addition, we have literary references to a few artists who were educated enough to achieve high positions in church and state, and who must have received some instruction in formal rhetoric. The learned iconoclastic patriarch John the Grammarian, for example was said to have earned his living as a painter in his earlier career. We also hear of a ninth-century bishop of Syracuse, Gregory Asbestas, who painted manuscript illustrations insulting his enemy, the patriarch Ignatius.[10] Even emperors were occasionally credited with artistic skills. Both Greek and Latin sources describe Constantine VII Porphyrogenitus as an accomplished painter. Although Liudprand of Cremona may have exaggerated in saying that this erudite emperor actually made works of art with his own hands,[11] the text of Theophanes Continuatus shows that, at the very least, he took a close interest in supervising the artists who worked in various media at his command.[12]

It is, indeed, likely that educated patrons had an important part to play in the transfer of rhetorical imagery and techniques from literature to art. In several instances, surviving works of Byzantine art themselves demonstrate a close collaboration between the painter and his patron. It has recently been shown, for example, that in the tenth century a senior bureaucrat, Leo Sacellarios, worked together with his artist to create a unique illustrated Bible, which is now preserved in the Vatican Library.[13] To serve as captions for the miniatures of the Bible, Leo composed literary epigrams that provided new expositions of the Biblical passages, and his artist appears to have worked with him in creating new images to illustrate the original content of the epigrams. Leo, certainly, was well educated; he had been to an elite school run by a teacher of grammar and rhetoric whose letters are our main source of information for higher education in tenth-century Constantinople.[14] Recent research has also brought to life the activities of another highly placed Byzantine patron, an imperial princess of the late thirteenth century; this lady assembled a team of scribes and artists in order to produce a series of illuminated manuscripts, and even provided the painters with venerable illustrated books from the imperial library to serve as models for the miniatures.[15] It is appropriate that these examples

of close collaboration between Byzantine artists and patrons are in the realm of manuscript illumination. For it is in this medium, also, that we will find some of the most direct portrayals of rhetorical description in Byzantine art, in the miniatures of springtime that illustrate St. Gregory's New Sunday Sermon (Figs. 29 and 30), and in the miniature of the madness of the Canaanite's daughter, which illustrates a homily quoted in the *Sacra Parallela* by John of Damascus (Fig. 75). Even if we suppose that the artists who originally created these miniatures did not fully understand the archaic language of the texts, we must assume that their patrons could comprehend this language, and that they gave the painters appropriate instructions. Once a motif had been introduced into the visual repertory, of course, it could be copied by other artists whatever their level of literary education. It is reasonable, therefore, to see the transfer of motifs from texts to images as a process in which both Byzantine artists and their more highly educated patrons had parts to play.

I ✦ *Rhetoric in the Byzantine Church*

Eloquence and Painting: Byzantine Perspectives

Byzantine authors made numerous references to the connections between verbal eloquence and the visual arts.[1] The Greek language itself encouraged the Byzantines to think in these terms. The word *graphē*, for example, was used for both writing and painting, *historia* could mean either a written history or a picture, whereas *schēma* was both a figure of rhetoric and a pose in painting.[2] The relationship between painting and eloquence had been a familiar theme of ancient rhetoric[3] that the fourth-century Fathers of the Greek church applied to Christian contexts. St. Gregory of Nyssa, speaking in the church of St. Theodore the martyr, compared the colored pictures on the walls to "a book endowed with speech," and added the famous phrase, "for painting, even if silent, knows how to speak from the wall."[4] A more extensive comparison of painting and rhetoric was made by St. Basil, in the introduction to a sermon on the forty martyred soldiers of Sebaste. This passage is worth quoting in full, for it played an important role in later Byzantine writing on art. Basil explains that he will "show to all, as if in a picture, the prowess of these men. For the brave deeds of war often supply subjects for both speech writers and painters. Speech writers embellish them with their words, painters depict them on their panels, and both have led many on to acts of bravery. For what spoken narrative presents through hearing, this silent painting shows through imitation."[5]

Basil's hint that the artist's eloquence might inspire others to emulate the martyr's courage was gratefully elaborated upon by the defenders of images during the iconoclastic controversy of the eighth and ninth centuries. The Patriarch Germanos I, who was deposed in 730 at the outbreak of the first period of iconoclasm, quoted from Basil's homily on the Forty Martyrs, and

commented that pictures, like words, inspired the attentive to imitate the deeds of the saints.[6] A contemporary champion of Christian art, John of Damascus, quoted the whole of St. Basil's text linking painting and oratory in his first treatise on images. John's commentary praised Basil for showing that "form through colors is coupled with speech,"[7] and for demonstrating "that the work of image and word is one";[8] after concluding the quotation, John exclaimed, "what more conspicuous proof that images are the books of the illiterate?"[9]

The usefulness of art as a means of instruction was only one of the arguments in favor of Christian images that John of Damascus derived from the relationship between writing and painting. He also exploited the multiple meanings in the term *eikōn*, which, like the English word "image," could mean both a concrete representation, as in a painting, and a conceptual representation, such as might be created in writing. Thus John was able to claim that art shared in the validity of Holy Scripture, because both Scripture and Christian art achieved their ends through the same means, through images: "[images are] a scripture that is concise and easy to interpret . . . they speak, they are not mute like the idols of the Gentiles, because all Scripture read in church recounts to us either the descent of Christ, or the miracles of the Mother of God, or the lives and struggles of the saints, by means of images."[10]

John derived a further argument in defense of Christian art from a late fifth-century thinker, Pseudo-Dionysius. This influential Neoplatonist had given to the term image (*eikōn*) yet another meaning; in his thought it referred to the objects that make up the visible world of the senses, because they act as reflections of the invisible world of the spirit.[11] This concept was directly taken over by John of Damascus: "for the invisible things of God since the creation of the world are seen and apprehended in created things. We see images in creation which faintly reveal to us the reflections of God, as when, for instance, we speak of the Holy and eternal Trinity imaged by the sun, or light, or a ray, or by a spurting fountain, or a gushing stream, or a river, or by the mind, or speech, or the spirit within us, or by a rose bush, or a flower, or a sweet fragrance."[12] In literature such "images" of the deity would be similes or metaphors. Since John believed that Christian painting had the same means and ends as Christian writing, it would follow from his arguments that the illustration of metaphors reflecting the world of the spirit should be an aim of Byzantine artists. We shall see that many of the images listed by John—the rays of the sun, the fountain, the river, and the flower—did, in fact, come to grace the religious art of Byzantium.

John of Damascus was not the last defender of images to use St. Basil's comparison of rhetoric and painting. St. Basil's text was pressed into battle again by Patriarch Nikephoros, who was deposed in 815 at the outset of the second period of iconoclasm. In his third *Refutation* of the iconoclast position, Nikephoros quoted Basil's comparison between artists depicting their subjects on panels and speechwriters embellishing them with words.[13] A little later in the same work, he suggests how an artist's ability to embellish and expand a subject could give his painting an advantage over the symbols and signs preferred by the iconoclasts. In this passage, Nikephoros explains that the development of a narrative subject, or sacred image, is more effective than a mere emblem, such as the cross: "besides, the [sign of the] cross brings us the Passion of Christ simply and without adornment. By the more uneducated it would hardly be understood as a sign of the Passion. But the Sacred Images not only embroider the Passion and delineate it in greater detail, but also they demonstrate with greater breadth and clarity the miracles and prodigies that Christ performed. . . . Furthermore, the cross is a symbol of the Passion, and it [only] hints at the manner in which He who suffered bore the Passion."[14] We shall see that after the end of iconoclasm Byzantine artists did indeed embroider the Passion of Christ; to do this they borrowed many techniques that had originated in rhetoric.

Thus the relationship between art and eloquence became an important concept in the arsenal of the defenders of images during the iconoclastic controversy. After the ninth century, when their victory had been won, the concept lived on as a literary conceit. The elaboration of the idea in later literature is well illustrated by two epigrams devoted to one of the best-known Byzantine artists of the twelfth century, Eulalios.[15] He is one of the few Byzantine painters of the twelfth century known to us by name, and one suspects that his name may have been preserved for posterity not so much because of the quality of his painting as because it enabled Byzantine writers to contrive puns between Eulalios and *eulalos* (eloquent). Thus Theodore Prodromos, a poet who was a contemporary of the painter, was able to give a new twist to an old literary cliché when he described an Annunciation painted by this artist which was so lifelike that Gabriel and the Virgin seemed to be speaking: "such is the art of Eulalios that he can make paintings worthy of his name, and mix colors that can talk (*lalounta*). Yet, stranger, this has not come about through the art of painting, but the maiden who is talked about (*perilalētos*) among men has guided the brush of Eulalios, and made his color so eloquent (*eulalon*)."[16] In

the late thirteenth or early fourteenth century the historian and poet Nikephoros Kallistos Xanthopoulos devoted another epigram to Eulalios; it describes the great mosaic of Christ Pantocrator in the central dome of the Church of the Holy Apostles in Constantinople, which has since been destroyed. This poem also uses the pun on Eulalios to renovate an ancient cliché of art criticism, the conceit that the artist must have seen God himself in order to produce so faithful a likeness. The epigram reads: "either Christ himself came down from heaven and showed the exact cast of his features to him who has such eloquent (*eulalous*) hands, or else the famous Eulalios ascended into the sky itself and with his skilled hand exactly delineated the appearance of Christ."[17]

This survey has shown that there were three major phases in Byzantine perceptions of the relationship between art and eloquence. In the first phase, the early Church Fathers applied a convention of pagan rhetoric to the Christian context, and saw painting that "knows how to speak from the wall" primarily as a means of instruction. In the second phase, during the iconoclastic controversy, the defenders of images elaborated upon the statements of the Fathers, and made the relationships between art and writing an important argument against their opponents. Finally, by the twelfth century the linking of art and eloquence had lost much of its force in polemic, but lived on as a convention in Byzantine literature.

In all the examples that we have quoted, the relationship between art and rhetoric has been seen as a positive feature, proving either the skill of the painter or the validity of the painting. On occasion, however, the Byzantines could link art and oratory in negative terms. Thus Gregory of Nyssa laments of the dead empress Flacilla, "it is not possible to demonstrate her qualities by means of speech; for no accurate likeness of her survives in art. But if any has been made, either in painting or in sculpture, they all fall short of the truth."[18] Five centuries later this idea of the insufficiency of speech and painting was echoed by Leo the Wise in an oration composed in honor of the previous emperor and empress, Basil I and Eudocia Ingerina. Following the conventions of Byzantine panegyric, Leo made a pretense of finding his subjects too lofty for his rhetorical arts: "where is the justice in diminishing their grandeur through the poverty of speech? . . . What speech describes must be a reflection like an image or a sketch; but these persons are infinitely above the appearances given by speech."[19] This sentiment, conventional and negative though it is, again shows that, in the mind of an educated Byzantine, art and rhetoric were closely allied.

The Structure of Byzantine Rhetoric

In the Roman and Byzantine empires, as the demands of political conformity reduced the importance of rhetoric as a means of real debate, epideictic or display oratory became the dominant form of public speech. The overt task of the orator became less to argue and to persuade, and more to make an elaborate display of conventional ideas, whether he was describing the beauties of a city or of a painting, or the glories of a ruler.[20] One Byzantine ideal of rhetoric was aptly expressed by Corippus, when he described the orators who spoke at the inauguration of Justin II as consul: "what arts and what intelligence they used! What effort to add ornaments to ornaments and praises to praises!"[21]

In the eleventh century, the Byzantine scholar Psellos, who flattered himself on his own eloquence, gave the following definition of rhetoric: "it proposes rules for the development of political subjects and for their divisions, and it adorns the language."[22] Here Psellos sees two functions of rhetoric: to provide the speaker with guidelines for the development of particular subjects by means of subdivisions, and to ornament his language. These two aspects of Byzantine rhetoric correspond to two commonly used classes of technical handbooks, the treatises devoted to the rhetorical subjects, and the treatises devoted to linguistic ornamentation. In this section we will briefly review each of these groups of textbooks in turn, beginning with those devoted to the subjects of discourse.

In Byzantine education the most prestigious authority on rhetoric was the second-century writer Hermogenes. Byzantine schoolmasters employed five textbooks that circulated under the name of Hermogenes, of which one was devoted to the *progymnasmata*, the exercises that trained the student to handle the various subjects of oratory.[23] Another work on the rhetorical exercises that was in common use in Byzantine schoolrooms was the *Progymnasmata* attributed to Aphthonius, a fourth-century author.[24] Hermogenes' treatise gives brief instructions for twelve different exercises, whereas Aphthonius discusses fourteen, and gives examples of each exercise to serve as models for the student. Thus after Aphthonius' discussion of "Encomium," which he lists as the eighth exercise, we find a model encomium of Thucydides, and another of wisdom.[25] After the instructions for his ninth exercise, "Censure" (*psogos*), Aphthonius appends a censure of Philip of Macedon,[26] whereas the next exercise, "Comparison" (*synkrisis*), brings us a comparison of Achilles and Hector.[27] In this study I shall be particularly concerned with the exercises of "Character Study" and "Description," which were discussed both by Hermogenes and by Aphtho-

nius. In character study, or ethopoiia, the students were supposed to recreate through an imagined speech the feelings of a famous character from history or mythology at some dramatic point in his or her life. Aphthonius' example is entitled "What Niobe would say when her children lay dead."[28] In both treatises, character study is followed by ekphrasis, or description; Aphthonius illustrates this exercise with a description of "the temple at Alexandria together with the acropolis."[29] Model exercises similar to those by Aphthonius were produced by other late antique and Byzantine instructors of rhetoric. In the twelfth century, for example, Nikephoros Basilakes, who taught for the church in Constantinople,[30] composed a collection of over fifty model pieces that correspond to seven of the exercises listed by Aphthonius.[31] Nikephoros Basilakes appears to have been most interested in character studies, for they make up half of his surviving pieces. The remarkable feature of the character studies by this teacher in an ecclesiastical school is that they are almost equally divided between pagan and religious themes. Thus not only do we find among the subjects "What Danae would say after she had been deflowered by Zeus changed into gold," but we also encounter "What the Mother of God would say when Christ changed water into wine at the wedding."[32]

The rule books and the examples of the *progymnasmata*, then, gave Byzantine students of rhetoric brief guidelines for completing their school assignments; in addition, late antique writers bequeathed to the Byzantines more detailed treatises on the topics of rhetoric. One of the most influential of these more specialized authors was the third-century theorist Menander, who was considered to have written two works on epideictic oratory.[33] According to Menander, epideictic rhetoric is specifically concerned with praise or with censure, although his discourses are devoted only to the various subjects and occasions of praise.[34] Among the many topics covered by his treatises, Menander gives rules for composing speeches in praise of countries, cities, harbors, and bays, and in honor of birthdays, marriages, embassies, and coronations. Funerary orations, which contain eulogies, are also included. In all, the treatises discuss some twenty-three topics of epideictic oratory, providing careful instructions for each.

To help would-be orators embroider their compositions, classical and Byzantine teachers prepared a long series of handbooks on figures of speech.[35] These texts take the form of lists, in which each figure of speech is defined in a few lines and illustrated by means of examples culled from classical writers. The explanations are extremely stereotyped, and are sometimes reproduced verbatim in one treatise from another. The illustrations, too, are often repeated,

except that the later treatises show a tendency to add some Biblical allusions to the quotations from pagan literature. A typical Byzantine example is a textbook of uncertain authorship, which was, however, attributed to George Choeroboskos, who taught in Constantinople between the eighth and the ninth centuries.[36] The author of this treatise discusses thirty-three different tropes, including metaphor and hyperbole, both of which will be important in our discussion of Byzantine art. His section on hyperbole follows the standard conventions of the handbooks. It begins, "hyperbole is an expression that goes beyond the truth for the sake of amplification.[37] An identical definition can be found in a treatise ascribed in a few manuscripts to the great grammarian Tryphon, who lived in the age of Augustus.[38] To illustrate hyperbole, the Byzantine writer quotes Homer's description of the horses of King Rhesus, "whiter than snow, and in running like the winds";[39] here again he repeats an example given in the textbook ascribed to the ancient grammarian.[40]

Metaphor receives more attention in the handbook attributed to George Choeroboskos than any other figure of speech.[41] Other Byzantine treatises, likewise, give a generous allotment of space to this trope. Metaphor, of course, became important in Christian literature so that, for example, Christ's glory could be imaged by the sun, or the Virgin could be addressed as a meadow or a flower. As we have seen above, in their use of this figure of speech Byzantine writers received a philosophical justification from Neoplatonic thought, which perceived the world of visible objects as a reflection of the unseen world of the spirit.[42]

We have reviewed briefly two types of textbook which were commonly available to Byzantine students of rhetoric—the works concerned with rhetorical exercises, and the treatises devoted to figures of speech. In the following pages we shall turn to the question of who these students were, and when and where they acquired their education.

The Teaching of Byzantine Rhetoric

In Byzantine education advanced instruction in rhetoric was the highest of several stages in the acquisition of literacy. The levels of literary education in Byzantium, as they existed in the second half of the eighth century, were described in the biography of Theodore of Stoudios, who went to school in Constantinople. Theodore, like other Byzantine schoolboys, began his education by learning how to read from a local schoolmaster, or *grammatistēs*. Continuing his education, Theodore studied grammar in order to obtain an

understanding of classical Greek, in particular through the reading of ancient poetry. Finally, he went on to study rhetoric, so that he could learn how to express himself according to the rules of late antique oratory.[43]

In the Byzantine empire during the Middle Ages, high-level instruction in rhetoric was available for the most part only in Constantinople.[44] The students were not numerous; it has been estimated that in the second quarter of the tenth century only two to three hundred pupils were passing through the schools that provided higher education in any given year.[45]

We do not yet have a complete picture of the structure of education in Constantinople. However, it is clear that some of the schools were small and private or semiprivate in character. The prestige and academic level of each of these schools depended on the personality and scholarship of the individual teacher who ran it.[46] These teachers could be either laymen or clerics.[47] By great good fortune, a collection of 122 letters has survived from the cantankerous pen of an anonymous schoolmaster, who wrote in the third and fourth decades of the tenth century. From the letters we learn that the author was a layman who ran a small school in Constantinople, where he taught grammar and rhetoric to pupils drawn from the families of the elite in the civil service and in the church. His school evidently had considerable prestige, for its pupils later attained high positions in the church and in the imperial bureaucracy. The school appears to have been supported both by fees charged to individual pupils, and by payments from the church. The precise purpose of these grants from the church is uncertain, but it is clear from the subsequent careers of the graduates, who included a deacon and a bishop, that the school played a role in the education of the clergy.[48]

This anonymous correspondence of the tenth century, then, shows us a small but prestigious school, run by a layman and providing instruction in grammar and rhetoric both for future lay officials and for ecclesiastics. If we move forward in time into the eleventh and twelfth centuries, our evidence suggests that the church came to play an increasingly direct role in the training of its clergy, and even of laymen.[49] A letter of Psellos tells us that in his time the patriarch appointed the directors of more than one of the schools in Constantinople, including that of St. Peter, a prestigious institution with a curriculum covering grammar, rhetoric, and philosophy as well as the exegesis of Scripture.[50] From the end of the eleventh century onward, Byzantine higher education was dominated by the patriarchate in Constantinople.[51] At the head of the educational hierarchy of religious instruction were three professors, the

teachers of the Gospels, of the Epistles, and of the Psalms.[52] But there was also in Constantinople a master of the rhetoricians (*maistōr tōn rhētorōn*), who was responsible for secular education.[53] This post was held by classical scholars of high caliber, such as Eustathios, later archbishop of Thessalonica, who wrote commentaries on Homer, Pindar, and Aristophanes.[54] It is possible that Nikephoros Basilakes, the author of the character studies of Danae and of the Virgin Mary quoted above, also held the post of master of the rhetoricians.[55]

The theological teaching apparently took place at the Great Church of St. Sophia, but we do not know where the master of the rhetoricians gave his instruction.[56] The church had schools attached to various ecclesiastical buildings in Constantinople; at the turn of the twelfth and thirteenth centuries an important academy was housed in the Church of the Holy Apostles. This school was the subject of a vivid rhetorical description (*ekphrasis*) by Nicholas Mesarites, who later became metropolitan of Ephesus.[57] The school at the Holy Apostles was evidently a recent foundation when Mesarites saw it.[58] According to his account, its instruction included both elementary and advanced courses, and its students were of all ages, from childhood to maturity. Thus Mesarites writes of the young children trembling under the angry gazes of their rod-wielding schoolmasters,[59] whereas at a higher level of instruction he describes the academic disputes: "now one thing, now another, is put forward for examination by the learners or by the teachers, . . . so that there are times when they . . . use rough words against one another, and accusations of ignorance and of disregard for philosophy and physics stream from their mouths."[60] Mesarites describes the young pupils beginning in grammar "continually reading their lessons and pacing up and down through the enclosure of the stoa,"[61] and he finishes his account of the literary curriculum with the study of rhetoric: "others, those who have attained the higher and more accomplished stages, weave webs of thoughts and transform the written sense into a riddle, saying one thing with their tongues, but hiding something else in their minds."[62] Elsewhere Mesarites tells us that the instruction in rhetoric included all forms of figures of speech.[63]

Although our information about higher education in Byzantium during the Middle Ages is not comprehensive, it is clear that training in rhetoric was provided for officials of the church in the capital, whether this was in a private school such as that run by the anonymous schoolmaster, or in a church school such as that at the Holy Apostles. Moreover, the teachers of the schools did not confine their careers to Constantinople, for they frequently moved to

ecclesiastical appointments in the provinces; in the late eleventh and in the twelfth centuries we know of a series of teachers from the capital who moved on to preferments in Asia Minor, Greece, and Bulgaria.[64]

Although the upper levels of the secular clergy received an education in grammar and rhetoric, there is less evidence that higher education in these subjects was either received or given by monks. It is true that many educated men, including the favorite pupil of the anonymous tenth-century schoolmaster, entered monasteries.[65] But in general the monasteries did not set out to foster secular learning, though they might provide religious instruction to their novices. The biographers of monastic leaders are careful to point out that their heroes, even if they received a secular education, treated it with suspicion or disdain. Thus Theodore, the abbot of Stoudios, though he studied grammar and ancient poetry, "did not retain the myths, but only what was useful." From his rhetorical training he kept only what related to the arrangement and harmony of speech, and he rejected all the vain refinements of the professionals.[66] Other abbots had been able to dispense with a classical education altogether, and devoted themselves to purely religious studies. The life of a contemporary of Theodore, St. John Psichaites, tells us that this saint "kept awake night and day over divine learning." As he was in possession of the true knowledge, he needed neither the minutiae of grammar, "nor the lies of the orators . . . nor the ability to embroider speech with Forcefulness and the Forms of Style" (here the biographer may be referring to the famous handbook by Hermogenes on the Forms of Style). John Psichaites could ignore rhetoric, for he held that "the natural beauty of the word, the true issue of things or the persuasiveness of speech on their own were able to convince men."[67] This disregard for classical learning is, of course, a biographer's cliché, but it is confirmed by the inventories of the books that were actually in the libraries of Byzantine monasteries. A catalogue from the important monastery on Patmos, for example, lists 330 titles that were in the library in the year 1201, of which hardly more than a dozen were on secular subjects. The monastery possessed two manuals of grammar, and two of medicine, but it did not own any texts on rhetoric.[68]

It would be a mistake to assume, however, that Byzantine monks were not exposed to rhetoric. If they themselves would not read treatises on pagan rhetoric, they did read the patristic authors who had studied rhetorical techniques, and who had clothed them decently in Christian guise. The library at Patmos, if it did not offer Hermogenes and Menander, did contain copies of the Cappadocian Fathers, St. Basil, St. Gregory of Nyssa, and St. Gregory of

Nazianzus.[69] As we shall see in the following pages, the works of these authors were thoroughly imbued with both the spirit and the methods of late antique oratory.

Rhetoric and Christian Literature

In the course of this chapter we have seen that rhetoric played an important part in the instruction of the Byzantine clergy. To understand how it was that a discipline that was secular in origin could have been so influential in Christian education, we must go back to the fourth-century Fathers of the Greek church, St. Gregory of Nyssa, St. Gregory of Nazianzus, and St. Basil, for it was their writings above all that brought about the marriage of Christianity and pagan rhetoric.[70] Although the three Fathers all claimed to have no use for the devices of oratory, their writings showed that they did not practice what they preached, for their homilies are replete with the contrivances of the schools. Their example was followed by later generations of Byzantine authors, who applied their rhetorical training to composing homilies, saints' lives, and even hymns.

It would hardly have been possible for the fourth-century Fathers to reject the forms of rhetoric entirely, for rhetoric had been the very essence of their education. Both Gregory of Nazianzus and his friend St. Basil had studied oratory in Athens;[71] Gregory of Nyssa had even taught rhetoric, before he was consecrated bishop.[72] However, all three pretended that they had been untainted by their experience in the pagan schools. "Let no one expect from us the more pompous style of speech," Gregory of Nyssa told his audience. "Even if we wanted it, we do not have such ability, since we are inexperienced in such speaking. And even if we had the capability to be pompous, we would not prefer the esteem of a few to the welfare of the public."[73] In spite of such statements, the two Gregories and St. Basil managed to combine the welfare of their flocks with the esteem of later generations who much admired the rhetorical ornaments with which they decorated their prose. Thus we find that a scholar of the late ninth and early tenth centuries, Arethas, bishop of Caesarea, could appeal to the contrived embellishments used by Gregory of Nazianzus in order to justify an involved style.[74] In a twelfth-century manuscript of sermons by the monk James of Kokkinobaphos we can find a pictorial recognition of a medieval writer's debt to the fourth-century Fathers. A miniature at the beginning of the volume, which is now preserved at the Bibliothèque Nationale in Paris, portrays the author of the sermons twice, at the right kneeling before the feet of St. Gregory of Nyssa, and at the left being taken

by the hand by St. John Chrysostom (Fig. 1).[75] St. Gregory is pointing out to the homilist the beginning of the Song of Songs, while St. John Chrysostom indicates the opening of St. Matthew's Gospel; the two Fathers had written commentaries on these Biblical works, to which the Byzantine writer in the miniature is making his acknowledgment.[76]

With respect to the visual arts, the most important of the rhetorical techniques in the works of the fourth-century Fathers were those concerned with vivid description, with eulogy, and with the heightening of emotion. In the following chapters I shall describe in more detail how the Fathers introduced these forms of rhetoric into the mainstream of Greek Christian literature, and how they eventually passed from literature into art.

The union of rhetoric and Christian learning came to be embodied in institutions such as the famous school of rhetoric at Gaza, which flourished in the sixth century and was staffed by Christians. The leading figure of this school, Procopius, was as adept at writing rhetorical exercises as he was at producing Biblical exegesis. Thus he composed a long description of a painting showing Phaedra yearning after her stepson Hippolytus,[77] but he also wrote commentaries on books of the Old Testament.[78] His foremost pupil, Choricius, wrote a couple of panegyrics of Bishop Marcian of Gaza, who had embellished the town with two new churches. In his formal descriptions of the churches and of their painted and mosaic decorations, Choricius was able to apply this favored exercise of the pagan schools to Christian subject matter.[79]

Another milieu in which Christian learning and pagan oratory rubbed shoulders was in the church schools at Constantinople. We have seen that in the twelfth century their teachers could write exercises with equal facility on subjects drawn from classical mythology and from the Gospels. In addition, the teachers attached to the patriarchate took part in state ceremonies at which they delivered speeches, such as panegyrics and funerary orations, which allowed them to make a rich display of their rhetorical expertise in a secular context.[80] The teachers in the employ of the patriarchate were Christian orators, who aspired to an ideal eloquently expressed by Mesarites in his encomium of John X Kamateros, who was patriarch of Constantinople between 1198 and 1206: "he is not only wise in divine matters . . . , but is most knowledgeable and exalted in all the wisdom concerning worldly matters, through which his speech is greatly enriched in a most refined and excellent fashion. . . . As a grammarian he is above Histiaios and Theodosius, as a rhetorician he is above Demosthenes and Hermogenes."[81]

Since the association of oratory and theology had been both sanctioned by

the Fathers and incorporated into Christian higher education, it is not surprising that rhetoric exerted a continuing influence on the literature of the Byzantine church. Naturally the sermon, which came closest in form and occasion to the secular orations, was most strongly affected, but other genres such as the saint's life and even poetry did not escape the long reach of the schoolmaster. The saints' lives frequently borrowed techniques from secular encomia, whereas to the Byzantines the categories of poetry and rhetoric were never as sharply separated as they are to us.[82] Already in the third century the influential theoretician Menander could claim to be providing guidelines that were used by "poets, prose writers and rhetoricians alike in artistically composing hymns to the gods."[83] In subsequent centuries some of the best and some of the worst of Byzantine liturgical poetry was to be strongly rhetorical in character, both in terms of its overall structure and of its adornment with figures of speech.

To summarize, the study of ancient rhetoric was consistently accepted by the Byzantine church, in spite of occasional avowals to the contrary. The higher levels of the secular clergy learned rhetoric; at times they taught it, especially at Constantinople from the late eleventh century onward. The textbooks of rhetoric became partially Christianized by the inclusion of examples drawn from the Bible and the Fathers alongside those from pagan literature. Conversely, the literature of the church absorbed many of the characteristics of late antique rhetoric, with respect to both structure and embellishment. The techniques of oratory were imprinted upon the minds of those who read Christian hymns and sermons or heard them in the liturgy, even if they had received no training in rhetoric; both learned patrons and less well educated artists were exposed to the forms of rhetoric. In the chapters that follow we shall turn to the individual types of rhetorical exercise, in order to find out how their practice in Christian literature affected the visual arts.

II ✣ *Description*

The Literary Genre

Among the rhetorical genres cultivated by the Byzantines, one of the most popular was ekphrasis, or formal description.[1] This exercise, as Hermogenes explains, can describe "persons, deeds, times, places, seasons, and many other things."[2] The textbooks on rhetoric emphasized that the purpose of the formal description was to make the writing as vivid as possible, so that the reader would seem to see what was described, before his own eyes.[3] A fifth-century rhetorician, Nicholas the Sophist, made the following distinction between simple narration and description: "[Narration] reviews a subject in general, [description] reviews it in particular. Thus it is narration to say: 'The Athenians and the Peloponnesians fought.' But it is description to say that each side employed such a kind of armament, and such a manner of equipment."[4] Sometimes Byzantine writers composed formal descriptions as separate rhetorical exercises, but often they incorporated them into literary compositions of other kinds, wherever they desired to heighten the vividness of their account, or to show off their literary prowess. Thus formal descriptions grace poetry as well as prose, and they enliven religious writings such as sermons and hymns along with secular works such as histories and letters.

Both for classical and for Byzantine writers a favorite subject of description was a building or a work of art. In the case of descriptions of works of art, it was conventional for the writer to parade his skill by setting himself up as the rival of the painter or sculptor: "We men of letters can use colors no worse than painters do," boasts an Early Christian writer, Asterius of Amasia, as he opens his description of a painting of the martyrdom of St. Euphemia.[5] These Byzantine accounts of buildings and their decoration were highly conventional in their language and outlook, but also often painstakingly accurate and detailed in their physical descriptions; for the modern historian these descriptions can

provide invaluable glimpses of the Byzantine art that has been lost or destroyed, once their coatings of rhetorical verbiage have been stripped away.[6]

Because of their value as evidence to the historian engaged in the reconstruction of lost Byzantine monuments, the formal descriptions of buildings and works of art are today the best known category of the literary genre of ekphrasis. But, in a different way, other types of formal description are no less relevant to an understanding of Byzantine art. The nature of this relevance can be simply explained by returning to Nicholas' distinction between narration and description. In many cases the account offered by the Bible of a given event is simple and succinct. The massacre of the innocents, for example, is related by Matthew in one sentence: "when Herod saw how the Wise Men had tricked him he fell into a great passion; and he gave orders and massacred all the children in Bethlehem and its neighborhood, of the age of two years or less."[7] According to Nicholas' definition, this would be a simple narration. It was a natural temptation for a Christian preacher with a classical education to elaborate upon Matthew's brief narration for the benefit of his hearers, and turn it into a description.[8] If the homilist had been trained in ancient rhetoric, the task of embroidering Matthew's account would be easy for him; he could simply borrow from pagan oratory the conventional description of a massacre that was a standard element in formal descriptions of wars, and apply it to Herod's slaughter of the innocents. As we shall see, Byzantine preachers repeatedly resorted to this device, from the fifth century up to the twelfth century. But artists, also, were faced with the task of turning Matthew's narration into a description. For when Matthew states simply that Herod ordered the massacre, he does not say who were the people who carried out the order, nor does he describe their armament and equipment, nor does he specify the method of execution that they employed. I shall try to show that in imagining these details Byzantine artists were guided by descriptions already provided by the homilists and hymn writers of the church, who had themselves been guided by the rhetoricians of the pagan schools.

The description of war was one of several types of literary ekphrasis that influenced Byzantine artists. Descriptions of tortures helped writers and artists alike to visualize the trials of the martyrs, just as the formal descriptions of the season of spring provided Byzantine artists with a treasure trove of images that could be applied to portrayals of the Virgin Mary. I shall review each of these types of description in turn, and explore the influence that each had on the visual arts of Byzantium.

Descriptions of War

Basil the Great explains in his homily on the Forty Martyrs that "the brave deeds of war often supply subjects for both speech writers and painters. Speech writers embellish them with their words, painters depict them on their panels."[9] My purpose in this section will be to examine the implications of this statement with respect to the Byzantine iconography of the Massacre of the Innocents, a scene in which the relationships between painting and writing were particularly close, as Gabriel Millet showed in his pioneering study of Gospel iconography.[10] We shall review both the literary and the artistic portrayals of the Massacre in some detail, beginning with the written sources; by comparing the two traditions we shall be able to observe how an ancient literary genre could breathe new life into Byzantine art during the Middle Ages.

In his treatise on the rhetorical exercises, Hermogenes gives clear instructions for composing descriptions of human actions. According to this standard textbook, the aspiring orator should divide his composition chronologically into three sections, describing first the prelude to the action, then the action itself, and finally its aftermath. Hermogenes explains how this triple division should be applied to a description of a war: "First we shall tell what happened before the war—the levying of troops, the expenditures, the fears; then the engagements, the slaughters, the deaths; then the trophy of victory, then the paeans of the victors, and the tears of the defeated and their bondage."[11] Ancient orators have left us examples of this type of description; Quintilian, for example, in the first century A.D., demonstrates how an orator can impart vividness to his speech by describing the capture of a town. In his illustration Quintilian leaves out the first of Hermogenes' stages, the prelude to the capture, but he follows the account of the event itself with a description of its aftermath, the tears and bondage of the defeated citizens. His description of the capture reads as follows: "in this way we can develop a pathetic speech about a captured town. For without doubt, he who says simply that the city was stormed, embraces all the ills that such a misfortune comprises, but he penetrates the emotions of his audience less because his brevity resembles a dispatch. But if you explain everything that the one word 'stormed' included, your audience will be shown the flames pouring through houses and temples, the crash of tumbling roofs, the one confused noise composed of many different cries, the uncertainty of some whether to flee, others clinging to their families in a last embrace, and the women and children weeping." Having completed the description of the capture, Quintilian turns to its aftermath: "then . . . you will

describe the chained prisoners driven each before his captor, the mother trying to keep her infant, and the victors fighting for the biggest share of the loot."[12] In closing Quintilian quotes from Virgil: "and trembling mothers pressed their children to their breast,"[13] and he adds the observation: "and this peak, as I see it, of excellence, is very easy to reach."[14]

Such illustrations of vivid description drawn from the calamities of war are found in other ancient textbooks on oratory, both Latin and Greek. The Roman textbook *Ad Herennium*, for example, which was written in the first century B.C., also tells how one should describe the blazing houses, the seizing of captives, and the children, of whom "some are torn from their parents' laps, others slaughtered on their parents' bosom, and others violated at their parents' feet."[15]

If we turn to Christian literature, we find that one of the most influential of the Greek sermons on the Massacre of the Innocents includes an extensive description of a war, directly in the tradition of secular rhetoric.[16] Its author, Basil, archbishop of Seleucia, was a preacher who delighted in rhetorical techniques. Although he wrote in the fifth century, his sermon on the Innocents lived on in the later literature of the Byzantine church, for successive generations of Byzantine homilists imitated it and tried to emulate it. Collections of sermons that were assembled for liturgical use in the twelfth and thirteenth centuries listed Basil's sermon as the reading for the feast day that commemorated the martyred infants.[17] Early in his sermon Basil declares that he seems actually to see the infants being massacred;[18] as often in Byzantine literature, this statement introduces an ekphrasis, in which Basil manages, with considerable artifice, to turn the one sentence of the Gospel narration into a fully developed description that closely follows the instructions of Hermogenes. As the textbook recommends, Basil divides his portrayal of the Massacre into the three stages of prelude, action, and aftermath. There was some justification in the Gospel for this rhetorical division of the story: the brief text mentions that Herod gave his orders before he massacred the children, and it obliquely refers to the third stage, the lament after the Massacre, by quoting Jeremiah: "So the words spoken through Jeremiah the prophet were fulfilled: 'A voice was heard in Rama, wailing and loud laments; it was Rachel weeping for her children, and refusing all consolation, because they were no more.' "[19]

Although the three-part division of the story may be implied in the Gospel, in elaborating the details of each of the stages Basil of Seleucia went far beyond the canonical text. His excuse for indulging in this rhetorical elaboration was mockery of Herod, who went through the whole procedure of a war in order

to slay the defenseless infants of Bethlehem. Thus Basil first describes the preparations for the war, with Herod sitting in splendor on a golden throne studded with gems, under a proud awning and taking counsel with his advisors. Basil ironically tells us how Herod levied his troops, and even how the king gave a speech of exhortation to his generals before the campaign, reminding them of their former successes and asking them to "rush like lions upon the city."[20] Then follows the second stage of the description, a long and bloody account of the slaughter of the children, a description that is distinguished more for its vivid detail than for its good taste.[21] Here the Gospel's single word "destroyed" becomes a long catalogue of cruelties, which was plainly inspired by classical descriptions of captured cities such as those quoted above. The Christian writer, like Quintilian, describes how the mothers held their infants in their bosom, and how they struggled to keep them when the soldiers tore them away; so violent was the conflict that the children were dismembered. Like the author of the *Ad Herennium*, Basil relates that some of the Innocents were murdered in their parents' arms. He also tells us how the mothers fled with their offspring, how some were smitten with fear as they gazed "at the flash of the sword,"[22] while other, more courageous mothers warded off "the swords' edges with their hands."[23] Finally Basil reaches the aftermath of the war; in this stage of the description he follows Hermogenes' instructions in describing both the tears shed by the bereaved mothers and the delusions of trophies and of victory entertained by Herod. The depiction of the lament spares us no appalling detail that might add to the horror of the occasion, or to the luster of the orator; each mother tearfully collected together the sundered limbs of her child, searched for any part of the body that might be missing, and, having found it, kissed it. At last she placed the complete corpse in her bosom, and broke into vehement cries.[24]

Basil of Seleucia's vivid portrayal of the Massacre follows a pattern that became standard for Byzantine descriptions of this episode. In the sixth century, the poet Romanos translated the conventional description from prose into verse, incorporating it into a hymn composed for the Feast of the Innocents. Like Basil of Seleucia, Romanos seems almost to delight in brutal detail: "[Herod] gave chase to the mothers, and when he overtook them, he snatched their nestlings from their very arms like little sparrows. . . ."[25] Some [of the children] were horrendously transfixed, . . . while others were dismembered. Others were decapitated as they sucked at their mothers' breasts."[26]

It is not necessary to quote at length the descriptions of the Massacre that were written by later Byzantine writers, for they faithfully repeat the motifs

given by Basil of Seleucia and by Romanos. However, the more recent authors should be mentioned briefly, because they demonstrate the continuity of the tradition in Byzantine literature, which was also reflected in art.[27] In a mid-eighth century sermon by John of Euboea, for example, many of the familiar clichés recur: the mothers fled holding their offspring; their children were little sparrows; the soldiers were lions tearing tender young calves; the murderers decapitated some infants, and dispatched others in their parents' arms.[28] Four hundred years after John of Euboea composed his description of the Massacre, the horrors were paraded again in a sermon by a south Italian preacher, Philagathus.[29] This twelfth-century author composed his homilies in Greek, and was well aware of the Greek rhetorical tradition.[30] His description of the murder of the Innocents echoes Basil of Seleucia's account in several details; however, Philagathus introduces a further refinement by describing first the Massacre itself, and then a painting of it, so that he is able to present the horrific details to the hearer twice over. Philagathus claimed that he had himself seen the painting, which he says was painted on a panel (*en pinaki*). It depicted Herod "sitting proudly on some high throne, giving sharp and savage looks with wide-open eyes. . . . Stretching out his right hand, he seemed to be commanding the soldiers to mercilessly harvest the field of children. They, springing like wild beasts, pitilessly dismembered the wretched infants. The painter depicted the unhappy mothers given to a piteous lament and mixing tears with blood. And one tore her hair, another scraped her cheeks with her nails, another tore apart her robe, and baring her chest, showed her breast, deprived of the feeding baby. Another collected together the scattered limbs of her dismembered child; and another held her newly slain infant on her knees and bitterly wept."[31]

This description of a supposed painting has so much in common with the purely literary tradition of earlier sermons that the reader is immediately led to suspect that Philagathus may never have seen such a painting at all; he may simply have invented it as a rhetorical device. However, the more one studies surviving paintings of the Massacre, the more difficult it becomes to dismiss the existence of the painting described by Philagathus. For by the twelfth century many of the descriptive clichés of the homilies had been incorporated into the artistic tradition; artists no less than orators could develop an ekphrasis of the Massacre. It is quite possible that Philagathus had seen a painting similar to the one he described. His sermon, therefore, presents us with a question of priority. If the preacher had really seen a panel painting of the Massacre, was he, at least in part, guided by this pictorial model rather than by the literary tradition? And if Philagathus had been influenced by a work of art,

had other writers been so affected before him? To put the problem in more general terms, did painting influence literature, did literature influence painting, or were there interchanges between the two media?

Given the many gaps in the evidence provided by surviving works of both art and literature, it is impossible to answer this question with complete precision. One can, however, demonstrate that in general it was the writers who led the way. A comparison of the remaining depictions in art with the descriptions in literature reveals that the individual motifs usually were employed by Byzantine homilists and poets before they were adopted by painters. We shall see that the descriptive details of the Massacre of the Innocents were added to the artistic tradition very slowly, over the space of some nine hundred years. In literature, however, the subject had been very fully developed by the fifth century. We shall also see that the possibility of occasional influence in the other direction, from art to literature, cannot altogether be excluded.

It is useful to begin our survey of the artistic tradition with the mosaic on the triumphal arch of the church of S. Maria Maggiore, in Rome, which was set between the years 432 and 440 (Fig. 2).[32] This is not the earliest surviving portrayal of the Massacre in art, but of all the early versions it is in some respects closest to the unadorned Gospel text, which places its emphasis on Herod's role in the massacre as the one who gave the orders, rather than on the soldiers who carried them out.[33] The mosaic shows us Herod enthroned, surrounded by his bodyguard, and raising his right hand to give the command to a soldier who gestures toward a group of mothers holding their children. The women show their distress only through their unbound hair, which they have let fall onto their shoulders. One mother alone attempts to flee; she turns away from the group at the right, and cradles her child against her chest in the fold of her garment. This placid portrayal of the Massacre is in marked contrast to all other early portrayals of the scene from the Latin West, which form a related group emphasizing the violent actions of the soldiers. This western group of images is found on carved ivories and sarcophagi ranging in date from the mid-fourth to the late fifth centuries.[34] A representative example is the dramatic vignette of the Massacre on an ivory panel of the early fifth century now preserved in the Staatliche Museen in Berlin, which was possibly originally part of a book cover with several scenes from the life of Christ (Fig. 3).[35] On the ivory Herod appears enthroned on the right, raising his right hand in command, while before him an unarmed soldier grasps an infant by the leg and swings the little body over his head to dash it against the ground. Behind the soldiers the mothers lament, their hair unbound, their faces distorted by

grief. One of the women raises her hands above her head in a conventional gesture of desperation.[36]

The earliest portrayals of the Massacre that survive from the eastern half of the empire are equally violent, but differ from the western images with respect to the details of the slaughter. For in the early eastern versions of the scene the soldiers are armed, and instead of throwing the children on the ground execute them with swords or spears. In visualizing these horrors, the eastern artists appear to have been guided by the Greek literary tradition. The first dated eastern depiction of the Massacre is a miniature in the Rabbula Gospel book in Florence, which was written in 586 at the monastery of St. John of Zagba in Syria (Fig. 4).[37] The scene is divided into two halves, on either side of the canon tables on folio 4 verso; on the left is Herod sitting on an elevated throne. The king leans forward, gazing intently and stretching out his hand to the other side of the page, where the Massacre is already taking place. He can best be described in the words of Philagathus as "sitting proudly on some high throne, giving sharp and savage looks with wide-open eyes. . . . Stretching out his right hand, he seemed to be commanding the soldiers."[38] The scene of slaughter that takes place opposite is abbreviated, but complex: a running soldier holds a child upside down by its ankle in his left hand, and in his right lifts his sword to dismember the body. The child's mother rushes at him to prevent the murder; she raises one hand to ward off the blow, and with the other still struggles to hold onto her child. All these details can be found in the description by Basil of Seleucia, which was written over a century before the miniature was painted. In Basil's ekphrasis the soldiers "rushed like lions";[39] the mothers "held fast with their hands to whatever of their children's limbs they could, as their children were dragged away;"[40] the infants were dismembered, in spite of the actions of the braver mothers, who warded off "the swords' edges with their hands."[41]

This close relationship between the fifth-century sermon and the sixth-century image strongly suggests that the illuminator was influenced by literary tradition, either directly, or indirectly through the copying of earlier works of art that had themselves been modeled upon sermons. However, it should also be recognized that the existence of other scenes of slaughter in both pagan and Biblical illustration may have aided the artist in his task of translating the written description into visual equivalents. A few surviving depictions of the capture of Troy show the Greek soldiers massacring the Trojan women and their children; the earliest of these, a vase painting of the seventh century B.C. from Mykonos, takes the form of a series of individual combats between the

mothers and the soldiers, who strike at the children with swords while the women fight to stave off the blows.[42] If such images were sufficiently widespread in the ancient world to have been available to early Byzantine artists, Christian painters could have used them as models when they visualized the conventional descriptions of hymn and homily. The depiction of the Massacre in the Rabbula Gospels could also have been modeled on an Old Testament scene, the Judgment of Solomon, which may have provided the motif of a soldier holding an infant by a limb in order to cut it in two.[43] But whatever the precise visual models employed by the artist who first created the Massacre scene found in the Rabbula manuscript, there can be little doubt that he was guided to them by a rhetorical text, such as the sermon by Basil of Seleucia.

Another early portrayal of the Massacre is found on a pressed earthen medallion, now preserved in the Abbey of St. Columban at Bobbio (Fig. 5).[44] This object probably dates to the sixth or early seventh century, and was brought to Italy as a souvenir from the Holy Land. Like the Rabbula Gospels, the medallion depicts a soldier on the left, who is apparently holding an infant by its ankle and raising his sword to slay it. On the right a mother is shown fleeing with her offspring; she is identified by the inscription in the border as Elizabeth who, according to the apocryphal Gospel, fled with the infant St. John into a cave in the mountains.[45]

The surviving Byzantine portrayals of the Massacre that were made in the century and a half after the end of iconoclasm, that is to say, in the second half of the ninth and in the tenth centuries, do not greatly expand upon the pre-iconoclastic versions of the scene. We may take as an example a miniature in a sumptuous illuminated manuscript of the Homilies of Gregory of Nazianzus in Paris, which was produced in Constantinople for the emperor Basil I, probably between 880 and 883 (Fig. 6).[46] Here we find Herod again enthroned on the left, in front of two officials. With his right hand he commands a soldier with an upraised sword to slay a child. In the background another soldier with a spear is seen pursuing Elizabeth and John into a cave in a mountain.

A striking contrast to the ninth-century illumination in Paris is produced by an eleventh-century miniature preserved in Leningrad, which presents a much more elaborate portrayal of the Massacre (Fig. 7).[47] This miniature probably dates to the third quarter of the century; it adorns an isolated leaf that evidently once formed part of a commentary on St. Matthew's Gospel.[48] In the eleventh-century illumination the scene has been expanded so that it fills two registers. Above, Herod leans forward intently to watch three soldiers, one of whom dismembers a child with his sword. In the hills in the background

a woman sits mourning, pulling at her hair with both hands. A tree, with a large bird's nest in its upper branches, recalls the simile used earlier by Romanos and John of Euboea," [Herod] snatched the nestlings from their arms like little sparrows."[49] In the lower register we see Elizabeth on the left, fleeing from a soldier with a spear; on the right the artist has illustrated each of the successive stages of the mothers' lament as described by Basil of Seleucia.[50] First a mother collects her dead child from the ground, then she holds the body against her bosom and kisses it. Finally, she places the corpse in her lap, and pulling her hair breaks into vehement cries.

This dramatic expansion of the Massacre scene can also be found in other eleventh-century Byzantine paintings. One of the finest examples is an icon of the Nativity and related scenes that is preserved on Mount Sinai (Fig. 8).[51] Here Herod's intent supervision has been exaggerated to such an extent that the king appears in danger of toppling from his throne, as he cranes forward to watch over the atrocities. The episodes of slaughter all echo the clichés of the literary tradition: as we look from left to right we are shown the children being decapitated, dismembered, and, in the words of Romanos, "horrendously transfixed" on the point of a spear.[52] At the right one child is murdered in its parent's arms. In the landscape above, Elizabeth takes flight from a running man whose streaming hair may allude to the sermons' conventional comparison of the executioners to lions or wild beasts.[53]

In the visual arts the next stage in the expansion of the iconography can be seen in the early fourteenth-century mosaic cycle of the Kariye Camii, in Constantinople, where the ekphrasis of the Massacre reaches its climax in Byzantine art. In this church the designer spread the description of the event over three lunettes in two successive bays of the southwest corner of the narthex (Figs. 9-11, 13, 14). A fourth lunette contained the Flight of Elizabeth.[54] Such an extensive portrayal of the Massacre was unprecedented in Byzantine art, but its counterpart in literature had been created by the fifth century.[55] At the Kariye Camii we find, for the first time in surviving Byzantine monuments, a clear division of the composition into the three chronological stages of the formal description—prelude, action, and aftermath. The artist has depicted the prelude in the left half of the first lunette, where we see Herod instructing his troops, and in the right half we see the beginning of the action, the Massacre itself (Fig. 9). At the Kariye Camii the two stages are clearly separated from each other through a compositional device that, in this context, appears to have been a recent innovation in Byzantine art. The division is achieved through the poses of the group of soldiers standing in the center of

the lunette; two soldiers on the left turn toward Herod, to receive his charge, but the soldier on the right turns away from the king and his retinue in order to proceed with the massacre.[56] In the right-hand corner of the mosaic the artist began his description of the crimes, showing one soldier in fast pursuit of a woman who, in Basil's words, is "gazing at the flash of the sword,"[57] while another kills a child whose mother throws up her hands and turns away in horror. In the second lunette the artist continues his catalogue of cruelties (Fig. 10). With one exception, the individual motifs encountered here were not new in Byzantine art; we have already seen the bodies transfixed on spears, the children being suspended by their ankles for slaughter, or being murdered in their mothers' arms. But it was an innovation for an artist to show so many episodes, with no fewer than nine soldiers still visible in the lunette, even though a considerable portion of the mosaic has fallen away; this reiteration of different varieties of brutality is extremely close to the literary ekphrasis.

It has been noted that a remarkable feature of this mosaic is the contrast between the horror of its content and the beauty of its presentation;[58] the colors are fresh, the drawing of the figures is elegant, and the landscape of the background enfolds the whole composition in a sequence of rhythmical curves. Furthermore, at least one of the motifs has the allure of ancient sculpture. At the extreme right of the lunette the artist has portrayed a mother fleeing with her offspring from one of the executioners (Fig. 11). Her back is turned to the viewer, but we see one side of her face as she glances over her shoulder at her pursuer; the soldier, meanwhile, stretches one hand out toward her, and with his other unsheathes his sword. This is the earliest surviving Byzantine depiction of the Massacre in which such a group appears; it may, however, be compared with a carving on Trajan's column in Rome, which shows the taking of Dacian captives (Fig. 12).[59] The Roman commander stands on the left, holding out his arm toward a woman who flees holding her child; the woman's back is turned toward us, but she looks over her shoulder at the soldier, like the mother in the mosaic. The inclusion of this antique theme at the Kariye Camii, whether it was rediscovered by the Byzantine artist or reinvented, helps to breathe new life into the repertoire of literary clichés that makes up the mosaic of the Massacre.

The designer of the mosaics in the Kariye Camii devoted the whole of a third lunette to the last stage of the ekphrasis, the aftermath (Fig. 13). Only the right half of this mosaic is preserved; it shows a group of mothers sitting huddled together as they mourn over the corpses of their children. One, in the center, raises her hand to her cheek in a conventional attitude of silent sorrow;[60]

at the same time she cradles the severed head of her child against her chest—
an image that echoes the hymn by Romanos in its gruesome realism (Fig.
14).[61]

The greatly expanded description of the Massacre that decorates the walls
of the Kariye Camii can be compared to other fourteenth-century portrayals
of the event that rival it in scope and variety of detail. In the church of the
Brontochion at Mistra, for example, a fresco of the Massacre occupied a whole
dome over the gallery that adjoins the south aisle of the church. The paintings
portray Herod giving his command to one group of soldiers, while other soldiers
turn away from the king to carry out his instructions. The massacre itself is
portrayed in great detail, the various episodes of slaughter being presented
against a cityscape, so that the scene gives the appearance of a picture of a
captured town (Fig. 15).[62] The motifs include a kneeling mother collecting the
corpse of her infant from the ground (Fig. 16, bottom left). Finally, the fresco
at the Brontochion also depicts one of the mothers seated in lamentation (Fig.
16, bottom right), a theme that may have been amplified in the portion of the
painting that has fallen away.

From the foregoing survey of the iconography of the Massacre in Byzantine
art, it is possible to identify three principal phases in the translation of the
simple Gospel narrative into a full-scale rhetorical description: the earliest
phase is illustrated by the Rabbula Gospels and the medallion in Bobbio (Figs.
4 and 5); the second is represented by the eleventh-century paintings on the
folio in Leningrad and the icon at Sinai (Figs. 7 and 8); the culminating phase
is reached with the mosaics of the Kariye Camii and the frescoes at Mistra in
the fourteenth century (Figs. 9-11, 13-16). In each of these periods new ele-
ments were transferred from the literary to the visual repertoire. Only in one
instance is it possible to identify a motif that may have been depicted in works
of art before it was adopted in literature; as far as I am aware, it was the
twelfth-century preacher Philagathus who first described Herod as "giving
sharp and savage looks with wide-open eyes."[63] He claims to have seen Herod
so characterized in a panel painting, and, appropriately, it is on an earlier icon
of the eleventh century, the panel at Sinai discussed above, that we find the
closest visual equivalent to his description. Here the king in his fury cranes
his head forward to watch his soldiers at their slaughter (Fig. 8); his dramatic
portrait intensifies a motif already exploited by earlier Byzantine artists, such
as the sixth-century illuminator of the Rabbula Gospels (Fig. 4). The image
was probably created by Byzantine artists in order to illustrate the Gospel text:
"when Herod saw how the Wise Men had tricked him he fell into a great

passion."[64] Philagathus could well have remembered such paintings of Herod when he came to compose his sermon. The south Italian preacher may, therefore, provide us with a rare instance of the reciprocal influence of art on literature.

Descriptions of Torture

The blood-soaked depictions of slaughter that have been reviewed on the preceding pages betray a Byzantine taste for horror that was expressed in other subjects favored by the rhetorical tradition. Torture itself was a frequent topic of description, both by pagan and by Christian writers, and I shall try to demonstrate how such descriptions affected the visual arts, especially scenes of the trials of the martyrs. In particular, I believe that literary description may provide an explanation for a puzzling inconsistency in Byzantine art. For there was one particular scene of martyrdom, the death of the Forty Martyrs of Sebaste, that came to be depicted with a far greater vividness and realism than any other; in Byzantine illustrations of this event both style and iconography were radically transformed under the influence of a rhetorical model.

In his *Declamations*, Seneca shows how the skilled performers of the early empire adorned their speeches with descriptions of tortures of various kinds. He quotes from a speech that was graced by a description of the old man who was tortured by the painter Parrhasius, so that the victim might serve as a model for a painting of Prometheus.[65] Another declamation in Seneca's collection presents to us the loyal wife, tortured by a tyrant whom her husband has plotted to destroy: "fires that had been extinguished by blood were rekindled; at times her tortures were stopped—just so that they could be applied the more frequently. They devised whips, blades, the rack, all the inventions of ancient savagery, all the innovations of modern savagery—what more should I say?"[66]

Antique orators frequently set out to emulate artists by describing tortures portrayed in works of art. The fifth-century rhetorician Nicholas the Sophist instructed writers to describe those formal characteristics of a statue or a painting that revealed the inner feelings of the subject;[67] his precepts are well illustrated in an ekphrasis ascribed to the fourth-century pagan orator Libanius, which describes a sculpture of Prometheus being devoured by the eagle.[68] Through a detailed account of the victim's physical appearance, which moves in turn from the head to the torso, and from the torso to the limbs, the author graphically conveys the suffering of his subject: his hair is long, unkempt and

squalid, his face is wracked by pain, his eyebrows are distended, his eyes and mouth are closed, his cheeks contracted, and his beard neglected; his neck is bent, his chest swollen out, his stomach contracted and consumed away; his right hand is bent back behind his head, his fingers are bent and interlaced, so that: "each [finger] has a different external appearance, but they all express one agony."[69] Another ekphrasis that was attributed to Libanius describes in similar detail a sculpture of Ajax, in which the physical distortions displayed the subject's frenzy of mind.[70]

Such formal descriptions of torture and suffering found a natural place in Early Christian homilies devoted to the torments of the martyrs.[71] Even John Chrysostom, who was less influenced by formal rhetoric than either of the two Gregories or St. Basil, resorted to the ekphrasis of torture. In the homily on *All the Martyrs* his description of the punishments of the saints brings to mind the declamation on the tortured wife quoted by Seneca. John Chrysostom tells us that the executioners first tortured the martyrs on the rack, but afterward "those bloodthirsty animals did not stop their mania there, but taking the [martyrs] down from the rack they stretched them over the coals on iron grids. And one could see again even harsher sights than before; from the bodies streamed drops . . . of flowing blood." Only at the end of his description does the preacher depart radically from pagan rhetorical tradition by observing, through a startling simile, that the victims rejoiced in their torture: "but the saints lay on the coals as if on roses, and thus regarded what happened with delight."[72]

Another Early Christian writer, Asterius of Amasia, followed the precedent of Libanius in applying his description of tortures to a work of art, in this case a painting of the martyrdom of St. Euphemia that the bishop had seen in her martyrial church.[73] According to Asterius, four episodes were portrayed in the painting: the interrogation of St. Euphemia, her torture, her imprisonment, and finally her execution. In his account of the torture, Asterius describes how the executioners cut out the martyr's teeth; he was so moved by the scene that he could hardly continue speaking: "but now I am shedding tears and my emotion impedes my speech: for the artist has so clearly painted the drops of blood that you would say that they are really pouring from her lips, and you would go away weeping."[74] But while Asterius says that the spectator is moved to tears, he concludes his description by declaring that the martyr herself received her execution joyfully: "soon after, the painter kindled a fierce fire in another place, and he gave body to the flame with red high lights here and there. In the middle of the fire he sets her, spreading out her hands to heaven

and showing no suffering on her face, but on the contrary, rejoicing that she was to depart to the blessed life of the spirit."[75]

Many other Early Christian and Byzantine descriptions of the trials of the martyrs contrast the severity of the tortures with the equanimity or even joy of the recipients or their families; the same antithesis can be found in many surviving works of Byzantine art. The Byzantine artist's usual approach to martyrdom is exemplified by the richly illustrated Menologium of Basil II, which was produced for the Byzantine emperor, probably in the early eleventh century.[76] No fewer than eight artists worked on the miniatures of this manuscript.[77] On its illuminated pages innumerable martyrs are submitted to a variety of meticulously delineated tortures, which they receive with an indifference that becomes almost monotonous. A typical case is that of St. Aristion, who is commemorated on page 9 (Fig. 17).[78] According to the text above the miniature this Saint "was committed to the fire. And thus in the furnace, . . . glorifying and magnifying God, he received his blessed and longed for end, taking the crown of incorruptible life. . . . And his saintly soul went up into Heaven and rejoices with the saints."[79] Following the spirit of this passage, the miniaturist has shown us the martyr standing seemingly unaffected in the midst of the flames, raising his eyes and hands toward heaven where the hand of God appears to encourage and reward him. By contrast, the executioner, who is adding fuel to the fire, has to shield his face from the intense heat with his hand. Only in a very few of the martyrdom scenes depicted in the Menologium do the victims give any sign of discomfort through their poses or gestures. These isolated instances of frailty, in which the saints indicate a muted suffering by clasping their wrists or covering their faces, only serve to highlight the unvarying fortitude shown by the other martyrs in the manuscript.[80]

In Byzantine iconography there is one important and striking exception to the general indifference of the martyrs to their suffering. From the tenth century onward there survives a series of remarkable portrayals of the Forty Martyrs, which are highly unusual among Byzantine scenes of martyrdom for their graphic portrayal of the torture of the victims. According to tradition, the forty saints were soldiers who met their death by being exposed in midwinter to freeze beside a lake in lesser Armenia. A famous ivory of the tenth century, now in Leningrad, shows the half-naked martyrs in a variety of contorted poses as they suffer in the cold (Fig. 19).[81] One of the younger soldiers, depicted in the front row at the center of the ivory, has allowed himself to be completely overcome by cold and exhaustion, so that he has to be sup-

ported on the arms of a companion. The sinuous, writhing motions of the other martyrs contrast strongly with the image of St. Aristion, praying calmly in the flames (Fig. 17). This portrayal of the death of the Forty Martyrs is so out of character with other Byzantine treatments of the theme of martyrdom that its origins deserve to be studied carefully.

It is interesting that the early images of the death of the Forty Martyrs are entirely different in character from the dramatic portrayal on the tenth-century ivory. The few versions of the scene that survive from the centuries before iconoclasm follow the usual pattern of Early Christian and Byzantine martyrdom scenes in stressing the victims' indifference to their torments rather than their pain.[82] The best preserved of the early versions of the scene is a fresco painted in the apse of the Oratory of the Forty Martyrs attached to the church of S. Maria Antiqua in Rome (Fig. 18).[83] The painting probably dates to the middle of the seventh century.[84] In contrast to the later ivory, the martyrs in the painting are represented in identical frontal poses; they stand rigidly in three rows, with their hands slightly raised in repeated gestures of prayer. Only one of the figures breaks the uniformity; he is the single renegade on the right of the scene who, according to the legend, was tempted to seek the warmth of the bath house that had been set up on the shores of the icy lake in order to break the martyrs' resolve and tempt them into recanting their faith. The remaining martyrs illustrate an imperviousness to suffering that had been described in the sixth century by Romanos, in two hymns that he composed for the forty saints' feast day: "undismayed by the gusts of the winds you were courageous in the spirit. You laughed, as you passed across the foamy depths."[85] "They took off their clothes and, as into a stadium, entered the lake naked; and during the night they sent up prayers to Christ."[86]

The Church of S. Maria Antiqua preserves a fragment from another fresco of the death of the Forty Martyrs, which probably also dates to the seventh century.[87] Only two of the saints are still preserved *in situ*, but their appearance suggests that the poses of the martyrs in this fresco were as regular and impassive as in the apse of the oratory. The two saints stand in identical frontal poses, with their right arms bent and held in front of their chests. This fresco, though it adorns a Roman church, may have been painted by a Greek artist, for there is a prayer inscribed in Greek in the border beneath the scene.[88]

The tenth-century ivory in Leningrad (Fig. 19), which so expressively portrays the suffering of the forty soldiers, is the earliest surviving post-iconoclastic work of art that portrays their martyrdom. It was followed by many similar portrayals in Byzantine art that stress the pain and suffering endured

by the forty soldiers. A closely related ivory has been preserved in Berlin (Figs. 20 and 22).[89] In the two ivories the martyrs are depicted in a similar variety of shivering poses, and both compositions differ from the frescoes of S. Maria Antiqua in that the upper half is filled by a vision of Christ enthroned in heaven and flanked by adoring angels. However, in the Berlin ivory the execution of the details is less fine, which indicates that it is a copy of the carving in Leningrad, or perhaps a copy of its model.[90] In the first half of the eleventh century, a Byzantine poet, Christopher of Mytilene, composed a brief epigram on a painting of the Forty Martyrs that must have been similar in appearance to the two ivories. The poet stresses the variety of the martyrs' poses: "See the victorious Forty of God here, standing by the lake, each one in another posture. But if they are not alike in their postures, in the trial by frost they have one mind."[91] This conceit, that differing external appearances all express one condition of pain, had already been employed in the ekphrasis attributed to Libanius, in the description of the fingers of Prometheus.[92] A painting of the death of the Forty Martyrs that is approximately contemporary with the eleventh-century poem has survived in the left side apse of the church of St. Sophia in Ohrid (Fig. 21).[93] Though the fresco is not a work of the same quality as the ivories, it does attempt to achieve the same end of portraying the variety of the martyrs' suffering. Some of the saints hunch their shoulders and hug themselves for warmth, while several of their number have collapsed and have to be supported on the arms of their companions. A somewhat later fresco of the torture of the Forty Martyrs, dated to the year 1106, has survived in the church of Asinou on Cyprus; here once more the Byzantine artist has shown the saints in many different attitudes of pain (Fig. 23).[94] We again discover the martyrs hunching their shoulders and hugging their chests, while in the center of the front row there is a repetition of the motif of the slumped youth who must be held up by his older colleagues. In addition, several of the martyrs clasp their wrists, press their hands against their cheeks, or grasp their chins—all conventional gestures of sorrow. Above the martyrs' heads there is a short poem, the first two lines of which state explicitly that the image is intended to convey the martyrs' agony: "Winter it is that causes pain, flesh it is that suffers here. If you give your attention, you will hear even the groans of the martyrs."[95]

The tenth-century ivory in Leningrad, therefore, presented another way of visualizing the martyrdom of the Forty, as an image of intense physical pain and suffering. This iconography was adopted also by artists of the eleventh and twelfth centuries, and it continued into later Byzantine art. As we have

seen, it was a radical departure from the traditional approach to scenes of martyrdom, which was to show the martyrs oblivious to their torture or even delighting in it. When medieval Byzantine artists portrayed the death of the Forty Martyrs alongside other episodes of martyrdom, they often created a striking contrast between the vividly expressed sufferings of the forty soldiers and the impassive poses of other martyrs. We may juxtapose, for example, two miniatures of an eleventh-century menologium that is now MS. gr. 183 in the State Historical Museum at Moscow. On page 91, Saints Maximus and Theo-dotus are shown in the flames, each standing frontally in symmetrical poses of prayer (Fig. 24).[96] However, the sufferings of the Forty Martyrs in the frost, on page 179, are depicted with far greater movement, variety, and drama (Fig. 25).[97] As they are consumed by the cold, the naked soldiers can be seen to hug themselves, to fall on their knees, to support their collapsed comrades, to grasp their wrists, to clasp their hands together, and to raise their arms to heaven.

In order to create the icon that expressed the suffering of the forty soldiers, Byzantine artists drew on a variety of visual models. Otto Demus has shown how several standard iconographical motifs that already existed in Christian art by the tenth century could have been adapted to the image of the Forty Martyrs that was carved on the ivory in Leningrad and on the related ivory in Berlin (Figs. 19, 20, 22).[98] The vision of Christ enthroned in a mandorla flanked by angels could have been derived from an Ascension scene, as could the martyrs in profile at the back of the group who raise their hands to heaven. Both of these motifs existed in the iconography of the Ascension as early as the sixth or seventh century, as the Palestinian pilgrims' flasks preserved in the Cathedral of Monza prove (Fig. 26).[99] The creator of the scene of the suffering martyrs, however, drew not only on Christian iconography; Kurt Weitzmann has shown that he also appears to have searched in the repertory of pagan art for the models of his contorted half-nude figures.[100] Some of the martyrs, for example, could have been taken from Byzantine illustrations of the battle of the giants against the gods, such as a tenth-century miniature in a manuscript of Nicander's *Theriaka*, which has been preserved in the Bibliothèque Nationale in Paris (Fig. 27).[101] In the lower right-hand corner of the ivories there is a martyr with his back turned to the spectator who raises his hand and looks upward; this figure could have been derived from one of the dying giants, such as the one depicted in the center at the bottom of the miniature. Toward the middle of the second row of martyrs there is another motif that may betray a source in pagan art. One of the older bearded martyrs gently puts his arm around the shoulders of a young companion in what

appears to be a tender embrace, a surprising gesture in a scene of martyrdom. Weitzmann suggested that the artist derived this composition from a painted version of a well-known classical sculpture group that showed Pan instructing Daphnis in the playing of the syrinx.[102] A parallel that is equally close in form and closer in content can be found in carvings of the Slaughter of the Niobids that adorn certain Roman sarcophagi; on several of these sarcophagi, such as an example in the Archaeological Museum at Venice, an old bearded tutor appears in the midst of the dying children with his arms around the limp body of a slain youth; the pair creates a group that is a striking echo of the two martyrs on the ivory (Fig. 28, left side).[103]

The Leningrad ivory, therefore, was based on a variety of visual sources, both Christian and pagan, that add greatly to the liveliness and realism of the scene. But although the identification of these models helps to explain how the new iconography of the Forty Martyrs was created, it does not explain why Byzantine artists felt the need to draw on mythological illustrations when they depicted this particular episode of martyrdom. An answer to the latter question may be found in two fourth-century sermons on the Forty Martyrs by Gregory of Nyssa and Basil the Great. The two brothers provide very similar descriptions of the torture endured by the saints,[104] which have already been compared to the visual image by Otto Demus.[105] Each ekphrasis moves in turn from one part of the body to another as it catalogues the physical consequences of exposure to cold. This technique of description was in the tradition of pagan rhetoric, and we have seen it used in the ekphrasis of a sculpture of Prometheus that was ascribed to Libanius.[106] Since St. Basil's description has a particular relevance to our discussion, we will quote it in full: "the body that has been exposed to cold first becomes all livid as the blood freezes. Then it shakes and seethes, as the teeth chatter, the muscles are convulsed, and the whole mass is involuntarily contracted. A sharp pain and an unspeakable agony reaches into the marrows and causes a freezing sensation that is impossible to bear. Then the extremities of the body are mutilated, as they are burned [by the frost] as if by fire. For the heat is driven from the extremities of the body and flees to the interior; it leaves the parts that it has abandoned dead, and tortures those into which it is compressed, as little by little death comes on by freezing."[107]

This graphic description is well matched by the scene on the Leningrad and Berlin ivories (Figs. 19, 20, 22); the martyrs are shaken and convulsed by the cold, their bodies are contracted, and their hands are limp as if all life has been drained from them. And it is not only the depiction of the suffering martyrs

themselves that corresponds with the sermon; Basil's text could also have prompted the inclusion of Christ enthroned between his angels. For although this heavenly vision had not been portrayed in the earlier version of the martyrdom at S. Maria Antiqua, Basil, in common with other writers, describes "powers coming down from the heavens and distributing great gifts to the soldiers, as if from a king."[108]

The iconography of the ivory in Leningrad, then, can be said to correspond in detail with a rhetorical description in a sermon by Basil the Great. But if we are to assume a connection between the fourth-century text and the tenth-century image, it is necessary to explain why the influence of the sermon was apparently so long delayed. We have seen that the earlier surviving depictions of the death of the Forty Martyrs, such as the seventh-century frescoes in Rome, show the martyrs in impassive poses of prayer. If we suppose that this was the only way in which the martyrdom of the Forty was portrayed in the centuries before iconoclasm, then it follows that Byzantine artists waited as long as five hundred years before they attempted to illustrate the fourth-century writer's vivid description of torture by freezing. On the other hand, if we conjecture that Basil's portrayal of the soldiers' torments had already been illustrated in early Byzantine art, it is still necessary to explain why Byzantine artists working after iconoclasm preferred to exploit the violent imagery of Basil's text rather than to adopt the more placid, and thus more conventional version of the scene that showed the saints in attitudes of prayer. The answer to the problem may lie in the role that Basil's oration on the Forty Martyrs played during the iconoclastic controversy. For it was in the preface of this same sermon that St. Basil made his often quoted comparison between art and rhetoric. It will be remembered that Basil explained that he would show the prowess of the forty soldiers to all "as if in a picture. . . . For the brave deeds of war often supply subjects for both speechwriters and painters. Speechwriters embellish them with their words, painters depict them on their panels, and both have led many on to acts of bravery. For what spoken narrative presents through hearing, this silent painting shows through imitation."[109] We have seen that these words were cited by Germanos I, by John of Damascus, and finally by Nikephoros in their respective defenses of images.[110] Basil's sermon must, then, have had a particular relevance to Byzantine religious art, which was kept alive as a result of the iconoclastic controversy of the eighth and ninth centuries. Not only did the sermon instruct the artist to imitate the orator, but in the ekphrasis of the martyrs' torture it provided a set piece of rhetorical description that was ideally suited for imitation. We do not know

when Basil's description was first illustrated; there is, however, no reason to suppose that the Leningrad ivory was the earliest attempt to render the vividness of the text, though it may have been among the most successful.

To summarize, in the portrayal of the Forty Martyrs, Basil's comparison of rhetoric and painting, conventional though it was, served as a guideline to the Byzantine artists who illustrated this scene. As a result, they created an image of martyrdom that was unique in its graphic portrayal of suffering. Three further observations may be made of a more general nature. First, the iconography of the Forty Martyrs shows that the influence of texts had the effect of introducing what may be called a selective realism into Byzantine art, which corresponded to particular set pieces of classical rhetoric. This phenomenon of selective realism is one that we shall meet again in the course of this study. Second, the depiction of the suffering martyrs on the Leningrad ivory shows that antique art and literature could be equal partners in introducing classical elements into a medieval image. It was Basil's text, conceived according to the conventions of late antique oratory, that prompted the creator of the icon to seek out the appropriate visual motifs in pagan art. Finally, we are shown how the controversies of the Byzantine church could give a sermon new relevance five centuries after it had been written down, so that a late antique description could have contributed to an artistic revival that took place after the ninth century.

Descriptions of Spring

A very popular subject of description among Byzantine authors was the season of spring. Its delights were catalogued by orators in their exercises, by correspondents in their letters, and by preachers in their sermons. These descriptions, though more pleasing to the modern ear than Byzantine accounts of torture and massacre, were hardly less stereotyped.

The most famous classical model of an ekphrasis of spring was written by the fourth-century sophist Libanius. In the pagan orator's description we can recognize nearly all of the motifs that were later to adorn the Christian homilies: "The spring . . . frees the [sun's] rays from the clouds. Then the sun is bright and gentle and delightful. . . . The earth brings forth its products, and then green fields gladden the farmers with hope. And the trees also regain their foliage, and everything promises fruits. . . . Then the sea lies open to sailors. Then the waves are not high, nor are they like mountains, but the surface of the sea is smooth . . . the perennial rivers are clear, the winter

streams are more moderate. And the springs are much better than in winter. . . . Men seem to have returned to life . . . taking delight in the songs of the birds and the scents of the flowers. The swallow sings in the spring, as does the nightingale. . . . But also the other species of birds appear everywhere flying. . . . The meadows are very sweet with the voices of lambs and, as I have said already, with flowers, with roses, with violets, with lilies, with all the other flowers that are not only sweet to see, but also sweet to take in one's hands.''[111]

The delights of spring listed by the pagan orator were precisely those that were selected for presentation by Christian preachers, and they were often paraded in the same order. It was a famous sermon on the New Sunday by Gregory of Nazianzus that gave the ekphrasis of spring a place of respectability in Christian literature.[112] This homily, which was composed for delivery on the first Sunday after Easter, became very popular in the later Byzantine church; it was one of the sixteen of St. Gregory's sermons selected for the "liturgical edition," which arranged them in the chronological order in which they were read during the liturgical year.[113] In his New Sunday homily, Gregory, having preached the rebirth of man through Christ, found pretext for describing the rebirth of nature during the "queen of the seasons." Like Libanius, Gregory saw "a more radiant sky and a higher and more golden sun." He too observed that "the springs flow more transparently, the rivers more abundantly, released from the bonds of winter." The homilist also was moved by the luxuriant growth of the plants, the sweet scent of the meadows, the mowing of the grass and the skipping of the lambs in the green pastures. Nor did the preacher forget the vessel leaving its harbor, and "the dolphin leaping around the ship, blowing out a very sweet spray, raising himself up above the [water], and following the sailors with joy." Meanwhile, on land, he observed that "the bird is just now building itself a nest, and one bird returns while the other remains; another flutters around, fills the grove with song, and chatters to man.''[114]

Descriptions of spring similar to those by St. Gregory and Libanius are scattered through the sermons and letters of later Byzantine writers. The purpose of these set pieces was sheer display; often they have only a tenuous relationship to the principal subject. At the turn of the ninth and tenth centuries, for example, the emperor Leo VI, finding himself called upon to deliver a sermon in honor of the dedication of a church in Constantinople, described not only the building itself but also the varied manifestations of the season in which it had been completed, from the swallows building their nests on the

rooftops to the sea monsters hiding their ugliness in the depths.[115] In the eleventh century, a Byzantine bishop, John Mauropous, having recently received a letter was struck by its resemblance to the birds that arrive in spring. On the one hand, the epistle sang to its recipient in sweet and melifluous tones like a nightingale from a grove; on the other hand, its appearance reminded him of a swallow, for the black writing on the white page produced a contrast of colors characteristic of this bird.[116]

Byzantine artists were also called upon to depict the clichés of spring in illuminated editions of the liturgical homilies of Gregory of Nazianzus. Among the earliest and certainly the finest surviving illustrations of Gregory's ekphrasis are those in a manuscript that is now housed in the library of the Greek patriarchate at Jerusalem (MS. Taphou, 14), but which was probably made in Constantinople or its area in the second half of the eleventh century. Its miniaturist devoted nine marginal vignettes to the motifs of Gregory's description. On folio 33, for example, he showed the grass being mown and the lambs in the meadows, as well as a ship surrounded by happily leaping dolphins and other fishes of various kinds, including a swordfish (Fig. 29).[117] The artist did not omit Gregory's reference to the vessel leaving its harbor, for he added a tall fortified harbor building in the right margin. In a miniature on the next folio (34) the painter incorporated into a landscape other motifs from Gregory's description (Fig. 30). In the background, on the left, he painted a grove of trees surrounded by a tall trellis; birds are fluttering above the grove, no doubt filling it with song, and chattering to the people who are reclining blissfully on mattresses in the meadow below. On the right we observe that another bird has just built itself a substantial nest in a slender tree, and has laid two eggs in its precarious new home.[118]

The illustrations of St. Gregory's homilies provide us with the most obvious instances in which Byzantine artists illustrated an orator's conception of spring. But there was another, less easily recognized context in which Byzantine artists portrayed the clichés of literary springtime. This context was the feast of the Annunciation. The primary association of the feast with the season arose from the date of its celebration, on the 25th of March. For Byzantine writers there was a divine logic lying behind the coincidence of the Annunciation with the renewal of nature. According to the sixth-century homilist Anastasius of Antioch, for example, the Annunciation took place at the same time of year as the first spring of the creation. God became man on the very day of the year on which he had made man; Adam was redeemed on the anniversary of his creation.[119] Thus Anastasius describes the feast of the Annunciation as "the

Birthday of the whole world, because everything has been returned to place and the old disorder has accepted order, because he who made us has become like us on account of us, renewing his aged and corrupted image, and changing it to a wealth of beauty."[120] Spring and renewal became constant themes in the Greek literature on the Annunciation. For the eighth-century patriarch Germanos I, the Annunciation was the "springtime feast of feasts";[121] for the twelfth-century preacher Philagathus it was the "spring of the advent of God," which began to shine after the end of "the winter of idolatry";[122] according to a fourteenth-century archbishop, Isidore of Thessalonica, the spring itself "hurries to announce clearly by its own beauty that this is the time during which universal joy is at hand."[123]

The feast's association with spring encouraged Byzantine authors to embroider their praises of the Annunciation with the imagery of the season. Here it is necessary to note that the homilists incorporated this imagery into their sermons by one of two methods. The more common technique, which was also very extensively used by poets, was the accumulation of individual metaphors of spring and fertility, many of which were drawn from the Bible, especially from the Song of Songs. The rarer technique was the formal description, structured according to the rules of rhetoric. In the latter case, the images were obviously derived not from Biblical but from pagan literature, and they were presented in the sequence established by the rules of ekphrasis. Because both these literary techniques had direct counterparts in the visual arts, we shall review the prominent examples of each in turn.

The accumulation of images was a technique that found its most effective expression in poetry devoted to the Virgin. A famous example is the reiteration of metaphors in the early Byzantine *Akathistos* hymn, which celebrates the stages of Christ's incarnation from the Annunciation to the Presentation. In the course of this hymn the poet repeatedly calls on the Virgin with long sequences of images:

Hail vine of the imperishable shoot;
hail field of the pure crop . . .
hail to you who plant the planter of our life . . .
hail, for you make a meadow of delight to flourish. . . .
Hail, flower of immortality . . .
hail, tree of splendid fruit, from which the faithful are fed;
hail, tree well covered with shading leaves, under whom many are
 sheltered.[124]

Similar clusters of images can be found in many later hymns in honor of the Virgin. Thus a thirteenth-century poem by Theodore Laskaris addresses the Virgin as a sweet-smelling meadow, as a flower, as a star, as a bright light, as the fount of a perennial stream, and as the welcome swallow.[125] Prose writers also praised the Virgin by means of such images, particularly in sermons on the Annunciation. A fifth-century homily lauded the Virgin of the Annunciation as a fount and a river,[126] as the flowering rod of Jesse,[127] and as "the never-fading paradise of chastity, in which the tree of life was planted and will bring forth the fruits of salvation to all."[128] An eighth-century sermon on the Annunciation, attributed to John of Damascus, termed the Virgin more fragrant than the lily, more red than the rose, and more florid than the variegation of spring.[129] In the eloquence of Leo VI, the Virgin became a fruitful paradise, a lily, and the rock from which gushed the fountain of life.[130] Similar images of fertility were also evoked by later homilies on the Annunciation. Many of these metaphors had a clearly Biblical origin, such as the fountain from the rock described in the book of Exodus,[131] Isaiah's prophecy of the flowering rod,[132] and the lily from the Song of Songs.[133]

A few Byzantine homilists chose to express the ideas of fertility and renewal associated with the Annunciation through the formal ekphrasis of spring; in this case the entire description became an elaborate metaphor for the feast that the homilist wished to glorify. For Anastasius of Antioch, for example, it was enough merely to remind his hearers of a famous description of spring by an earlier author; at the end of his sermon he quoted the first lines of the ekphrasis in St. Gregory's New Sunday sermon, and explained that he cited this passage "in order that I may confirm what I have said with a quotation from the Fathers, and, so to speak, add to it some adornment through which it will have charm."[134] Other Byzantine preachers had less humility, and imitated Gregory's ekphrasis in its entirety. In the tenth century, John Kyriotes, who besides being a homilist was a poet and a rhetorician, adorned a sermon on the Annunciation with a full description of the spring, complete with the requisite golden sky, the calm sea, the flowering land, the singing birds, the leafing trees, the gentle streams, and the limpid springs. Now is the time, says our preacher, when the birds, the fishes, and the animals bring forth their young, at different times and in different places, but all seeming to celebrate the renewal of our nature.[135] In the fourteenth century, Isidore, archbishop of Thessalonica, embellished a sermon on the Annunciation with a similar ekphrasis of spring. Here too we find the sun stripping the clouds from its rays, the earth producing grass and furnishing dyes to painters from its flowers, the

flocks skipping and leaping, and the nestlings spreading their wings and preparing themselves for variegated song.[136]

Thus the Byzantine sermons on the Annunciation were embellished with metaphors of renewal and fertility either through a series of individual images or through a structured ekphrasis. The former method, which was more frequent in literature, was also more commonly reflected in art, for later Byzantine artists not infrequently embellished their portrayals of the Annunciation with one or two discreet metaphors of renewal. Before we look at these images in more detail, however, it is necessary to make a basic distinction between two types of Annunciation scene, which correspond to two successive stages in the story of the Annunciation as told in the Book of James. According to this popular apocryphal account, the Angel first called out to the Virgin as she was filling her pitcher at a well. Mary was startled by the voice, and fled into her house without replying. There she set down her pitcher of water and took up the purple thread that she was spinning for the veil of the temple.[137] As she was spinning, the Angel appeared a second time and spoke to her again.[138] Byzantine artists, therefore, illustrated two Annunciation scenes, one showing Mary holding a pitcher by the well in a garden, and the other depicting Mary with the purple thread, indoors in her house. In the decoration of churches Byzantine artists usually illustrated only the second and final Annunciation scene, but in extensive cycles they also included the first Annunciation by the well. In the late twelfth-century frescoes of the church of the Hagioi Anargyroi in Kastoria in Macedonia, for example, the second Annunciation was depicted in the place of honor, over the main apse (Fig. 31),[139] whereas the first was shown on the south wall of the nave (Fig. 32).[140] In the scene over the apse the elaborate architectural background behind the spinning Virgin clearly indicates that the action is taking place indoors, whereas in the fresco on the south wall a garden setting is suggested by the elaborate nest of foliage that surrounds the mouth of the well.

In some later Byzantine works of art the two scenes were conflated into one composition. In a fresco at Perachorio in Cyprus, which was probably painted between 1160 and 1180, we find the Virgin standing between her house, on the right, and a lion-headed fountain, on the left (Figs. 33 and 34).[141] The visual evidence of the fountain and the house suggests that the fresco is intended to portray both episodes of the story in one image. In a number of other Byzantine Annunciation scenes, especially of the eleventh and twelfth centuries, discreet landscape motifs, such as trees, birds, or gardens, accompany the iconography of Mary spinning before her house. However, since the well is

absent in the setting of these particular Annunciation scenes, they should not
be given the same interpretation as the fresco at Perachorio; they are not
conflations of the indoor and the outdoor stages of the two Annunciations.
Rather, their landscape elements should be thought of as metaphors of renewal,
inspired by the literary traditions that we have reviewed above.

The commonest of these metaphors with which Byzantine artists adorned
the Annunciation was the plant or tree. One of the earliest surviving paintings
of the Annunciation that includes this motif is the eighth-century fresco in
the church of S. Maria at Castelseprio, in Lombardy (Fig. 35).[142] Here Mary
is shown sitting indoors; she has set her pitcher of water down on the floor
and holds the spindles of wool in her left hand. Through an opening in the
wall painted in the background one can see a tree with sinuous branches. In
the illusionistic rendering of the Castelseprio painter the tree appears as a detail
fitting naturally into the background—a piece of landscape glimpsed through
a window. Very different in character is an Annunciation of the eleventh
century contained in a lectionary manuscript on Mount Athos (Dionysiu Mon-
astery, MS. 587, folio 150).[143] Here the tree appears as an isolated motif,
growing incongruously from the roof of a low arcade beside the Virgin's house,
and set against an abstract gold ground (Fig. 36). The somewhat awkward
juxtaposition of the tree with its architectural setting underlines its function
as a metaphor that is distinct from the rest of the background to the scene.

Trees can be found in the background of several other Byzantine Annun-
ciation scenes of the eleventh century;[144] in some twelfth-century paintings
the trees were replaced by flowers, or even whole gardens. In the fresco at
Perachorio white lilies grow beside the fountain,[145] whereas in a late twelfth
century painting in the Macedonian church of St. George at Kurbinovo a neat
garden is arranged on the roof of the Virgin's house (Fig. 37). The garden,
which contains cypress trees and a plant in a large vase, is surrounded by a
fence in allusion to the "garden close-locked" of the Song of Songs.[146] Similar
roof gardens can be found in two Annunciation icons of the twelfth century
preserved on Mount Sinai (Fig. 42),[147] and in several other late twelfth- and
thirteenth-century wall paintings in Macedonia and Serbia.[148] Occasionally the
trees harbor birds in their branches; on a twelfth-century enamel plaque from
the golden altarpiece in the church of San Marco, Venice, we may observe
three white birds perched in a small tree occupying an inconspicuous corner
to the right of Mary's throne (Fig. 38).[149] The workmanship of this enamel is
probably Venetian,[150] but the detail of the birds may be eastern in origin. For
it also occurs in an unpublished Greek fresco at Monē Proussou in Evrytania,

which is also possibly of twelfth-century date.[151] Here the Virgin's house supports a palm tree flanked by two birds that peck at its hanging clusters of grapes. The same composition accompanies an Annunciation scene in the mosaic cycle in the Cathedral of Monreale. These mosaics are primarily the work of Byzantine craftsmen who were employed by the Sicilian king William II; it is probable that most of the mosaics were set in the penultimate decade of the twelfth century.[152] In the bottom section of the right-hand face of the arch that precedes the apse, there is a panel depicting a palm tree flanked by two birds perched on branches on either side of its trunk (Fig. 39).[153] Above this mosaic, in the right-hand spandrel of the arch, stands the Virgin of the Annunciation. There is also a palm tree in the corresponding panel on the left-hand side of the arch, underneath the angel Gabriel, but here the birds are missing (Fig. 39). Although the palm on the right-hand side has clearly been restored, the presence of the same motif at Monē Proussou argues that the composition of the mosaic at Monreale is original, and that the bird-bearing tree was perhaps designed not merely as a space-filler, but also as a visual metaphor that referred to the Virgin of the Annunciation above. It is also possible that the arch at Monreale incorporates two other images of the Annunciation, in the form of the tall plants that grow from vases immediately under the figures of Gabriel and the Virgin. The ornament under the Virgin takes the shape of a green branching candelabrum that grows from a bowl piled with red fruit; it culminates in a large flower topped by a fan of red petals (Fig. 40). Above this flower hangs a garland containing more fruit, and above that curves a shell. This complicated plant form may have originated in manuscript illumination. Similar designs can be found in the headpieces of manuscripts produced in Constantinople earlier in the twelfth century, especially in a book of homilies on the Virgin Mary by the monk James of Kokkinobaphos, which is now in the Vatican library (MS. gr. 1162). On folio 3 of this manuscript, before the opening of James' sermon on the Conception of the Virgin, there is a headpiece that contains at its center a tall plant rising like a candelabrum from a vase, sporting red fan-shaped flowers, and flanked by baskets of fruit (Fig. 41).[154] At Monreale this ornament acquires a new significance. It is not merely a useful decoration for an awkward corner of the wall surface, but through its association with the Annunciation the plant also illustrates the images of fertility and fruitfulness evoked by the hymns and homilies.

There are, then, several surviving Byzantine Annunciation scenes, especially from the eleventh and later centuries, which demonstrate that artists tried to adorn their illustrations of this feast with one or more of the metaphors that

had been aired by poets and preachers. These works of art correspond to our first method of literary embellishment in that they incorporate individual images selected from the literary repertoire. The second method of embellishment, the formal ekphrasis, had much less influence on the visual arts than the first. However, among surviving Byzantine paintings of the Annunciation there is one important attempt to reproduce a formal ekphrasis. It can be found in an icon of superb quality in the collection at Mount Sinai, which through its distinctive style can be dated to the end of the twelfth century, and through its technical and conceptual refinement can be assigned to an artist from Constantinople (Fig. 42).[155] The iconography of this Annunciation scene is extremely unusual. At the left we see Gabriel approaching with a running step; he is splendidly attired in a gold robe that swirls around his body as if the material were endowed with a writhing energy of its own. The angel stares with an intent, one might almost say troubled expression at the Virgin, who is shown on the right, sitting on a sumptuous gold throne and holding the purple wool in her hands. In front of the two figures runs a stream with an irregular, indented bank. An extraordinary variety of creatures can be observed in the water, including a swordfish, an octopus, and a fish leaping above the water. We can also see herons and ducks in the river, while on the land we find other birds flapping their wings or bending their necks to preen themselves. Behind the Virgin rises a tall, etherial building that is painted entirely on gold. On a flat roof to the right there is a little garden with trees and a few smaller plants; two of the trees give the appearance of cypresses swaying gently, as if blown by a breeze. Another tree affords a perch to two birds in its upper branches. Above this garden, at the top of the building, we can see two more birds, probably storks, sitting in a nest that is precariously balanced on the ridge of the gabled roof. The whole scene is suffused with a warm golden light that colors the earth, the sky, the buildings, and even the figures themselves. The source of this illumination is suggested by the golden arc that appears in the sky at the top of the painting, and from which a dove symbolizing the Holy Spirit descends to the Virgin along a burnished ray of light.

The wealth of images in this Annunciation scene is unique in Byzantine art. Although, as we have seen, there was a recognized iconography of the Virgin at the well or fountain, it is unprecedented for her to sit enthroned in a landscape traversed by a river—a river, moreover, that is teeming with birds and all kinds of aquatic creatures. In portraying Mary in such a setting the artist appears to have revived a device of ancient illusionism that had been exploited by Early Christian artists. Among the closest known parallels to the

Byzantine icon are the mid-fourth century dome mosaics of Santa Costanza in Rome, which are now only known through watercolor copies (Fig. 43).[156] Here the Old Testament scenes were arranged on a receding stage whose front edge was created by the jagged bank of a river in the foreground; in the water various sea creatures and river birds disported themselves, just as on the icon. It should be noted that whereas in the Early Christian mosaic the river bank creates an illusion of a real landscape receding into depth, in the twelfth-century Byzantine icon the illusion is deliberately denied. For the ground that lies behind the bank is an unnaturalistic gold, which merges without any perceptible division into the golden buildings on the horizon.[157] Thus there is a curious disjunction between the apparent solidity of the river bank and the flat etherial quality of what lies behind it. A similar stylistic contradiction is presented by the Virgin's house; its elegant golden structure seems far too insubstantial to support a roof garden, complete with wind-blown trees. And there is something slightly incongruous about an etherial mansion that is crowned by two large storks sitting comfortably in their nest. The overall impression given by the Sinai icon is that it makes an uneasy union between landscape motifs drawn from an illusionistic tradition and a setting that is in other respects otherwordly and abstract.

Both the iconographic peculiarities and the stylistic inconsistencies of the Sinai icon can be explained with reference to literary tradition. For the artist has evidently attempted, like Anastasius of Antioch, John Kyriotes, and Isidore of Thessalonica, to embellish his portrayal of the Annunciation with an ekphrasis of spring. Though the artist has not illustrated all of the standard clichés, he has depicted a great many of them; under the golden light of the sun we see the trees with their foliage, the river freed from the bonds of winter, the sea creatures, the birds in the grove, and finally the nest on the rooftops. It is possible that the artist of the icon was partially guided in his portrayal of the ekphrasis by the earlier miniatures of St. Gregory's New Sunday sermon. We have seen that one of the paintings in the Jerusalem manuscript shows a landscape with nesting birds (Fig. 30), and another page illustrates swordfish and leaping dolphins (Fig. 29). The eleventh-century miniatures could not, however, have been the source for all of the unusual motifs in this Annunciation. It is difficult to imagine that the Sinai icon could have been created without additional recourse to a more ancient model similar to the Santa Costanza mosaic.

The rhetorical inspiration of the Sinai icon may help to explain not only its iconography but also its style. In sermons, the ekphrasis of Spring forms a

self-contained unit of late antique rhetoric that is distinct from the main body of the homily. In the icon, too, there is a sharp stylistic and conceptual division between the scene of the Annunciation itself and the rhetorical landscape elements that have been grafted onto it. In order to illustrate the landscape conventions of the ekphrasis, the Byzantine artist made use of an illusionistic river setting characteristic of Late Antique and Early Christian painting. The result was a curious division in his style, which combined elements of illusionistic landscape from antiquity, with the abstract gold background of a middle Byzantine Annunciation scene such as the miniature in the Dionysiu lectionary. Here again, then, as in the iconography of the Forty Martyrs, we have an example of selective realism in Byzantine art inspired by a rhetorical model.

I have attempted to show how a particular type of rhetorical embellishment, the formal description, was transferred from the literature of the Byzantine church to its art. It has not been my intention to deny that Byzantine artists used visual models; rather, my aim has been to show how artists were occasionally guided in their selection of these models by rhetorical texts. Since ekphrasis was an exercise that had been formulated in antiquity, it was appropriate that artists seek out classical models when they illustrated its descriptive clichés. The tradition of ekphrasis never died out in medieval Byzantine literature, and we have seen that its influence in art was also not confined to any one period. Though they differ greatly in style and technique, the tenth-century ivory with the Forty Martyrs, the twelfth-century icon with the Annunciation, and the fourteenth-century mosaic with the Massacre of the Innocents all had two characteristics in common: they all revived motifs from ancient art and they were all inspired by rhetorical descriptions. Thus the art of ekphrasis can truly be described as a hidden, but long-lasting spring of Hellenism in Byzantine art.

III ✣ *Antithesis*

The Antithesis in
Byzantine Art and Literature

In the Byzantine church, antithesis was more than a figure of speech; it was a habit of thought. This stylistic device, common both to antique rhetoric and to the literature of the Bible, provided Christian writers with a ready-made mould in which to cast the paradoxes of their faith. The Fathers of the Greek church made liberal use of antithesis in order to express the paradoxical nature of Christ's incarnation, for it enabled them to clothe unfamiliar mysteries in a linguistic convention that pagan education had made familiar to their audiences.[1] Throughout the history of the Byzantine church preachers, poets and liturgists continued to favor this figure of speech as a means of expressing the oppositions of Christian thought. Artists also arranged their compositions in antitheses, in many cases illustrating specific clichés of the literary tradition.

In the writings of the fourth-century Fathers we find antitheses inspired both by the Bible and by the rhetorical performances of the schools. Gregory of Nazianzus, for example, at the end of his third theological oration, which was directed against the heretic Eunomius, demonstrated the combined humanity and divinity of Christ with a torrent of antitheses that runs through the whole career of Christ on earth. I shall quote only a few examples from this catalogue of paradoxes, which in the printed edition fills two pages: "He reclined in a crib, but he was extolled by angels, revealed by a star, and adored by Wise Men. . . . He was hungry, but he fed thousands. . . . He was weary, but he is the rest of the weary and of the burdened. . . . He has shown weakness and has been wounded, but he heals every malady and every weakness. . . . He dies but he gives life, and by death he destroys death."[2] At the conclusion of this list, St. Gregory ventures an apology, lest his extravagant use of antithesis should savor of empty rhetoric: "This is our response to those who

are fond of riddles; we have not made it willingly, for garrulity and verbal antitheses are not pleasant to the faithful . . . , but we have made it out of necessity because of our opponents . . . in order that they may see that they are not wise in everything, nor are they invincible in their superfluous arguments that make the Gospel of no account."[3]

The popularity of antithesis in the later literature of the Byzantine church is amply demonstrated by the numerous commonplaces that incorporate this figure of speech. These clichés often found expression in Byzantine art. Many are variations on the theme of the human infant who is also divine, a theme that was not only central to Christian writing but that had also been used by pagan orators. We can already find the idea in Menander's instructions for composing a speech in praise of a ruler. In the first place, says Menander, the orator should praise the ruler's fatherland and his family. However, should these happen to be undistinguished, the orator can claim that his hero's real parentage is divine. In his illustration of this theme, Menander expresses it in antithetical terms: "many in appearance are from men, but in truth are sent from God. . . . Thus Herakles was believed to be the son of Amphitryon, but in truth he was the son of Zeus. So our ruler in reputation is from men, but in truth his conception is from heaven."[4]

In ecclesiastical literature a common motif was the juxtaposition of Christ the human child with Christ the divine creator of the world. Thus a fifth-century homilist declared in a sermon on the Annunciation: "The Emmanuel came forth to this world which he had made of old, recently an infant, but before the ages God; He lay in a manger, and found no room in an inn, when he had prepared the everlasting tabernacles."[5] Other writers expressed the contrast between Creation and Nativity more succinctly. Another sermon on the Annunciation, attributed to the sixth-century homilist Anastasius of Antioch, declared, "he, who made the years and who existed before the ages, began his years," and also, "he, who was the maker of men, became man."[6] A later Byzantine sermon, attributed to John of Damascus, addressed the Virgin of the Annunciation with similar antitheses: "Hail, because you have borne a baby, [who is] the fashioner of babies and upholder of the universe. . . . May you rejoice, O Lady Mother of God, through whom the uncreated is created."[7] Poets also praised the Virgin through the opposition of her child with the creator; in the early Byzantine *Akathistos* hymn, for example, the Wise Men "saw in the hands of the Virgin him who formed men with his hand."[8] The same antithesis was applied by Byzantine writers to images of the Christ Child in art. Thus the patriarch Photius, in a sermon that he delivered

in 867, described the mosaic of the Virgin and Child in the apse of St. Sophia in Constantinople with familiar words: "a Virgin mother, carrying in her pure arms the common creator, reclining as a baby for the common salvation of our kind."[9]

Closely related to the commonplace of the infant creator is that of the infant ruler. Again, we find that the opposition of the Child held by his mother with the Almighty enthroned in heaven was constantly repeated in sermons, in liturgical poetry, and in descriptions of works of art. The homilies on the Annunciation once more provide us with a string of examples. Thus a fifth-century preacher, who has been quoted above, puts the conceit into the mouth of Mary addressing her child: "Heaven is your throne, and yet my bosom carries you."[10] In the sermon attributed to John of Damascus we read, "he who is rich goes begging, he who is highest becomes a babe . . . and he who carries all is carried."[11] A later homily by the emperor Leo VI declares, "you conceived in your womb him who lays hold of all . . . you carried him by whose nod all things are carried."[12]

The opposition of Mary with the throne of heaven was a favorite theme in liturgical poetry. The sixth-century poet Romanos described how the angel of the Annunciation wondered at the mystery of the incarnation: "The whole sky . . . and the fiery throne do not contain my master; and this poor girl, how does she receive him? Above he is terrible; and how can he be seen below?"[13] Similarly, in a hymn that was sung on the eve of the feast of the Annunciation, the angel is amazed that "he who, at the highest of the heavens, is incomprehensible, is born of a Virgin. He who for his throne has the sky and for his footstool the earth, is contained in the womb of a woman."[14]

The juxtaposition of Mary and of the throne of heaven was also evoked in descriptions of works of art. Both this commonplace and that of the infant creator can be found in an anonymous Byzantine epigram describing an icon of the Virgin and Child, which may have been written around the year 900: "the babe . . . who holds all things requires [her] lap as if he were on a throne; he who sets in place the whole of creation with his hand is embraced by human hands."[15] The antitheses of this description were echoed three hundred years later by Mesarites, in his account of the Nativity mosaic in the Church of the Holy Apostles in Constantinople: "he who holds together all things in his omnipotent hand is carried by a hand without strength."[16]

The constant repetition of antitheses in the homilies and liturgies of the Byzantine church came to be mirrored in its paintings and mosaics. The opposition of images in literature had a decisive influence on Byzantine art,

particularly on the arrangement of programs in churches. But before we look at this aspect of Byzantine art in more detail, it is necessary to make a basic distinction between two types of antithesis: that which involves simple opposition, and that which combines opposition with formal emphasis.

The handbooks on rhetorical figures, both classical and Byzantine, recognized that in an antithesis the pattern could be created either by the content alone or by an interplay of words and content in combination.[17] This can be illustrated by two examples given in an anonymous Byzantine treatise on figures. In the first example, "darkness is released, the light sinks back," the opposition is simply of the ideas of darkness and light;[18] in the second example, "they honor the unjust plutocrats more than the just poor" (timōsi mallon tous *adikous ploutountas*, ē tous *dikaious penomenous*),[19] the figure is created by a juxtaposition of words that are related in form but opposed in meaning. These two types of antithesis were reproduced in Byzantine art. Sometimes Byzantine painters, or their patrons, juxtaposed images solely for the sake of an opposition of ideas; but on other occasions they linked through formal similarities images that were opposed in content, and thus emphasized the antithesis of ideas by means of visual analogies.

A good example in Byzantine art of an antithesis of the first type is provided by the wall paintings in the porch of the church at Asinou, on Cyprus. Here two images illustrating opposing ideas were juxtaposed without any attempt to link them by similarities in their formal composition. However, an inscription that encircles one of the paintings demonstrates without a doubt that the designer intended to create an antithesis on the model of the literary commonplaces.

The paintings of the porch at Asinou apparently belong to two phases. To the earlier phase we should probably assign a fresco of the Virgin and Child painted in a semicircular lunette over the east door of the porch, which opens into the nave (Fig. 44). When this image was first painted, at the beginning of the twelfth century, the church had no porch, so that the fresco was on the exposed outer wall of the church. By the time a porch had been added to the original building, in the thirteenth or early fourteenth century, the painting of the Virgin and Child must have weathered, and had therefore to be retouched.[20] The second phase of the decoration of the porch at Asinou is dated to the year 1332 or 1333 by an inscription painted on the lintel of the east door. At this time the image of the Virgin and Child was incorporated into a newly painted program of frescoes that covers the whole porch, and that primarily illustrates the Last Judgment.[21] The new paintings were explained by

copious inscriptions, one of which surrounds the Virgin and Child and relates this image in antithesis to the Last Judgment scenes that surround it: "how is he who holds together all judgments held as a babe in a Virgin's arms?" (Fig. 44).[22] The formulation of this inscription describing the infant judge follows the same pattern as the commonplaces evoking the infant creator and ruler that were quoted above, such as Mesarites' description of the Nativity mosaic in the Holy Apostles: "he who holds together all things in his omnipotent hand is carried by a hand without strength."[23] Indeed, the inscription is so true to the literary formula that it does not even provide an accurate description of the painting it frames; for the Virgin at Asinou is not in fact holding her child, as the legend claims, but raising her hands in a gesture of prayer. The bust of the infant Christ is enclosed in a medallion, which is painted over her chest. Thus the inscription does not faithfully describe the physical appearance of the fresco, but it does evoke in a general sense the paradox of the incarnation, which is signified in the image by the suspension of the Christ Child in a medallion, as if in a miraculous emblem in front of the Virgin's body.[24] In addition, the inscription evidently refers to the opposition between the painting of Mary with her infant ("a babe in a Virgin's arms") and the Last Judgment scenes directly facing it ("he who holds together all judgments"). For in the lunette over the west door of the porch the portrayals of Christ's divine justice confront the image of his incarnation over the east door (Fig. 45). Here we see the empty Throne of Judgment, the river of fire that descends to consume the damned, and the saved rising on clouds from their tombs, while an angel blows the last trump.[25]

The association of the Virgin and Child with scenes of the Last Judgment is an unusual feature in Byzantine church decoration; at Asinou, as we have seen, it was partly due to the special circumstance of the incorporation of an older painting into the fourteenth-century scheme of decoration. However, in spite of the probable older date of the painting of the Virgin, and in spite of the lack of visual similarities between the two confronting images, the inscription proves that the designer of the fourteenth-century program intended the pair of frescoes to be related in antithesis.

Although the association of the Virgin and Child with the full cycle of the Last Judgment is not common in Byzantine churches, in one fourteenth-century building, the Church of the Holy Apostles in Salonika, a similar antithesis was made more succinctly by the confrontation of Mary holding her infant with the Hand of God holding the souls of the righteous. In this instance there is no inscription, but the formal relationships between the opposed images them-

selves make it clear that the designer of the program intended an opposition. As at Asinou, the paired paintings are situated over the east and the west doors of the porch. Over the entrance leading from the porch to the church proper the Virgin sits enthroned, holding her child on her lap (Fig. 46); to her right kneels the donor of the paintings, the abbot Paul, who probably commissioned the work soon after the year 1315.[26] Opposite the enthroned Virgin, above the door leading from the inner to the outer porches, the lunette is filled by a great hand that descends from an arc-shaped segment of sky at the top; its curved fingers hold a huddled mass of little souls, which are tightly bound so that they resemble infants in swaddling clothes (Fig. 47). This image was in the first place inspired by a passage in the Book of Wisdom (3:1): "But the souls of the righteous are in the hand of God, and the tortures of death shall not touch them." The hand with the souls was a relatively uncommon motif in Byzantine art; it was usually associated with portrayals of the Last Judgment, and more rarely with the Creation.[27] However, in confrontation with the painting of the Virgin and Child the Hand of God also evokes an antithesis similar to the one expressed by the inscription at Asinou: "how is he who holds together all judgments held as a babe in a Virgin's arms." The juxtaposition of the two paintings in the Church of the Holy Apostles also echoes the formulae of the literary tradition, particularly those referring to God holding all creation in his omnipotent hand, such as the lines attributed to John of Damascus: "Hail, because you have borne a baby, [who is] the fashioner of babies and upholder of the universe."[28] By means of this opposition of ideas, the theme of the Virgin's intercession on behalf of the donor, portrayed in the east lunette, was augmented by the depiction of the saved souls in the west lunette.[29]

The paintings at Asinou, on the one hand, and at the Holy Apostles in Salonika, on the other, may serve as parallels in Byzantine art to the two types of antithesis distinguished in literature. At Asinou the inscription tells us that the frescoes illustrate an opposition, between the Virgin holding Christ as her baby, and Christ holding the power to judge. But the actual depictions of the Virgin and of the Last Judgment have no specific visual relationship to each other, other than their confrontation on facing walls of the porch. Nor do the paintings illustrate the particular imagery evoked by the antithesis, for the Virgin over the east door does not actually hold her child. In contrast to the frescoes at Asinou, those in the Holy Apostles at Salonika go beyond the simple juxtaposition of ideas to create formal relationships between the images that sharpen the antithesis, and that provide an explicit illustration of the language

of the literary commonplaces. The Virgin is indeed shown holding her child in her hands, while the corresponding image presents the hand of the Almighty in dramatic isolation. Furthermore, the souls of the righteous are portrayed as if they were children, who reflect the infant carried by Mary.

Byzantine designers made use of antithesis in different ways when they planned the decoration of churches, as the confrontations of images in the porches at Asinou and at the Holy Apostles in Salonika demonstrate, the one through an inscription, the other by visual means. In the following pages we will see how the principle of antithesis influenced the illustration of feast scenes in Byzantine cycles, not only through simple juxtapositions, but also through subtle iconographic changes that gave formal emphasis to the opposition of ideas.

The Birth of Christ and the Death of the Virgin

The antithesis of Christ's infancy on earth with the Virgin's assumption into heaven was an important principle of composition in Byzantine art, which affected not only the arrangement of mosaics and frescoes in churches, but also the design and iconography of the images themselves. The iconography of the Dormition of the Virgin, in particular, underwent subtle changes that reflected the close relationship of this scene to portrayals of the infant Christ with his mother.

Mary's role at the birth of her son, and Christ's role at the death of his mother, were often linked together in the literature and liturgy of the Byzantine church as contrasting illustrations of a common truth—the incarnation of Christ. When Byzantine writers described how Christ descended at Mary's death, received his mother's soul into his own hands, and conveyed her to heaven, they saw this as proof of his birth as a human being. John of Damascus, for example, in his three homilies on the Dormition of the Virgin, repeatedly returned to this theme: "oh how is this holy soul, being separated from the body that received God, itself received in the very hands of the Creator of all, who rightly pays her honor, for though she was by nature his servant . . . , he made her his own mother by the dispensation [of the incarnation], for he was in truth incarnate, and did not feign his humanity."[30] Elsewhere John exclaims, "come down, come down Lord, to pay back to your mother the debts you owe your parent for having nourished you."[31] Other Byzantine homilists likewise made Mary's reception into heaven an occasion for celebrating her role in her son's incarnation. Thus Germanos I, in the early eighth century,

imagined that Christ promised to repay his dying mother for the care he had received as a child: "entrust your body to me, because I entrusted my divinity to your womb. . . . I wish to . . . give back to you the returns due for my stay in your womb, the pay for feeding me with milk, the exchange for bringing me up, the full payment for your affections."[32]

The nativity of Christ and the death of the Virgin were also associated in liturgical poetry. For example, in the third ode of the hymn that is sung on the morning of the feast of the Dormition, John of Damascus declares of the Virgin: "having brought forth the true life you depart to the life which is divine."[33] So also, in a hymn by the eighth-century poet Cosmas, which is also incorporated into Matins on the feast of the Dormition, the holding of Mary's soul by Christ is seen as a reflection of his nativity: "the angelic powers were amazed seeing their own master in Sion holding in his hands the soul of a woman. For he said as a son to her who brought him forth immaculately, 'Hither, venerable one, be glorified together with your son and God.' "[34]

The more rhetorical of the Byzantine authors encapsulated the relationship between the Nativity and the Dormition in neatly turned antitheses. The emperor Leo VI, for example, wrote of Mary: "because you held God when he was invested with flesh, you are held in the hands of God when you are divested of flesh."[35] A later writer, the tenth-century poet and rhetorician John Kyriotes, made a similar juxtaposition of the holding of the child and the holding of the soul, when he imagined Christ speaking in an epigram: "formerly, Virgin, you embraced me in your arms; I sucked the mother's milk from your breast. Now I myself, having embraced your spirit, send your body to the place of delight."[36]

The confrontation of the death of the Virgin with the infancy of Christ became as much of a convention in Byzantine art as in literature. In the visual arts the antithesis was created in two ways: first by the simple juxtaposition of images that evoked Christ's infancy and the Virgin's death, and second by internal modifications to the Dormition scene, so that it echoed the composition of the Virgin with her child.[37] The juxtaposition of the two images became an important theme in the decoration of medieval Byzantine churches. The opposition was already made by the tenth-century wall-paintings in the New Church at Tokalı Kilise, in Cappadocia, where one of the earliest portrayals of the Dormition is preserved. A large cycle of scenes, from Christ's Nativity, Infancy, Ministry, and Resurrection, cover the walls and roof of the main hall of this cave church.[38] From this cycle two feast scenes were separated out and presented behind a screen of arches on the east wall of the church, on either

side of the central apse—on the north side of the apse was the Dormition, which is largely preserved, and on the south side of the apse was the Transfiguration, which is mostly lost. Under each of these two feast scenes there is a low niche with an arched top, which originally framed a painted icon (Fig. 48). Evidently the designer of these paintings wished to establish a relationship between the icons and the two isolated feast scenes that were positioned directly above them.[39] Beneath the Transfiguration there was a bust of Christ, now completely destroyed. Under the Dormition, on the other side of the apse, there is a bust of Mary, also much damaged (Figs. 49 and 50); according to the sketch given by Guillaume de Jerphanion, she was shown holding her child on her left side and pressing his head against her cheek in a tender embrace (Fig. 50). This icon is directly beneath the painting of Christ standing behind Mary's deathbed in the Dormition (Fig. 49).[40] In the feast scene, Christ echoes his mother's gesture in the icon by holding her soul on his left side, in order to present it to an angel who stands beside him. The affectionate gesture of Mary in the icon immediately beneath the Dormition echoes the words of Christ as imagined in the sermon by Germanos: "I wish to . . . give back to you . . . the full payment for your affections."[41]

The arrangement of the tenth-century program of paintings in the New Church at Tokalı Kilise suggests, then, that their designer intentionally associated the Dormition with the Virgin and Child. The purposeful nature of this juxtaposition is demonstrated by the future development of the Dormition scene in Byzantine art. For by the twelfth century, Byzantine artists had made two subtle modifications in the composition of the Dormition scene, which enabled them to relate it more closely to the image of the Virgin with her child. At first Byzantine artists introduced these visual links between Mary's death and the infancy of her son in a tentative fashion; by the fourteenth century, however, the parallels had become distinct and explicit. An early instance in which a Byzantine artist modified the composition of the Dormition in order to relate it visually to the image of the Virgin and Child can be found in the frescoes in the church of St. George at Kurbinovo, in Macedonia, which are dated by an inscription to 1191.[42] The eastern apse of this church portrays a magnificent enthroned Virgin, flanked by two standing archangels. The Virgin corresponds to the *Hodēgētria* type in that she cradles her child across her body, with one hand holding his torso and her other hand holding his feet (Fig. 51).[43] In the fresco of the Dormition on the facing west wall, Christ too is flanked by two standing archangels, and he cradles his mother's soul with his hands in positions that mirror those of the Virgin in the apse (Fig. 52). But

the most significant link between the two images can be found in the pose of the soul in Christ's arms. Unlike the soul in the fresco at Tokalı Kilise, and in the other surviving Dormition scenes that date before the late eleventh century, the little figure at Kurbinovo does not have the appearance of a rigid, tightly bound miniature mummy, but it is clothed in a looser garment, and it bends its legs. The soul appears to *sit* in Christ's arms, and thus to echo the pose of Christ sitting in the arms of his mother. A comparison between the Dormition at Kurbinovo and one of the finest early depictions of the scene, a tenth-century ivory plaque now in Munich,[44] reveals the great change of emphasis in the late twelfth-century painting (Figs. 52 and 53). In the earlier ivory, Christ holds the soul well away from his body, high up toward the angels who fly down to receive it, and the soul itself is stiff and rigid. In the later version of the scene at Kurbinovo, however, Christ presses the soul to his chest, and it sits like an infant in his arms.

The fresco of the Dormition at Kurbinovo is followed by a series of thirteenth- and fourteenth-century portrayals of this scene, in which Byzantine artists attempted to draw parallels between the birth of Christ and the death of Mary through the visual pun of the sitting child and the sitting soul. In the thirteenth-century frescoes at Sopoćani in Serbia, for example, the creator of the famous Dormition on the west wall of the nave also hinted at the motif of the sitting soul by showing its legs slightly bent beneath its tight wrapping of cloths (Fig. 54).[45] In later depictions of the Dormition, Byzantine artists came to portray the seated pose more distinctly. At Kurbinovo and Sopoćani, Christ's arms envelop the soul, so that it appears to be half sitting and half carried; but in several late thirteenth- and early fourteenth-century portrayals of the scene, Christ's arms no longer embrace the soul, but are extended under it like a throne. This is the case in the mosaic on the west wall of the nave of the Kariye Camii in Constantinople, an image that is full of contradictions (Fig. 55). The little soul is bound tightly and, like a miniature corpse, its arms are crossed over its chest; yet it sits up on Christ's hands like a child.[46] From the beginning of the fourteenth century, the sitting soul became a common feature of the iconography of the Dormition in Byzantine art.

By the second half of the twelfth century, Byzantine artists had made another formal change within the Dormition scene that further emphasized its relationship to the imagery of the Virgin and Child. In all the early versions of the Dormition, such as the tenth-century ivory in Munich, Christ holds the soul on one side of his body, but turns his head away to the other side to look at his mother's face as she lies on her deathbed (Fig. 53). In the ivory carving,

the soul is held on the left side, whereas the head of the bed is on the right. In most subsequent Dormition scenes, such as the painting at Kurbinovo (Fig. 52), the positions are reversed, so that Christ holds the soul to the right, while he looks down toward his mother's face on the left. But from the second half of the twelfth century onward, a few Byzantine works of art made a significant change in this composition. A wall painting in the church of St. Nicholas tou Kasnitzē at Kastoria returns to the older design of the Munich ivory by depicting the head of the Virgin's couch on the right side (Fig. 56); however, the artist kept the usual position of the soul to the right of Christ, so that the son now turns his head as if to look down both at the soul in his arms and at the body lying on the couch.[47] This change in the position of the soul, though it is slight, is of considerable significance because it immediately creates an echo of the *Hodēgētria* icon in which the Virgin holds the child to one side of her body and inclines her head to look down at him. The similarities with the *Hodēgētria* become even greater when the soul assumes a sitting position, as we find, for example, in the Dormition scene on an early fourteenth-century mosaic icon in Florence, a work that was in all probability produced in Constantinople (Fig. 57).[48] Here the head of the couch has returned to its usual position on the left; the soul also is to the left side of Christ, but now sitting in the cradle of his arms, so that the group becomes a mirror image reflecting icons of the Virgin *Hodēgētria*, such as the contemporary mosaic in the Kariye Camii (Fig. 58).[49] In the mosaic icon in Florence, the antithesis of the Virgin's death and Christ's infancy is not created by the juxtaposition of two separate images, as at Tokalı Kilise; the antithesis is now evoked within the one image of the Dormition through formal echoes of the familiar but unseen type of Mary with her infant in her arms.

The tenth-century paintings in the New Church at Tokalı Kilise are unusual, but not unique, among medieval Byzantine programs in placing the Dormition on the east wall. From the eleventh century onward, we find that Byzantine churches usually display the Dormition on the west wall of the nave; in the apse facing it there is generally a portrayal of the Virgin, with or without her child, and often also a depiction of the Annunciation on the arch that frames the apse. Thus, in a general sense, the theme of the incarnation of Christ through Mary is echoed on either side of the church, on the east side through Christ's conception and on the west side through Christ's reception of his mother into heaven.[50] The confrontation of the Dormition, on the one hand, and of the Virgin and the Annunciation, on the other, was a significant opposition that reflected the literature and liturgy of the church. It is also notable

that when, for some reason, the designer of a Byzantine fresco cycle was not able to put the Dormition in its usual place on the west wall facing the apse, he often still contrived to juxtapose it either with the Virgin and Child, as in Tokalı Kilise, or with the related feast scene of the Nativity. At the church of Panagia tou Arakou at Lagoudera, in Cyprus, for example, the late twelfth-century series of wall paintings present the Dormition on the south wall of the nave, in direct association with the Virgin holding her child (Fig. 59).[51] The reason for the unusual position of the Dormition on the south wall is not known, for the original west wall at Lagoudera has been removed.[52] One may speculate that the surface of the west wall was broken by one or more windows that would have made it unsuitable for a large composition such as the death of the Virgin. For whatever cause, the designer of the paintings transferred the Dormition to the lunette at the top of the south wall, under the arch that carries the vault. He divided the square space below the Dormition into two rectangular panels, of which the left frames the standing figure of the Virgin, whereas the right frames the archangel Michael. The artist took some pains to make the juxtaposition of the Virgin and Child with the Dormition more effective by means of the upper painting's formal design. To begin with, he employed for the first time in surviving Cypriot wall paintings a comparatively rare variant of the Dormition which shows Christ standing not in the center of the scene, but somewhat to the left side, so that he moves closer to the head of his mother as she lies on the couch (Fig. 60).[53] If the fresco at Lagoudera is compared with the almost contemporary version of the Dormition at Kurbinovo (Fig. 52), it will be seen that the shift in Christ's position forced the artist to give up the clarity and symmetry of the traditional arrangement. At Lagoudera the important central position is no longer occupied by Christ but by a censing bishop. Moreover, the lower part of Christ's body is now over-lapped by the head and shoulders of St. John, who was traditionally shown bowed at the head of the couch. Furthermore, owing to the shape of the lunette at Lagoudera, the artist had to abandon the symmetry of two angels flanking Christ in favor of a single flying escort. Of course, although the change in Christ's position entailed a certain awkwardness in the composition, there were compensating gains. Instead of hierarchy and symmetry, the artist expressed a closer emotional relationship between Christ and his mother as she lay on her deathbed. But, perhaps more importantly, the artist at Lagoudera also emphasized the relationship between the figure of Christ holding his mother's soul, on the left side of the lunette, and the icon of Mary with her child, on

the left side of the wall below (Fig. 59). Both Christ and Mary stand with their heads inclined to the left side, the one looking at his mother's body, the other at her infant son. Even the pair of small angels holding the symbols of the Passion at the top of the icon of the Virgin provide an echo of the angel that flies down to receive her soul in the Dormition scene above.

Many of the fresco cycles that do not display the Dormition on the west wall pair it with the feast of the Nativity rather than with an isolated image of the Virgin and Child. Again, when Byzantine artists juxtaposed the death of the Virgin with the feast scene portraying her son's birth, they often strengthened the association by creating visual connections between the two images.

An early example of the juxtaposition of the feasts of the Dormition and the Nativity can be found in the cave church of Kılıçlar Kuşluk, at Göreme in Cappadocia, whose paintings probably date to the first half of the eleventh century.[54] The west wall of this church could not accommodate a depiction of the Dormition, because its surface was broken up by five arched niches.[55] The designer therefore placed the death of theVirgin as close to the west wall as possible, on the north side of the semicircular barrel vault that roofs the nave (Fig. 62).[56] Directly facing this scene, on the south side of the vault, he put the Nativity (Fig. 61).[57] The artist who carried out the decoration related the two scenes to each other primarily through his parallel renderings of the Virgin—lying on the mattress in the Nativity and lying on the couch in the Dormition. The two designs reflect each other in mirror image. In both scenes Mary's body slopes upward toward the west, and the mattress and the couch have identical shapes with rounded tops, and identical decorations made up of a crisscross pattern alternating with transverse bands and rows of circles.

There is another evident juxtaposition of the Dormition with the Nativity in a slightly later fresco decoration at Göreme, in the cave church of Saklı Kilise, which was probably painted around the middle of the eleventh century.[58] Here the Dormition scene takes its canonical place, on the west wall (Fig. 64).[59] Directly adjoining it, at the west end of the south wall, is set the Nativity (Fig. 63).[60] Once again, the painter has tried to relate the two scenes to each other by making visual parallels, although the similarities that he has drawn are quite different from those emphasized by the artist of Kılıçlar Kuşluk. The Virgin in the Nativity has not been depicted lying on a mattress, but she sits on a rock holding her tightly bound baby by his shoulders as he lies in his crib; thus her gesture echoes the image of Christ holding her bound soul in

the Dormition scene. Another echo is created by the unusual shapes of the crib and of the deathbed; both have distinctive squared-off tops that give the appearance of projecting headpieces.[61]

The most striking instance of the juxtaposition of the Nativity and the Dormition in Byzantine art is furnished by the mid-twelfth century mosaics of the Martorana, in Palermo. The mosaic decoration in this church was carried out by Byzantine artists on behalf of George of Antioch, a Greek who was a high official under King Roger II of Sicily.[62] The arrangement of mosaics in the Martorana seems to have been determined by the presence of openings in the upper halves of the north, south, and west walls of the original church. In each of the side walls there is a large window that only allowed room for a single standing figure on either side of the opening. The original west wall of the nave was destroyed when the church was extended in the sixteenth century. However, if the earlier west wall was also pierced by an opening, it could not have provided sufficient space for a composition showing the death of the Virgin.[63] Possibly for this reason the designer of the program moved the Dormition to the western barrel vault, the same position that it occupies at Kılıçlar Kuşluk, where the west wall is broken up by lunettes.[64] Opposite the Dormition, on the other side of the western barrel vault, the designer of the mosaics placed the Nativity (Figs. 65 and 66).[65] Nowhere in Byzantine art is the antithesis expressed with more grace. As at Kılıçlar Kuşluk, the artist associated the two images through the design of the mattress in the birth scene and the couch in the death scene; both have rounded ends and are decorated at the top and at the bottom by triple bands set off against a white ground. As at Saklı Kilise Mary holds her newborn infant in her hands, echoing the gesture made by Christ at the moment of her death. The opposition of the infant and the soul is further strengthened by the similarity between their bindings, both of which consist of alternating diagonal stripes of grey and white. Finally, both scenes are framed at the top by facing pairs of angels, one pair stretching out their hands to receive the Virgin's soul, the other pair reaching up toward the star. With its play of contrasts and similarities this mosaic seems a worthy counterpart in art to Byzantine literature's most elegant antitheses, such as the phrase turned by the emperor Leo VI: "Because you held God when he was invested with flesh, you are held in the hands of God when you are divested of flesh."[66]

In the Mirož monastery at Pskov, in Russia, there is a fresco cycle of the middle of the twelfth century that also makes a very striking juxtaposition between the Dormition and the Nativity.[67] At Pskov, however, the designer

did not place the Death of the Virgin at the west end of his church, but on the east wall, to the north of the apse (Fig. 67). In the corresponding position to the south of the apse he situated the Nativity (Fig. 68). Several factors demonstrate that these two scenes were intended to be seen as pendants. In the first place, they are displayed at a lower level than the other major feast scenes, which are all either painted on the vaults or framed by them. Second, the portrayals of the Nativity and the Dormition are twice as high as the registers of scenes above and beside them; thus the two feasts stand out as a pair. Third, the Nativity and the Dormition, respectively, adjoin icons of Christ and the Virgin, which were clearly painted as pendants on the pillars flanking the apse. Not only did the artist at Pskov stress the relationship between the Nativity and the Dormition through their scale and position in the church, but he also employed the usual formal devices to connect the scenes. Thus the Virgin, placed in the center of the Nativity, holds the child, whose swaddling clothes resemble the bindings of the soul held by Christ.

In the case of several churches that we have discussed, it is possible to demonstrate or to speculate that the primary reason for shifting the Dormition from its customary place on the west wall was practical; the presence of windows or niches at the west end of the church did not leave enough space for a large composition. Thus, when it was not possible to confront the Dormition with the Virgin in the apse, Byzantine designers chose to confront it with the Nativity. In a few churches, however, the Dormition was not positioned on the west wall even though there was evidently ample space for it. Instead, the Crucifixion was put on the west wall, whereas the Nativity and the Dormition were set facing each other on the north and south walls. In these buildings the designers appear to have deliberately abandoned the traditional juxtaposition of the Virgin in the apse with the Dormition on the west wall in favor of a new opposition of two feast scenes facing each other on either side of the church. Such was evidently the arrangement of the early thirteenth-century fresco decoration in the Church of the Virgin at Studenica in Serbia. Here the west wall, which is undivided at the center by windows, was given to a monumental Crucifixion, surmounted by two smaller scenes of the Raising of Lazarus and the Entry into Jerusalem.[68] On the north and south walls there were large compositions of the Dormition and the Nativity, which have, however, only survived in the guise of sixteenth-century copies of the original frescoes.[69] The arrangement of frescoes in the church of the Virgin at Studenica was repeated later in the thirteenth century at the church of the Annunciation at Gradac, also in Serbia. Here again the Crucifixion occupies the west wall of

the church, whereas the Nativity and the Dormition face each other in the lunettes under the central dome on the south and north sides of the church.[70] The artist at Gradac took some pains to make the compositions in the two lunettes symmetrical. On the south side he arranged several episodes connected with the birth of Christ around a central group that shows Mary reclining by the crib and stretching out her hand to hold her swaddled child. The group of Mary with her baby is directly underneath a large square window; in the corresponding position in the lunette on the north side, we find the answering figure of Christ holding his mother's soul, also beneath a square window. The position of Christ compressed under the window led to a curious anomaly in the design of the Dormition scene; for the Lord is actually depicted as of lower stature than some of the flanking apostles.[71] In both the north and the south lunettes the windows appear to have been flanked by angels, who brought added harmony and symmetry to the paired scenes.

The mosaics and wall paintings that we have examined in this section reveal that the antithesis of Christ's birth and infancy with his mother's death was an important principle of composition in medieval Byzantine art. Not only did the programs of Byzantine church decoration frequently juxtapose the Dormition with the Virgin and Child or with the Nativity, but Byzantine artists sought to underline these juxtapositions by relating the images to each other in their formal language. By the end of the twelfth century the association of the Dormition with the Virgin *Hodēgētria* had brought about subtle changes in the traditional iconography of the Dormition, so that the icon of Mary's reception into heaven became a reflecting mirror of her son's reception onto earth.

The Lord Enthroned on a Donkey

The story of Christ's Entry into Jerusalem, with its paradox of the Lord riding in triumph on an ass, provided Byzantine writers with a special opportunity to indulge in displays of antitheses. The most popular antithesis was that of Christ on the donkey and Christ on the heavenly throne. Romanos was so taken by this juxtapositon that he used it three times in his hymn on the Entry; it appears first in the opening line of the introduction: "You who are carried on a throne in heaven, but on a foal on earth, Christ the God."[72] The antithesis reappears in a slightly different form in the second verse of the hymn: "One could see him [carried] on the back of a foal, who [is carried] on the shoulders of the Cherubim."[73] The conceit recurs for the final time in the

seventh verse: "And now you have mounted a foal, you who possess heaven as your throne."[74]

The same opposition of donkey and throne crops up again and again in Byzantine sermons on the Entry. To illustrate this repetition, it is sufficient to give examples from two sermons, one written before and one after the iconoclastic controversy. The earlier sermon was composed by Andrew of Crete; it appears to have been popular in the Byzantine church during the Middle Ages, for a large number of manuscript copies, dating from the ninth to the sixteenth centuries, reproduce its text as a reading for Palm Sunday.[75] Andrew of Crete expresses the antithesis in language very similar to that used by Romanos: "what is cheaper than a donkey, what meaner than a beast of burden? But he, though he was rich and was carried on the backs of the Cherubim, was not ashamed to sit on a foal as [if it were] a throne."[76]

Our second example is drawn from a sermon written about two hundred years later by the emperor Leo VI: "he who has mounted the heaven of heavens, is put on a foal; he who is seated upon the Cherubim, is sitting on the back of a dumb beast."[77]

Another convention much loved by Byzantine writers was the opposition of the crowds acclaiming Christ on earth with the angels acclaiming him in heaven. This antithesis was inspired by the similarity between the songs of the disciples at the Entry and of the heavenly host at the Nativity. St. Luke's Gospel reports that as Christ began to descend from the Mount of Olives, his disciples sang, "blessed is he who comes as king in the name of the Lord! Peace in heaven, glory in highest heaven."[78] Byzantine homilists found in this acclamation an echo of the angelic chorus that accompanied the annunciation of Christ's birth to the shepherds: "glory to God in highest heaven, and on earth his peace for men."[79] In the fifth century, Proclus of Constantinople declared that the throngs who greeted Christ at his Entry displayed the intelligence of angels, for they hailed him as a king even though his mount was a paltry ass: "and it was as if the crowds, though they saw such penury, were snatched into heaven, understood heavenly matters, and joined in chorus with the angels; for they borrowed the voices of the Seraphim and shouted those similar sounding cries, saying: 'Blessed is he who comes in the name of the Lord, King of Israel.' "[80] In a later passage Proclus made a more abrupt juxtaposition of the angelic with the earthly hosts in a series of antitheses: "who taught [the crowds] this unison? The grace from above; the revelation of the Holy Spirit. Therefore they shouted openly: 'Blessed is he who comes in the name of the Lord, King of Israel'; the soldiers on earth, the angels in heaven; the mortals,

the immortals; the walkers on earth, and dancers in heaven."[81] These antitheses were repeated in a seventh-century sermon on the Entry, which is probably to be ascribed to Leontius of Jerusalem.[82] The numerous surviving manuscripts containing this work, which range in date from the ninth to the fourteenth century, suggest that in the Middle Ages it was one of the most popular readings for Palm Sunday.[83] Leontius' antitheses are sufficiently similar to those of Proclus to raise the suspicion that the earlier sermon served as a model to the later writer. "Consider," says Leontius, "the divine knowledge of the crowd which shared in the ministrations of the angels! Treading on earth, and dancing in heaven; clothed in bodies, yet seeking the roles of those without bodies."[84] The comparison of the human to the angelic throngs recurs in the sermon on the Entry by Andrew of Crete, which, as we have seen, was also well known in the medieval Byzantine church: "[the crowds] sang the songs of the angels with the angels; they extolled with the Cherubim; they praised with the Seraphim; not with lips of fire, but with lips of clay they lifted up that fearful hymn to him who for us came from above to us. . . . Do you see how the earthborn are made heavenly, and how, on a par with the Seraphim, they speak of God? What could be more paradoxical than the unlearned singing on earth of that terrifying revelation together with the chorus on high, in order that men on earth might dance even with the angels?"[85]

The faithful of Byzantium would hear crowds and angels juxtaposed not only in the sermons that were read on Palm Sunday, but also in hymns for this feast. They would listen, for example, to the hymn by Romanos: "you accepted the lauds of angels and the lays of children, who cried out to you: 'You are blessed, you who come to call up Adam [from the dead].' "[86]

Before we turn to the influence of these literary conventions on Byzantine art, it is necessary to consider one more antithesis that confronted Christ in the Entry with Christ in his Glory. This commonplace contrasted the image of radiance with that of penury; for an example, we can listen once more to the hymn by Romanos: "the sun is the chariot of light and yet he himself is your slave. He is bright on his carriage, and yet he himself submits to the commandments of you as creator and God. And now a foal delights you [as a mount]."[87] Byzantine audiences would hear the same confrontation of worldly indigence and divine radiance in the frequently recited sermon on the Entry by Leontius. The seventh-century writer explains that the crowds were prompted by divine revelation to receive Christ into Jerusalem as a ruler, even though he lacked the usual trappings of a Roman emperor making a triumphal entrance into a city: "therefore they did not look for a worldly diadem on the

Lord; for they knew that he rules eternally; they did not look for a purple robe, for they beheld him cloaked in light, as if in a garment; they did not look around him for a throng of soldiers, for they believed the prophet when he proclaimed: 'Myriads upon myriads served him, and thousands upon thousands of archangels stood by him.' "[88]

The juxtaposition of Christ entering the earthly Jerusalem with Christ in his heavenly glory is a theme that has as long a history in art as in literature. The opposition of these two images forms the centerpiece of the famous sarcophagus of Junius Bassus, a city prefect of Rome who died in the year 359 (Fig. 69). The carvings on the front of this tomb are divided into two registers, each containing five scenes; in the center of the lower series Christ can be seen riding the donkey into Jerusalem, whereas directly above he appears enthroned above the heavens, with his feet resting on the arched veil held by the personification of the sky.[89] Although it is clear from the positions of these two scenes that the designer of the sarcophagus intended to make a confrontation between them, they do not echo each other in their formal design. The Entry into Jerusalem conveys a strong sense of movement from left to right; Christ sits astride the ass and holds its reins, while his mount carries him toward two men who have come from the city to welcome him, one laying his garment under the animal's feet, the other holding the branch of a tree. By contrast, the scene above is a static, centralized composition. Christ sits in the middle in a frontal pose, between two standing apostles who flank him symmetrically on either side. From the very natures of the subjects, one would expect that the portrayals of the Entry and of Christ enthroned would be different; for one illustrates an action in time and space on earth, the other the timeless ceremonial of the court in heaven. Yet in the Middle Ages a few Byzantine artists managed to reconcile these contrary ideas and to produce an Entry scene that depicted both movement and timeless stability in one image. In creating this synthesis the Byzantine artists exploited a feature that since the sixth century had distinguished all eastern portrayals of the Entry from those produced in western Europe. The great majority of western works depicted Christ riding with his legs *astride* the donkey, just as in the carving of the fourth-century Roman tomb, but Byzantine art invariably showed Christ riding sidesaddle, so that both of his legs were visible to the viewer.[90] The Byzantine convention invited artists to draw a visual parallel between the images of Christ the rider and Christ the ruler, or, in the words of the sermons, between the ass and the throne. A good example of this juxtaposition can be found on an early thirteenth-century painted beam now at Mount Sinai, which once sur-

mounted a sanctuary screen.[91] The beam, which does not survive in its entirety, preserves five scenes under arcades. In the central arcade is a Deesis, which shows Christ enthroned in a completely frontal pose and flanked on either side by the symmetrical figures of Mary and St. John the Baptist, both raising their hands in intercession, and both turned in three-quarter view toward their Lord in the center (Fig. 70). As a centralized composition, the Deesis on the beam is analogous to the carving of Christ in heaven on the sarcophagus of Junius Bassus. On each side of the Deesis on the beam at Sinai there are now two feast scenes; the Baptism and the Transfiguration on the left, and the Raising of Lazarus and the Entry on the right. In the Entry scene Christ adopts a completely frontal pose that corresponds in detail to his posture in the Deesis (Fig. 71). In contrast to most other Byzantine depictions of the Entry, Christ turns his head neither toward the crowds coming from Jerusalem, nor toward the disciples following behind him, but stares straight at the viewer. The rider does not hold the reins of his mount, but in his left hand he holds a scroll, while his right hand is raised before his chest, in a gesture of address; his knees are spread apart, but his feet are close together, the one slightly lower than the other. All of these points can be matched in the enthroned Christ of the Deesis (Fig. 70), excepting only that in the latter scene Christ holds a book instead of a scroll. Thus the painter of the beam succeeded in creating a visual counterpart to the literary convention of Christ who is "carried on a throne in heaven, but on a foal on earth."

It is instructive to compare the beam at Sinai with a western depiction of the Entry that was evidently intended to express the same opposition of ideas. On folio 110v. of the famous Golden Gospels of Echternach, which were produced for the German imperial house in the eleventh century, there is a painting of the Entry beneath an antithetical legend reading: "The ruler of heaven becomes the poor rider of an ass" (Fig. 72).[92] In his illustration of this text the miniaturist kept to the usual western convention and showed Christ riding astride his mount. Thus, when Christ raises his right hand he does not appear to address the viewer but the crowd that is coming from Jerusalem on the right of the picture. In the western version of the scene there is little sense of the paradox between the lateral motion of the rider and the frontality of the ruler, which was so strikingly expressed by the Byzantine artist (Fig. 71).

Even among Byzantine portrayals of the Entry there are relatively few parallels for the completely frontal pose that Christ assumes on the beam from Sinai. Usually he turns his head, either toward his destination, or in some cases back to his disciples.[93] When Byzantine artists did not depict Christ in

a totally frontal pose, however, they could employ other means to relate his humility on earth to his heavenly glory. At Kurbinovo, for example, a late twelfth-century painter borrowed an image from the sermons and surrounded the riding Christ with light in order to express his divinity. The Entry at Kurbinovo forms part of a monumental composition of five scenes on the west wall of the church (Fig. 73). Although the frescoes on this wall were painted by at least two different hands,[94] they were related to each other both thematically and visually to create a unified ensemble. The designer who laid out the frescoes divided the wall space above the western door into three zones. In the first zone, at the bottom, he put three feast scenes, the Entry on the left (Fig. 74), the Dormition in the center (Fig. 52), and the Transfiguration on the right. The feast scenes belong to a cycle that encircles the north and south walls of the church.[95] The whole width of the second zone of the west wall is occupied by one composition that shows the Ancient of Days, the aged God of Daniel's prophecy (Daniel 7:9). He is enthroned in glory, flanked by many-winged Cherubim and Seraphim, and adored by two large kneeling angels (Fig. 73). In the third and highest zone there are the remains of a Pentecost scene, which showed the apostles seated in an arc under the illumination of the Holy Spirit. As Lydie Hadermann-Misguich has pointed out in her monograph on the frescoes at Kurbinovo, the three zones of the west wall together evoke the Trinity.[96] In the center of the lowest zone, in the Dormition scene, the incarnate Son stands framed by an aureole of light (Fig. 52). Directly above, and also encircled by light, sits the Father. Finally, the axis of lights was crowned by the radiance of the Holy Spirit, which shone from the center of the Pentecost at the top of the wall (Fig. 73).

Hadermann-Misguich has shown that the composition of the west wall at Kurbinovo may have been inspired by the liturgy of St. John Chrysostom, which evokes both the Trinity and the angelic hosts that guard the Almighty.[97] Before the Great Entrance, for example, the choir sings: "We, who mystically represent the Cherubim, and who sing the thrice holy hymn to the life-giving Trinity, let us put away all worldly care, so that we may receive the King of All, invisibly escorted by the ranks of angels."[98] The prominence and diversity of the heavenly beings attending the Ancient of Days in the fresco at Kurbinovo may also echo St. John Chrysostom's liturgy, especially the first secret prayer of the *anaphora*: "We thank you also for this service, which you have deigned to receive from our hands, even though you are surrounded by thousands of archangels and myriads of angels, by the Cherubim and the Seraphim that are six-winged, many-eyed, raised on high on wings, singing, crying, shouting the

triumphal hymn and saying: 'Holy, holy, holy, Lord of Sabaoth, heaven and earth are full of your glory. Hosanna in the highest: blessed is he who comes in the name of the Lord.' "[99] This last acclamation, which is sung by the choir, repeats the words of the crowd at Christ's Entry into Jerusalem (Matthew 21:9). Thus the liturgy of St. John Chrysostom, like the sermons and hymns for Palm Sunday, links together the songs of the angels with the chants that welcomed Christ into Jerusalem.

It is evident that the painter of the Entry scene at Kurbinovo was well aware of the conventions in the liturgy and sermons that juxtaposed Christ's Entry into Jerusalem with his court in h eaven. For the artist drew clear visual parallels between Christ flanked by his human escort in the lower zone and God enthroned among his ranks of angels in the upper zone. The Ancient of Days is depicted sitting in a frontal pose, with his right knee raised higher than his left knee; in the Entry Christ assumes a similar frontal pose, except that his head is turned back toward his disciples. But a more striking parallel is created by the arrangement of the landscape in the Entry, which echoes the aureole of light surrounding the Ancient of Days (Figs. 73 and 74).[100] The semicircular highlight around the top and sides of the Mount of Olives forms the upper border of an aureole; its right border is outlined by the curved trunk of a tree that two children are climbing; and the low hillock from which the tree grows suggests the aureole's base. Thus, like the aged God in his heavenly court above, Christ riding into Jerusalem is framed by a circular glory, which is also bordered by a halo of light. In this context even the curved back of the donkey becomes an allusion to the heavenly throne, for it echoes the curve of the cushion that carries the Ancient of Days. The painter of Kurbinovo achieved a visual equivalent of the antithesis in the popular Palm Sunday sermon by Leontius: "they did not look for a purple robe, for they beheld him cloaked in light, as if in a garment; they did not look around him for a throng of soldiers, for they believed the prophet when he proclaimed: 'Myriads upon myriads served him and thousands upon thousands of archangels stood by him.' "[101] Since the painter at Kurbinovo had to manipulate the whole composition of his Entry scene in order to bring out the antithesis, his fresco is one of the most striking instances of the influence of a literary figure of speech upon the style of a Byzantine artist.

The Centurion's Son and the Canaanite Woman's Daughter

The examples of antithesis that we have considered in the foregoing pages have all hinged on the paradox between Christ's mortal and divine natures.

Our last example, however, is different in that it contrasts the behavior of Christ toward two suppliants who both asked him to perform miracles; according to the account in the Gospels, the centurion whose boy was paralyzed received an immediate offer of help, whereas the Canaanite woman whose daughter was possessed by a devil met with an initial refusal. St. Matthew records that, after the centurion had made his request, Christ immediately replied: "I will come and cure him."[102] To the pleas of the Canaanite woman, however, first "he said not a word in reply," then he issued two rebuffs: "I was sent to the lost sheep of the house of Israel, and to them alone," and "it is not right to take the children's bread and throw it to the dogs." Only when the Canaanite woman answered, "true Sir, and yet the dogs eat the scraps that fall from their master's table," did Christ relent and immediately cure her daughter.[103]

The earliest surviving sermons on the Canaanite and the centurion elaborate upon the different ways in which the two suppliants were received by Christ. The antithesis was stressed in a homily on the Canaanite's daughter that has been attributed to John Chrysostom, and that was certainly written before the early fifth century, although its real authorship is uncertain.[104] Here we find the Gospel story artfully retold so as to heighten the drama of Christ's rejection of the Canaanite woman's pleas. The homilist puts into the mother's mouth a harrowing description of her possessed daughter: "have pity on me," the Canaanite says to Jesus, "how may I see her distorted eyes, her knotted hands, her unkempt hair, the discharge of foam, the invisible executioner who is inside her, the flogger who is not seen, but whose scourges are visible? I stand by as spectator of another's evils, I stand by as my natural [feeling] stabs me. Have pity on me. The storm is hard to bear, the emotion, the fear. The emotion is [born of] natural [feeling], the fear of the devil. I am not able to approach [her], nor to hold back. Emotion pushes me, and fear hinders me."[105]

After the mother's impassioned speech, the homilist goes on to extract the maximum possible effect from Christ's icy indifference to her plight: " 'But he said not a word in reply.' A strange thing! She appeals to him, she begs him, she bewails her misfortune; she magnifies her tragedy, she describes her suffering in detail, and the lover of man does not reply, the Word is silent, the fount is shut off, the doctor withdraws his remedies. What is this strange thing? What is this paradox? You approach others, but when this woman approaches you, do you drive her away?"[106] But, continues the preacher, even if Christ was unmoved, we know from St. Matthew that his disciples were certainly affected by the woman's cries: "since the woman did not meet with an answer, they came to him saying, 'Send her away, because she calls after

us. . . .' [The woman] brought spectators around her, she collected people and the disciples beheld her human pain."[107]

Finally, the writer of the sermon creates a specific antithesis between the receptions that Christ gave the Canaanite and the centurion: "and when the unfortunate suffering woman came, appealing on behalf of her daughter, and begging for release from her misfortune, then you say: 'I was sent to the lost sheep of the house of Israel, and to them alone.' But when the centurion came to you, you say: 'I will come and cure him.' "[108] Thus the sermon dramatizes the Gospel account through a double juxtaposition; the warmth of the woman's entreaty is contrasted with the coldness of Christ's rebuff, and the rejection of the Canaanite is set against the success of the centurion.

The same pair of juxtapositions was stressed in the slightly later sermons on the centurion's son and the Canaanite's daughter by the fifth-century preacher Basil of Seleucia. In his homily on the healing of the centurion's son, Basil, too, contrasts Christ's quick response to the centurion's needs with his rough refusal to aid the Canaanite: "[Christ] anticipates the [centurion's] requests with his good deeds. Why, therefore, tell me, O Lord, did the daughter of the Canaanite not meet with the same readiness, even though she was beseeching for the same [favors] through her mother? But when the Canaanite begs, she is classed with the dogs, and when she seeks a haven she experiences waves, and in addition to her emotional wounds she is also wounded by your words: 'It is not right to take the children's bread and throw it to the dogs.' But this [centurion] gets the cure almost before he requests it."[109]

Basil of Seleucia explains Christ's apparently heartless rejection of the Canaanite as his means of displaying the faith of the gentile woman before the Jews: Jesus at first refused her request in order to draw from her a full public confession of her faith. In his explanation of Christ's behavior, the preacher again takes the opportunity to contrast the treatment of the Canaanite with that of the centurion, for in each case Christ achieved the same end, the public statement of a gentile's faith: "For [Christ] wishes to publicize the faith of the gentiles before the eyes of the Jews, and to make the ungrateful Jews spectators of the good sense of the gentiles. This is the reason he puts off the beseeching Canaanite, so that she, because of the delay, might call out: 'Sir, even the dogs eat the scraps that fall from the table'; but [the centurion], because of the readiness of Christ, might say: 'Sir, I am not worthy that you should come under my roof.' At one time [Christ] makes use of speed, at another he makes use of delay, according to the need. . . . Thus the Lord of all, wishing to lay bare the faith that lies hidden in souls, at one time keeps the gift back, but at another time runs to the rescue of the afflicted."[110]

The second of the two juxtapositions exploited in the sermon attributed to Chrysostom, the contrast between the mother's impassioned request and Christ's silent rebuff, is a major element in Basil of Seleucia's sermon on the Canaanite woman. Again the homilist gives the suppliant a vivid speech describing both the insanity of her daughter and her own resultant suffering: "I am unable to bear the pain of the sight," says the mother of her possessed child, "She starts up from the house and roams through the city, she stretches out her hands into the air, her gaze is twisted, her hair uncovered. The child I brought forth is the lodging of a devil. . . . She gives vent to loud cries like the howls of dogs; she is seen yet she doesn't see; she is swept along by her course, she is piteous in silence, and more dreadful in speech. Her punishment has no fixed limit, she spends her nights sleeplessly, but she finds the days more grievous than the nights; she starts up from the bed and continuously cries out her misfortune."[111] Again, as in the sermon attributed to John Chrysostom, the mother's vivid description of her daughter's suffering makes a striking contrast with Christ's wordless reception of her pleas. The homilist once more explains that Christ's apparent inhumanity was a device to demonstrate the gentile's faith to the Jews, and to make her a cause of reproach to them: " 'But he said not a word in reply.' O philanthropic silence, in the guise of misanthropy! Loud-voiced silence, accusor of the Jews! . . . You denied God after his miracles, but she believed in him before his miracles."[112]

Medieval preachers who spoke on the centurion and the Canaanite repeated in their sermons the same juxtapositions that had been exploited by the early Byzantine homilists. Thus in the twelfth century, the south Italian preacher Philagathus composed a sermon on the centurion's son that contains the standard antithesis between the treatment of the two suppliants: "Jesus says to [the centurion]: 'I will come and cure him.' Why did he answer so readily, and immediately bring on the cure, and yet was not accustomed to do this in other cases? . . . To the Canaanite who entreated passionately for her daughter, he said: 'It is not possible to take the children's bread and give it to the dogs.' But in the present case, as soon as he heard that 'my boy lies at home paralyzed,' he hastens to the cure."[113]

The Greek sermons on the centurion's son and the Canaanite's daughter had both a direct and an indirect impact on Byzantine art. One of the sermons, the composition attributed to Chrysostom, was illustrated directly in a manuscript containing the *Sacra Parallela* by John of Damascus. The manuscript, which is now in Paris, Bibliothèque Nationale, gr. 923, is clearly provincial, although its precise origin is in dispute;[114] it should, however, be dated to the ninth century. The *Sacra Parallela* quotes an abbreviated version of the sermon on

the Canaanite; this version retains the full text of the woman's entreaty to Christ, with its emotional description of her plight, but it omits the comparison with the centurion.[115] In the manuscript in Paris the shortened sermon is accompanied by a vivid sequence of five miniatures.[116] The second of these illuminations, on folio 167, is set beside the woman's speech of entreaty; it shows the Canaanite standing behind her daughter, who writhes on the ground before her eyes (Fig. 75). The mother leans her head to one side and hunches her shoulders in expression of her grief, a pose that illustrates her own words, as they were imagined in the homily: "I stand by as spectator of another's evils, I stand by as my natural [feeling] stabs me."[117] The portrayal of the possessed daughter, with her distorted body and writhing hair, also corresponds to the violence of the mother's description. The following miniature, on the verso of the same folio, is set beside the passage that contrasts the ardor of the Canaanite's pleading with the coldness of her reception (Fig. 76). As the Canaanite kneels before Christ, her two hands extended in supplication, the Lord draws his right hand back against his body. This gesture is intended to convey Christ's refusal to speak to the woman, a meaning that becomes clear if we compare the gesture that Christ makes in the last of the miniatures devoted to the sermon, the illustration of Christ's final granting of her request, which appears on folio 170 (Fig. 77). Here Christ stretches out his hand toward the woman at his feet, and extends the first two fingers to indicate his address to her: "Woman, great is your faith. Be it as you wish!" Thus the illuminator of the manuscript first showed the horror of the girls's suffering, then the indifferent silence of Christ, and finally the words of healing.

The illustrations of the sermon in the *Sacra Parallela* can assist us in interpreting the ways in which the healings of the Canaanite's daughter and of the centurion's son were portrayed in Byzantine Gospel books. In the Gospels of the third quarter of the eleventh century in Paris, Bibliothèque Nationale, gr. 74, the story of the Canaanite's daughter is illustrated twice, first as it is described by Matthew, and then as it occurs in Mark. Mark's text describes the mother as a "Phoenician of Syria" by nationality, but his story is essentially the same as Matthew's account of the Canaanite, who was also a gentile. The miniature that accompanies Matthew's version, on folio 31 verso, focuses on Christ's silent reception of the mother's pleas (Fig. 78). It does not show the healing of the afflicted girl at all, but only the Canaanite with her arms stretched out to Christ, who stands in front of her with his right hand held close to his body. Here, as in the earlier miniature illustrating the sermon in the *Sacra Parallela*, Christ's gesture should be understood in negative terms, as his silent

refusal to come to the mother's aid. For contrast we may turn to the painting on folio 14 verso of the Gospels in Paris, the left side of which shows Christ acceding to the request of the centurion by extending the first two digits of his outstretched right hand (Fig. 79). Christ repeats this positive gesture at the right of the same miniature, where he appears again at the boy's bedside in order to effect the cure. The second miniature depicting the miracle of the gentile woman's daughter, which accompanies St. Mark's text on folio 79 of the Gospels in Paris (Fig. 80), is markedly different from that which illustrates St. Matthew's Gospel (Fig. 78). Here the mother kneels at the Lord's feet, while Christ receives her with the positive gesture of extending the first and second fingers of his outstretched right hand. In the right half of the miniature Christ once more makes this gesture as he stands by the daughter's bed and heals her. Thus the miniature illustrates the same sequence of events as the depiction of the centurion's boy on folio 14 verso (Fig. 79); first Christ addresses the suppliant, then he performs the miracle at the bedside. Evidently, in the Gospel book in Paris, the second version of the healing of the gentile woman's daughter does not illustrate Christ's refusal to help the woman, but his eventual granting of her wish, and the healing of her child.

The slightly later Byzantine Gospel book in Florence, Biblioteca Laurenziana, MS VI. 23, also depicts the miracle of the gentile woman's daughter twice. As in the manuscript in Paris, the miniature that accompanies St. Matthew's account, on folio 32, clearly shows the initial rejection of the woman, whereas the illustration of St. Mark's text shows the granting of her request and the cure. But the miniature for St. Matthew in the Gospels in Florence portrays the rebuff by means that are more dramatic than those employed in the manuscript in Paris (Fig. 81).[118] At the left the painting shows the possessed daughter in the woman's house, tossing on her bed with her hair streaming out behind her. At the right the Canaanite strides with outstretched arms after Christ, and then falls in supplication at his feet. But the Lord emphatically turns his back on the woman huddled behind him, and raises his hand to address two disciples who stand at the right edge of the scene. His rebuff to the Canaanite and her tenacious reply are illustrated by the little vignette at the center of the miniature, where two dogs with open mouths wait expectantly at a table at which two diners are sitting. Thus the miniature, like the sermons, dramatizes the story through the contrast of the girl's torments, as she writhes on her bed, with Christ's apparent indifference, as he turns his back on her mother. The second miniature of the gentile woman's daughter in the manuscript in Florence, the illustration for St. Mark's Gospel on folio 77, portrays

the actual healing of the child (Fig. 82).[119] On the left Christ is shown twice addressing the woman, who first kneels and then stands before him. On each occasion the Lord raises his right hand to speak, pointing with the fingers. Finally, on the right, we see the woman after she has returned home to find her daughter cured; she stands behind the bed in which the girl lies peacefully and spreads her palms in a gesture which in Byzantine art can indicate both joy and astonishment.[120]

In Byzantine art the portrayal of the Healing of the Canaanite's Daughter that comes closest to the treatment in the homilies is a late twelfth-century mosaic in the Cathedral of Monreale. The execution and even the layout of the mosaics in this church were essentially the work of Greek artists and designers whom King William II brought to Sicily in the late 1170s.[121] The mosaic of the Canaanite's daughter illustrates the two principal juxtapositions made by the sermons; it confronts the daughter's madness with Christ's indifference, and it contrasts the rejection given to one suppliant with the favorable reception accorded to the other. At Monreale the healings of the centurion's son and of the Canaanite's daughter occupy analogous positions at the east ends of the north and south aisles of the nave. Each mosaic is a mirror image of the other, to the extent that it is plain that the designer intended them to form a pair linked by their subject matter, by their visual composition, and by their location within the building. As Otto Demus has shown, the designer cleverly arranged the two scenes in the awkward spaces at the corners of the aisles in such a way as to convey the idea of miracles effected at a distance, an element common to both healings.[122] The Canaanite woman is shown pleading with Christ at the east end of the north, or inner wall of the south aisle (Fig. 85). Around the corner, on the narrow east wall of the aisle, her daughter is portrayed tossing on her bed, even as the devil, represented by a small black figure with wings, escapes from her open mouth (Fig. 86). Opposite, in the north aisle, at the east end of the inner wall, we find the centurion presenting his request, which is recorded in the inscription from Matthew above his head: "Lord, my son[lies] in bed paralyzed and badly twisted" (Fig. 83).[123] On the east wall of the aisle his paralyzed son lies on a bed, his body twisted from his disease (Fig. 84). The compositions of the mosaics in the north and south aisles echo each other precisely. In each case the suppliant stands on the east side and presents the request to Christ, who stands to the west, surrounded by a group of apostles (Figs. 83 and 85). The portrayals of the afflicted pair on the narrow east walls of the aisle are also very similar (Figs. 84 and 86). Each lies on a bed, in a contorted position with

the head facing the outer wall of the church. The backgrounds of both mosaics are occupied by architectural screens containing five openings, of which four have squared tops, and one an arch. In each mosaic two of the openings are shaded by a porch, carried on three columns. However, though the architectural backgrounds are very similar, they are not identical; for example, in the row of openings behind the centurion's son the single archway appears nearest the outer wall, but in the row behind the Canaanite's daughter it is second nearest. Such minor differences between the two backgrounds rule out the explanation that their similarity is simply due to mindless copying from a single workshop pattern; rather, the slight differences between the backgrounds suggest that the artists deliberately attempted to relate the two scenes visually, but wished to avoid the monotony which would have resulted from images that were completely identical.

The pairing of the two miracle scenes at the eastern ends of the side aisles at Monreale was noted by Paul A. Underwood in an important study of the iconography of Christ's ministry.[124] Underwood related this juxtaposition to an idea expressed by the south Italian preacher Philagathus, who around the middle of the twelfth century spoke in Sicily, especially in Palermo.[125] The praises of the Norman kings that Philagathus included in his sermons give to his work the character of court oratory, and he may indeed have preached in Sicily at the request of the Norman rulers.[126] According to Underwood, the mosaics of the Canaanite's daughter and of the centurion's son were linked together at Monreale in order to show Christ's "equal treatment of the two sexes, of individuals from different stations in life, and of those who were despised as pagans."[127] In support of the first interpretation, that the mosaics illustrate Christ's impartiality toward men and women, Underwood quoted a passage in Philagathus' homily on the centurion's son, in which the preacher cites several pairs of miracles to demonstrate that Christ gave his benefits to each sex equally.[128] However, a close reading of the sermon reveals that although the healings of the Canaanite's daughter and of the centurion's son are both included in the list of pairs through which Philagathus demonstrates Christ's impartiality toward the two sexes, these healings are not associated with each other, but with other miracles; Philagathus links the Canaanite's daughter with the healing of demoniacs, and he pairs the centurion's son with Simon's mother-in-law: "[Christ] dragged very many away from their demonic frenzy, but he also cured the little daughter of the Canaanite when she was troubled with demons. . . . He heals the boy of the centurion, delivering him from his disease; but also he rebuked the fever that was violently burning in

Simon's mother-in-law."[129] But if Philagathus does not link the centurion's son and the Canaanite's daughter specifically because of the difference in their sexes, he does, as we have seen, bring them together later in the same sermon for another reason, in order to contrast the divergent reactions of Christ when they sought his aid.[130] This also must be the principal point of the juxtaposition made by the mosaics at Monreale. Apart from the slight variations in the architectural backgrounds that we have already noted, the main differences between the two miracle scenes lie in the characterizations of the suppliants and of the ways in which they are received. The centurion approaches Christ with his back bowed, in a pose of humility that accords well with his words as quoted by Matthew: "Sir, who am I to have you under my roof?" (Fig. 83).[131] On the other hand, the Canaanite comes running toward Christ and the apostles with her arms outspread, a pose that may illustrate the disciples' description of her: "see how she comes shouting after us" (Fig. 85).[132] In the mosaic depicting the centurion's request, Christ replies by stretching out his right hand and pointing with the first two fingers (Fig. 83). This gesture clearly indicates the immediate granting of the cure, for, with one exception, it is used by Christ in all of the miracle scenes at Monreale. Christ repeats the gesture, for example, in the mosaic of the healing of the leper in the south aisle (Fig. 87). The one miracle scene in which Christ does *not* make this sign of healing is the mosaic of the Canaanite's daughter. Only in the latter scene does Christ fail to extend his hand toward the sufferer, but holds his right palm close against his chest, as he hears the mother's pleas in a cold silence (Fig. 85). It is the same gesture of refusal that we have encountered in the illustrations of the *Sacra Parallela* and of the Gospels in Paris (Figs. 76 and 78). Furthermore, the artist, following the accounts in the Gospel and in the homilies, has stressed Christ's indifference by showing us how his disciples are clearly affected by the woman's insistent cries, so that they form an agitated group around their master, who stands immovable in their midst.

To summarize, the antithesis between Christ's readiness to help the centurion and his refusal to aid the Canaanite had its origins in the rhetoric of early Byzantine sermons; in the mid-twelfth century it was echoed by a Greek homilist who preached in Norman Sicily; and at the end of the twelfth century it guided the layout and composition of the Byzantine mosaics at Monreale. However, the mosaics at Monreale go beyond the illustration of Christ's rebuff to the Canaanite; like the earlier Byzantine manuscripts they portray the torments of the illness itself, as well as its eventual cure. Not only do the mosaics very effectively juxtapose Christ's reactions to the centurion and to

the Canaanite, they also exploit the second antithesis favored by the sermons, the contrast between the vividness of the woman's appeal and the coldness of Christ's response. The mosaic of the possessed daughter (Fig. 86), waving her arm and starting up from her bed, can best be described in the words of her mother's entreaty, as they were imagined by Basil of Seleucia: "she stretches out her hands into the air, her gaze is twisted, her hair uncovered. . . . She gives vent to loud cries like the howls of dogs . . . she spends her nights sleeplessly, but she finds the days more grievous than the nights; she starts up from the bed and continuously cries out her misfortune."[133] The artists at Monreale succeeded in capturing the drama of the descriptions in the early Byzantine homilies and in juxtaposing the tortured image of the girl's madness with the impassive figure of Christ, standing aloof and unaffected by the turmoil that surrounds him (Figs. 86 and 85). Here, once more, we can see how the literary embellishments of the sermons nourished the imagination of Byzantine artists, enabling them to produce an art in which dramatic and didactic content were skillfully intertwined.

In the mosaic at Monreale the final episode of the Gospel story is indicated by the devil flying from the child's mouth, which shows that her madness is portrayed at the very moment of its cure. A Latin inscription above the Canaanite refers to this event, by quoting Christ's words as he finally granted the mother's request: "Woman, great is your faith. Be it as you wish. And from that hour her daughter was cured."[134] Thus the artists at Monreale illustrated both stages of the Gospel account, Christ's rebuff to the Canaanite and her daughter's eventual cure. At the same time, they borrowed from pulpit oratory the techniques of antithesis that enabled them to stage the successive acts of this drama to the greatest possible effect.

IV ✛ *Hyperbole*

The Flight of Symeon

Hyperbole was a favorite ornament in the trinket box of Byzantine style. This rhetorical figure decked out both verbal and pictorial compositions in the form of literary clichés and their visual equivalents. In this chapter we shall focus on a convention of Byzantine art and literature that was ultimately derived from the standard definition of hyperbole given in the handbooks on rhetorical figures. These treatises commonly gave half a dozen examples in illustration of hyperbole, of which one was Homer's description of the horses of King Rhesus: "whiter than snow and in running like the winds."[1] We can, for instance, find this quotation in the handbook attributed to the Byzantine rhetorician George Choeroboskos, where it is presented with the following explanation of the figure: "hyperbole is an expression that goes beyond the truth for the sake of amplification, as when one says of someone running vigorously that 'he runs like the wind.' Or hyperbole is a statement that exaggerates the truth, for the sake of emphasis or comparison. Thus, for emphasis [Homer says]: 'they ran over the tips of the ears of wheat and did not break them' . . . for [he] emphasizes the state of being greatly raised from the ground (*to meteōron*) while running."[2] This definition of hyperbole finds a direct echo in a commonplace of the sermons on the Presentation of Christ in the Temple. Byzantine homilists often described how the priest Symeon ran impetuously to greet the infant Messiah in the temple; in their accounts we hear how the old prophet seemed to dance, how he was raised from the ground by his enthusiasm, and how he even flew through the air in his haste to meet the child. The point of departure for these exaggerated accounts of Symeon's joyful reception of Christ was a single phrase in St. Luke's Gospel: "And he came in the Spirit into the temple" (Luke 2:27). Nowhere does the Gospel text mention that Symeon was running, far less that he was flying; but the By-

zantine preachers employed the license of hyperbole in their sermons, and transcended the truth for the sake of rhetorical effect.

A striking example of the use of hyperbole can be found in an anonymous Greek sermon on the Presentation that was probably written before the seventh century.[3] The numerous manuscript copies of this homily, which date from the ninth to the fourteenth centuries, attest to its popularity in the Middle Ages as a reading for the feast of the Presentation.[4] The vividness of its writing can be judged from its description of Symeon hurrying to the temple and searching for his promised savior: "the old man Symeon, having stripped off the weakness of age, and having put on the vigor of hope, hurried before the law to receive the provider of the law. . . . He was full of yearning; he was full of hope; he was full of joy. . . . The Holy Spirit proclaimed the glad tidings, and before Symeon reached the temple he was excited by the eyes of understanding, and had rejoiced as if he already had what he desired. . . . And most swiftly traveling raised from the ground (*meteōroporōn*) on his steps he reaches the long-holy shrine, and . . . spreads his holy arms before the temple's Lord."[5] At the end of this passage the anonymous author echoes the very wording of the definition of hyperbole given in the treatise by George Choeroboskos. In a later paragraph the homilist goes on to describe the old man dancing for joy, as the Old Testament prophecies are fulfilled before his eyes.[6]

An even more exaggerated account of Symeon's enthusiasm enlivens a sermon attributed by some manuscripts to Timothy of Jerusalem, but of uncertain authorship; it appears, however, to have been written between the sixth and the eighth centuries.[7] In this homily the Holy Spirit addresses Symeon directly, saying to him: "wake up, old man, why do you sleep? . . . Go more quickly; he who delivers you has come." This exhortation is followed by a remarkable portrayal of Symeon's hurried search for Mary and her child: "Thereupon Symeon was renewed by the swiftest wing of desire, and as if levitated by the spirit he reached the temple before Joseph and the Virgin. . . . And having reached the temple, he stood near the doors, awaiting the revelation of the Holy Spirit. While Symeon was in the temple he saw many mothers entering the temple with their infants in order to carry out the sacrifice of the purification, in amongst whom was also the mother who carried the uncommon child. But Symeon moved his eyes round this way and that way, and when he saw many mothers in the common guise of humanity, but only the Virgin girt about with boundless and divine light, he ran down and separated the other mothers, shouting before everyone: 'Give me room, that I may possess the [child] for whom I yearn.' "[8]

This vivid description of Symeon's impetuousness, one might almost say of his impatience, may have served as the model for an even more theatrical account of the Presentation in a sermon by the ninth-century preacher George of Nicomedia.[9] This homily is notable for its highly emotional tone, which is a striking characteristic of other homilies by George of Nicomedia, particularly a very influential sermon on the death and burial of Christ.[10] The homilist imagines that the old Symeon was too weak to go unaided to greet the Messiah in the temple, and thus had to answer the exhortations of the Holy Spirit with a request for assistance: "Give your hand to old age, Paraclete, support me with your grace. For my body is now weary, and is too tired to walk. Lift me up, O omnipotent and untiring force, lift me up in my weakness and old age, and carry me off quickly to these events. For should I wish to use my own feet for walking, I will certainly delay on the road, and those events will pass and I will not see them. And how melancholy it would be, if I should not experience those things whose reflections I received long ago."[11] Fortunately, the Spirit listened to Symeon's plea, and provided the old man with appropriate transportation: "O miracle! [Symeon] does not use his own feet in the service of the mystery, but the Holy Spirit becomes his chariot and brings him to the temple like a person with wings and like another airborne Habakkuk."[12]

In this dramatization of the Presentation, Symeon's eagerness was reciprocated by that of the infant held in Mary's arms: "[The mother] held [the child] back for a little, for she did not yet clearly know that the old man had arrived at the temple in the Spirit. But then, when she saw the divine baby leaping in her arms and striving to jump out into his hands, she more quickly recognized the force of the mystery, and gave over the child to the outstretched hands of the old man."[13]

To a lesser extent poets also spoke of the impetuosity of Symeon when they described the tableau of the Presentation. Even today the liturgy for the Presentation incorporates an eighth-century hymn by Cosmas of Maiuma that encourages Symeon with the following words: "Be strong, you hands of Symeon, slackened by age; and you weakened legs of an old man, move in a direct course to meet Christ."[14]

Our study of the Byzantine literature on the Presentation shows that the image of Symeon flying through the air to meet Christ was an exaggeration of the Gospel text that was introduced at least as early as the sixth century. The hyperbole was also reflected in works of art, where its first undoubted appearance dates to the seventh century. The earliest surviving portrayal of the Presentation in Christian art is the mosaic on the triumphal arch of the

church of Santa Maria Maggiore in Rome, which was set between 432 and 440 (Fig. 89).[15] In the Roman mosaic, Symeon approaches from the right to receive the child, who is still held in his mother's arms. The old man bows deeply, and holds out his draped hands toward his infant master. The bending of Symeon's right knee has led some commentators to read haste into his pose.[16] It is possible, however, that Symeon's posture merely indicates submission to the child who is also his Lord; for in a carving on the triumphal column of Marcus Aurelius, a group of barbarians approach the emperor in the same posture of respect, with their feet set wide apart, their hands draped, and their backs bowed.[17] The stately portrayal of Symeon in the fifth-century Roman mosaic contrasts with a much livelier characterization of the old priest in a seventh-century mosaic that has recently been discovered in Constantinople (Fig. 88). This mosaic adorned a building that once stood on the site now occupied by the mosque of Kalenderhane.[18] In contrast with the Early Christian mosaic in Rome, the Byzantine mosaic in Constantinople reduces the scene to its three essential actors: Christ, his mother, and Symeon. At the Kalenderhane Mosque the old man's veiled hands convey his reverence, while his bowed back expresses both his age and his submission to the authority of Christ. But most remarkable is the position of Symeon's legs; the knees are bent, but the feet are close together and pointed downwards, so that the aged priest seems to dance on the tips of his toes. Furthermore, his feet overlap the lower edge of the frame around the mosaic, with the result that Symeon does not stand on the ground, but, in the words of the sermon, he appears to be "levitated" in the air.[19]

In Byzantine art after iconoclasm we find Symeon portrayed in a spectrum of attitudes. In some versions of the Presentation he stands quietly, or steps forward to receive Christ without obvious haste.[20] In other portrayals, however, artists tried to convey the priest's eagerness by showing the old man in a running pose. And in a few cases they even showed Symeon raised in the air, in a literal illustration of the rhetorical hyperbole.

The earliest illustration of the running pose can be found on an enameled cross of the early ninth century in the Vatican Museum, which bears an inscription of Pope Paschal I (Fig. 91).[21] The cross portrays seven scenes, which include the Presentation on the lower arm. Symeon again approaches from the right, with his hands covered and his back slightly bowed; his forward leg is bent at the knee and the heel of his trailing foot is raised off the ground. A comparison of Symeon with the figures in the other scenes on the cross demonstrates that the priest's pose was now intended to convey his haste, as well

as his submission to Christ. In the enamel of the Baptism, immediately below the Presentation, an angel also ministers to Christ with his hands covered, but there is less movement in his stance; the angel's feet are set closer together than those of Symeon, and his left heel is lifted less far from the ground line. The static kneeling pose adopted by the first of the Three Kings in the Adoration scene, on the right arm of the cross, can likewise be distinguished from the quick steps of Symeon as he runs up to hold the child. A parallel to the Presentation scene on the Roman cross may be found in a ninth-century description of a Byzantine mosaic, in which Symeon's posture was evidently also intended to convey his haste and enthusiasm. In his sermon on the church built by Stylianus Zaoutzes, the emperor Leo VI described how the mosaicist made a play between Symeon's age and his impetuosity: "now a man afflicted by old age receives the babe in his arms; as you behold this, you may perceive a contest between age and the youthful ardor that seizes the old man through his joy: trying to forget the burden of his years he quickly stretches out his arms to pick up the babe, but they prove weaker than his desire."[22]

Several later Byzantine paintings of the Presentation reproduce the running pose adopted by Symeon on the Vatican cross. In a manuscript of the Menologium in the Historical Museum at Moscow, which can be dated between 1034 and 1041, the bent legs and inclined gait of the running priest make a striking contrast with the more reserved pace of Joseph, who trails behind Mary at the left edge of the scene (Fig. 90).[23] A wall painting of 1199 in the Russian Church of the Savior-on-the-Nereditsa expressed Symeon's impetuosity by similar means, and also contrasted the swiftly raised steps of the old man with Joseph's more measured tread.[24] Some later Byzantine artists depicted Symeon with his knees bent, his feet close together, and his toes pointed downwards, in the same manner as the seventh-century mosaicist who worked on the site of the Kalenderhane Mosque. The old priest adopts this dancing stance in the magnificent thirteenth-century wall painting at Sopoćani,[25] and also in a fourteenth-century icon now preserved at Mount Sinai.[26]

In a few churches, Byzantine artists depicted the Presentation on either side of an arch. When the Presentation was arranged in this manner, the location of the image and its design could work together to translate the language of the sermons into visual effect. In the cave church of El Nazar in Cappadocia, which probably dates to the tenth century, the Presentation is disposed around the arch that leads into the south apse; Joseph stands above the left side of the opening, Mary and her child over its center, and Symeon over its right side.[27] The artist arranged the figures in such a way that Symeon's running pose fits

the shape of the arch, so that the old man appears to be striding up the curved slope in order to reach Christ at its top. A more subtle portrayal of the Presentation around an arch can be found in the Palace Chapel at Palermo, in Sicily (Fig. 92). This mosaic belongs to a group made by Byzantine craftsmen working shortly before the middle of the twelfth century.[28] The Virgin and Symeon, both leaning forward in running poses, are set on either side of the east face of the arch that leads from the crossing into the nave. In this location they are juxtaposed with the Virgin and the angel of the Annunciation; for the Annunciation is displayed on the west face of the triumphal arch leading from the crossing into the apse, the usual position for this scene in the Byzantine scheme of church decoration (Fig. 93). The designer of the mosaics in the Palace Chapel has been criticized for destroying the plausibility of the Byzantine iconography of the Presentation, because he separated the main protagonists on either side of the arched opening; as a result, it has been said, it seems as if Mary would never hand the child to Symeon across the void.[29] However, the disposition of the Presentation around an arch is not an arrangement foreign to Byzantine art; it occurs in Byzantine churches both before and after the twelfth century.[30] Furthermore, the criticism misses the point of the arrangement of the figures. The descriptions of the Presentation in Byzantine sermons suggest that the intervening space of the arch should not be seen as an interruption, but as an element of the design, which expresses the old man's miraculous transport through the air to Christ and his arrival on the wings of the Spirit. Thus the artist exploited the curve of the arch to show Symeon both running and, as it were, flying across the architectural void. This interpretation of the mosaic is supported by a small but significant detail. Symeon's raised right foot slightly overlaps the line edged by semicircles that borders the arch and provides a frame for the scene. Thus, as in the seventh-century mosaic in Constantinople, the old priest appears to float in front of the picture plane (Figs. 88 and 92). In the Annunciation scene on the facing arch the same device conveys the rushing flight of the angel Gabriel, who is set directly opposite the airborne Symeon (Figs. 92 and 93).[31] The juxtaposition of the priest with the angel is itself an echo of the sermons on the Presentation. The homily by George of Nicomedia, for example, terms Symeon "a man in nature, but in virtue an angel . . . a man associating with men in the flesh, but in the spirit a fellow citizen with the angels."[32]

The essential features of the Presentation mosaic in the Palace Chapel were repeated in the slightly later mosaic in the church of the Martorana in Palermo, which was built for the Greek rite (Fig. 94).[33] Here again the designer arranged

the scene in the spandrels of the western arch of the crossing, opposite the Annunciation that occupies the eastern arch.[34] The Presentation at the Martorana has suffered less from later restorations than the mosaic in the Palace Chapel, and its rendering of the action is more graceful. As in the Palace Chapel, Symeon is portrayed running; however, he leans farther forward, so that his body conforms more closely to the curvature of the arch. The Christ Child reciprocates the old man's enthusiasm, and by stretching out both his arms strains to reach his greeter, while his mother still holds him back. In the Martorana, as in the Palace Chapel, the mosaic effectively conveys a sense of impetuosity and movement across intervening space, which answers well to the hyperbole of the sermons.

It should be noted in conclusion that the Greek sermons that employed hyperbole in describing Symeon's journey to the temple were known and read in southern Italy. The anonymous sermon that described Symeon as "swiftly traveling raised from the ground on his steps" was incorporated into a liturgical homiliary that was copied in the tenth or eleventh century at Bisignano in Calabria.[35] A thirteenth-century south Italian collection of sermons and saints' lives, also arranged according to the liturgical calendar, includes the sermon attributed to Timothy of Jerusalem that speaks of Symeon "renewed by the swiftest wing of desire . . . as if levitated by the spirit."[36] Thus the influence of Byzantine literature on the art of Norman Sicily could have been twofold. In the first place, the artists who were imported from Byzantium by the Norman rulers would have brought with them traditional compositions that had already been influenced by the literature of the Greek church. But, second, it is also possible that the more literate of the resident Greek artists and patrons could have acquired a knowledge of Greek texts through the liturgy of their own church in southern Italy.

V ✛ Lament

The Lament in Rhetoric

According to Manuel Philes, a poet who wrote in the fourteenth century, one of the achievements of Byzantine art was to "represent in material form the emotions of the spirit."[1] During the centuries after iconoclasm, Byzantine artists were increasingly concerned with depicting human sentiment and emotion, especially sorrow. In their attempts to humanize the telling of the Gospel story, the artists were greatly influenced by literary models, particularly by hymns and sermons. In this chapter we will consider the effect that one genre of church literature, the lament, had on both the structure and the imagery of Byzantine art. The chapter is divided into three sections, of which the first is devoted to the common characteristics of laments in classical literature and in late antique rhetoric; the second focuses on the laments of the Virgin in the writing of the Byzantine church, and shows how many of these Christian laments derived both their organization and their images from the classical tradition; and the third section shows how the structure and metaphors of the literary laments influenced the iconography of the Lamentation over the body of Christ in Byzantine art.

Since the time of Homer an essential characteristic of laments in antique literature was the contrasting of different periods of time for pathetic effect.[2] The person making the lament either would contrast present suffering with past happiness, or would refer to the bleakness that awaited in the future. In the Iliad, for example, when Andromache grieves over the dead body of Hector, she first describes her present plight as a widow, left with a son who is still an infant;[3] then she imagines the future, in which her son will be either enslaved or killed.[4] When it is Helen's turn to lament for Hector she contrasts the present with the past: she recalls Hector's habitual gentleness toward her, and bewails her fate now, when "no longer is anyone else in wide Troy gentle

to me or friendly, but everyone shudders at me."[5] The same literary device brings drama to Hecuba's lament in the *Daughters of Troy* by Euripides. At the beginning of her speech, Hecuba explains: "first I would like to sing of my [past] happiness, for I will induce more pity for my [present] evils."[6] She goes on to describe how she married a king, and became the mother of princely sons;[7] finally she turns to her future, in which she imagines that she will be taken as a slave to Greece, there to make her bed upon the ground and to cover her wasted body with rags.[8]

The chronological contrasts of ancient literary laments eventually found their way into the textbooks of the schoolmasters. Late antique rhetoricians set out their rules for composing laments under several different headings. Their pupils would have encountered the lament as an example of ethopoiia, or character study, one of the standard rhetorical exercises. Lament was also an important ingredient in monody, which was a speech of praise and mourning in honor of a young person. Lament also entered into the makeup of the more formal epitaphios logos, which was delivered at a funeral. To an educated Byzantine, the most familiar of these rhetorical forms was character study, for, from the fourth to the fourteenth centuries, this was one of the most popular exercises in the rhetorical curriculum.[9] Character study took the form of an imagined speech in which a personality from history, mythology, or the Bible expressed his or her thoughts and emotions at a crucial episode in his or her life. The purpose of the exercise was for the orator to stir the emotions of his audience through the vividness of his performance. The subjects chosen for character study were highly varied. Among the topics in the collection ascribed to the fourth-century pagan orator Libanius we find the laments of Achilles for his dead companion Patroclus,[10] and of Niobe for her children, who had been slain by Apollo and Artemis.[11] In other speeches Libanius presented the dilemmas of characters assailed by fear, such as the coward who saw a battle painted in his own house,[12] or the covetous coward who found a sword of gold.[13] Byzantine writers expanded the range of subjects to include the speeches of characters from the Bible. The large group of character studies composed by Nikephoros Basilakes portrays figures from the Old and the New Testaments, as well as from classical mythology; indeed, this twelfth-century Byzantine cleric expressed the feelings of Herakles, Zeus, and Danae as readily as those of David, Peter, and the Virgin Mary.[14] One of his speeches, for example, gives the words of Zeus when he saw Io turned into a cow,[15] and another quotes Mary when she saw the water turned into wine.[16]

However stereotyped and artificial character study was, it did foster a continuing interest in the portrayal of human drama and feeling in Byzantine literature. In this respect the exercise of character study achieved the same end as description, or ekphrasis, but by different means. Description was concerned with the external symptoms of feeling, such as gestures, actions, and physical features. Character study was concerned with the internal psychological symptoms, expressed through direct speech. In the course of his rhetorical training, then, a Byzantine would receive a thorough education in the expression of sentiment. This training was applied beyond the walls of the schoolroom. A homilist such as Basil of Seleucia, who wished to dramatize an account of the Massacre of the Innocents, could portray the mothers' grief both through character study, which gave the words of their laments, and through description, which depicted their actions and appearance.

The rules for composing character studies were carefully set out by late antique rhetoricians, who also composed models for their readers to imitate. The fourth-century writer Aphthonius tells his students to divide their exercises "into the three time periods, present, past, and future,"[17] and puts these instructions into practice in a model character study entitled "What Niobe would say when her children lay dead."[18] Niobe, according to Aphthonius, would have begun by bewailing her present fate with a series of antitheses: "what [good] fortune am I exchanging for what [mis]fortune? I am childless now, who seemed blessed with children before!"[19] Then the unhappy Niobe would have turned to the past: "before I came into competition with Leto, I was a more enviable mother."[20] Finally, she would lament her future: "Whither shall I turn? Whom shall I cling to? What kind of burial will suffice for me, now that all my fallen children have been destroyed?"[21] The fifth-century rhetorician Nicholas the Sophist gives similar instructions for dividing character study into the three time periods, but he gives them with greater pedantry: "we will begin, then, from the present, and we will return to the time that is past, then from there we will turn again to the present. For we will not come to the future immediately, but we will briefly make mention of the present circumstances, and in this way we shall examine the future. Let us take, for example, the character study 'What Peleus would say, on hearing of the death of Achilles.' He will not immediately remember the old happiness, but having first lamented his present [ill] fortune, he will contrast and compare the good things which happened to him of old, his marriage to the goddess, the honor he received from the gods, his many [deeds] of prowess. Then he will lament by also giving

his present circumstances, that such evil fortune has surrounded him after such good fortune; and in this way he will forecast how many [future] evils he is likely to fall into because of the loss of the one who will succour him."[22]

Nicholas not only instructs the budding orator on how he should organize his character studies but he also prescribes the style in which they should be written, saying that "the recital should consist of shorter clauses," because "it is characteristic both of those who rejoice and of those who lament to introduce one thing after another briefly and abruptly."[23] The examples of character study that will be quoted below demonstrate that many late antique and Byzantine authors followed Nicholas' advice, and composed their pieces of rapid, short clauses.

We shall see that the rules for character study were of considerable assistance to Byzantine writers when they tried to enter into the psychology of characters from Biblical history. This was especially the case when they came to compose speeches of mourning. There were, however, other rhetorical models that Byzantine authors could follow if they wished to create imaginary laments. Late antique pagan oratory distinguished between several types of speeches in honor of the dead; these are discussed most fully in the treatises attributed to the third-century theorist Menander.[24] Menander described three different types of oration on the recently dead. One type was monody, which was generally addressed to young persons, and which mixed praise for the qualities of the deceased with lamentation for their loss.[25] A second type of oration for the dead was the speech of consolation, which mingled lamentation with observations that were intended to comfort the bereaved.[26] A third type was the more formal epitaphios logos, which was delivered at the funeral.[27] Since the monody and the funerary oration had a considerable influence on the Christian laments, it is worthwhile to look at Menander's instructions in some detail. His rules for the composition of monody are very close to those laid down by other authors for character study; in fact, a monody can be thought of as a character study removed from the realm of the imagination into real life.[28] Menander begins by drawing his students' attention to the laments of Andromache and Hecuba in Homer's *Iliad*.[29] Then he goes on to discuss the three chronological divisions, and the topics that are appropriate for each.[30] When he comes to the future, he recommends that the orator speak of the dashed hopes of the dead person's family: "you were a splendid and glorious family up till the present hour, you plume yourselves on your gold and your wealth and your renowned nobility; but all has been demolished and upset by the one who has fallen."[31]

Although Menander's rules for monody are similar to the conventions of character study, they go beyond them in one important respect, for Menander also requires the orator to describe the funeral and even the corpse: "then, after the three time periods, you will describe the carrying out of the corpse, and the gathering of the city. . . . Then you will portray the form of the body, how he was who has cast off his beauty, the redness of his cheeks, the voice that has been shrouded, the down that appears withered, the locks of hair now no longer admired, the pupils and glances of his eyes that have gone to sleep, and the curves of his eyelids, no longer curves but everything has collapsed."[32]

Menander's instructions for the funerary oration (epitaphios logos) call for a more elaborate panegyric of the dead man's life and achievements, according to the usual sequence of an encomium. The speaker is advised to praise in turn the dead man's family, his birth, his appearance, and his character, his upbringing, his education, and his pursuits.[33] This again will lead to contrasts of the present with the past and with the future, for the orator will not forget to point out that the happy auspices of the dead man's birth were frustrated by his untimely end: "then, after the family, you will talk about the circumstances of his birth. 'O, in vain were those portents, in vain were those dreams that appeared to refer to him when he was born. . . . Someone prophesied the very best [for him], each of his relatives and friends was hopeful, they made sacrifices to the family gods, the altars were stained with blood, the whole house kept a holy day. But a demon, as it seemed, mocked at the favorable omens. . . . Those who brought him up had too great hopes in him. But woe for our misfortunes! Now he is snatched away.' "[34]

As early as the fourth century, Christian writers were composing speeches for the dead according to the rules of Menander. The most striking example of this transposition of pagan rhetoric to a Christian context is to be found in the writing of Gregory of Nyssa. In a passage devoted to the Widow of Nain, Gregory describes the plight of the woman whose son had died just as if he were following Menander's instructions for monody and the funeral oration.[35] He starts with the description of the mother's present circumstances: "The mother . . . of the deceased was a widow. . . . What, then, is said? That she had no hope of bearing children, to assuage the misfortune of her bereavement; for the woman was a widow."[36] Gregory then proceeds to the young man's past, describing his birth, upbringing, and pursuits, according to the sequence laid down in Menander's textbook: "for him alone she knew the pangs of childbirth, him alone did she nurse at her breasts; he alone made her table joyful, he was the only cause of joy in her house, playing, working, exercising,

shining in public, in the palaestras, and in the gatherings of the young."[37] From the past, the lament moves to the frustration of the widow's hopes, and to the difficulties that awaited her in the future: "he was already at the age for marriage, he was the young branch of his family, the line of succession, the staff of old age."[38] Finally, the lament closes with a description of the corpse: "But his very youth added a new subject for lamentation. For he who speaks of a young man, speaks of the flower of a spring that has withered away, when his cheeks were just budding with down, not yet covered by a thickness of beard, but still shining with beauty."[39] In speaking of the withering buds of the down on the young man's cheeks, St. Gregory is conscientiously following Menander; indeed, he repeats the instructions for monody almost word for word.

Although modern readers may find Gregory's lament artificial, and even unoriginal, it was greatly admired by later Greek writers. The twelfth-century preacher Philagathus went so far as to quote the whole of Gregory's lament verbatim in one of his own sermons on the Widow of Nain.[40] In introducing this quotation, Philagathus says that he would be out of his mind if he tried to change what had been so eloquently said by Gregory of Nyssa. In medieval Greek literature, to borrow from the right authors was a virtue, not a vice.

The Lament of the Virgin in Byzantine Literature

The theme of Mary's lament at the death of her son has a long history in Greek literature, extending from the sixth century to the present day.[41] In the Byzantine period the laments of the Virgin often echo the conventions of character study and of speeches for the dead that had been codified by late antique rhetoric. Thus, in the Byzantine laments, we find the present contrasted with the past, when Mary juxtaposes the death of Christ with his miraculous birth, and the present contrasted with Mary's lost hopes for the future, when she recalls the promises made by Gabriel at the Annunciation and the visit of the three kings. Frequently, also, Mary describes the corpse and, with a familiar image, compares it to a withered flower. Even her language is reminiscent of character study, for Mary often speaks in short sentences and uses many antitheses. Sometimes the mourning Virgin goes so far as to quote directly from the model exercises given in the rhetorical handbooks. Thus, in the Byzantine period many of the laments attributed to the Virgin derived both their structure and their imagery from late antique rhetoric. We shall see that these conventions passed from literature into Byzantine art.

Among the early laments of the Virgin, there is one that corresponds particularly closely to rhetorical models. It can be found in a sermon on the Presentation that is sometimes ascribed to Timothy of Jerusalem, though it is of uncertain authorship.[42] The homily appears to have been written between the sixth and the eighth centuries. In it the Virgin delivers her lament, not on the occasion of her son's crucifixion, but when she supposed that she had lost him after she had taken him as a twelve-year-old child to visit the temple in Jerusalem.[43] The homilist relates that Mary was pierced with anguish at the disappearance of her child, whom she had tried to find for three days. Even so, she did not forget the rules of rhetoric when she came to compose her lament. She began with the present: "alas for my misfortune; when I expected plenty I contemplated loss. Alas, who has despoiled me of my treasure? Who has led my treasure astray? Who has hidden my hope?"[44] From the present Mary moved to the future, and to the frustration of her hopes for Christ's reign that had been awakened in her by the words of the angel Gabriel: "alas, no longer will I hear that I am 'Blessed among women.' No longer will they say, 'Blessed is the womb that carried you.' I was withered, not blessed. . . . Where is the greeting of the Archangel Gabriel?"[45] Finally, Mary completed the sequence by recalling the glorious events of Christ's nativity in the past: "where is the light of the star? Where the adoration of the Magi? Where the joy of the shepherds? Where the praises of the angels? When I expected to rule, I have been abandoned in poverty."[46]

Not only does the organization of this lament follow the standard divisions into three periods of time, but its style is also that recommended for character study; the speech is composed of short, rapid sentences, many of which contain antitheses. The Virgin's lament over her lost child is, in effect, a rhetorical set piece, which the preacher inserted into his sermon in order to enliven it for his audience.

In the ninth and tenth centuries, Byzantine authors began to compose elaborate prose laments that they imagined the Virgin to have delivered after her son's crucifixion. These speeches repeated or elaborated upon the rhetorical conventions already contained in the sermon attributed to Timothy of Jerusalem. An important ninth-century lament is contained in a homily by George of Nicomedia on the crucifixion and burial of Christ.[47] This work survives in at least eight manuscripts, dating from the tenth to the fourteenth centuries.[48] A tenth-century collection of homilies in the Vatican Library reproduces the sermon among the lections for Good Friday.[49] Demetrios Pallas has shown that the typikon of the Evergetes Monastery at Constantinople provides more spe-

cific information about the place of George of Nicomedia's sermon in the liturgy; for this text, which goes back to the eleventh century, recommends that the homily be read on the eve of Good Friday.[50] In the homily George of Nicomedia relates how Christ was crucified, and how his dead body was taken down from the cross. At each stage Mary participated in the drama. When the corpse was laid upon the ground, then Mary "fell upon it and bathed it with the warmest tears." She began her lament "in a gentle voice, and with the most moving words."[51] Once again Mary contrasts the present with the past, here juxtaposing the embraces that she gave her child in infancy and in death: "I am now holding him without breath whom lately I took in my arms as my own dearest one, whose sweetest words I heard."[52] Another convention of rhetoric that occurs in this sermon is the metaphor of the withered flower. The conventional image is skillfully turned by the homilist into an antithesis between the creator and the crucified, when he has the Virgin describe her dying son: "may all the delight of the meadows look sad with me. For, behold, he who adorned you with many-colored flowers is suspended on the wood having suffered dishonor. He who beautified you with freshness and fragrance is hung up without beauty and shapeless in his humanity—the pure beauty, the unchangeable bloom, and his mother's perpetual delight."[53]

George of Nicomedia was probably also the author of another lament of the Virgin, which he incorporated, somewhat paradoxically, into a sermon on the Presentation.[54] In the sermon's dramatization of the Presentation of the Christ Child in the temple, Mary presses Symeon to explain the meaning of the prophecy that he makes to her in St. Luke's Gospel (2:35): "and a sword will pierce through your own soul also." The homilist imagines that Mary asks the old priest anxiously, and a little disrespectfully, "for what reason will the sword run through my soul? Because I broke the Sabbath? Because I transgressed the law? . . . In what respect, small or great, have I ever broken the law? . . . Speak quickly, lest we suspect you of going too far and of having grown old."[55] In response to this accusation, Symeon gives Mary a full summary of the events of Christ's forthcoming Passion, concluding with her lament for the death of her son. He tells her especially how she will remember the miraculous conception and the Virgin birth in the past, and also how she will recall Gabriel's good tidings for the future.[56] Here too, therefore, a Byzantine homilist links the Annunciation and the Nativity with the theme of the Virgin's lament.

Perhaps the most eloquent among the surviving Byzantine laments of the Virgin is a prose piece that has generally been attributed to the tenth-century author Symeon Metaphrastes.[57] The manuscript on which this attribution is

apparently based dates, however, to the late fourteenth century.[58] Another manuscript, of the thirteenth century, ascribes the lament to the twelfth-century schoolmaster Nikephoros Basilakes.[59] This lament is highly rhetorical in character; indeed, the thirteenth-century codex that assigns the text to Nikephoros Basilakes specifically identifies it by its title as an exercise in character study: "what the Mother of God might have said when she embraced her son, the God and Savior Christ, at his burial."[60] In the course of her speech, the Virgin links the conventional contrasts of past, present, and future into a chain of antitheses. Repeatedly she refers to the broken promises of the Annunciation: "even Gabriel's greeting turns out to be almost the contrary for me. For now it is not the case that 'The Lord is with me,' as he promised to me, but you [Lord] are wandering without breath and among the dead in the innermost chambers of Hades."[61] At one point Mary goes so far as to compare the fire of the deity incarnate in her womb with the flames of her grief: "once things that cannot be mingled were mingled without harm, and an immaterial fire of divinity did not burn my womb; but now another fire feeds on all my insides, and injures me to the center of my heart. I received through the angel pledges of joy, and I took away all tears from the face of the earth, but [now] these tears are increased by my own tears."[62] The Virgin likewise makes a series of antithetical allusions to Christ's nativity; she introduces these reminiscences with an exclamation quoted from Aphthonius' model character study of Niobe lamenting her slain children: "what misfortune am I seeing in place of what good fortune!" she declares. "The star shone by day at your birth and was renewed from your magnificence . . . but today you have hidden the very sight of the sun, and you have brought night in the middle of day. . . . There the star summoned Persian [kings] on bended knee, here the fear of the slayers of God has driven both acquaintances and friends far away. There was the bringing of gifts and adoration, here the division of tunics, the mocking, and the crown of insults."[63] Like George of Nicomedia, the author of this lament draws a pathetic contrast between the images of Mary holding her child in her arms as a baby and as a dead man: "Nicodemus alone . . . placed you painfully in my arms, which even lately lifted you joyfully as an infant. . . . I raised you in a mother's arms, but leaping and jumping as children do. Now I raise you up in the same arms, but without breath, and lying as the dead. Then I dipped my lips in your honey-sweet and dewy lips. . . . Many times you slept on my breast as an infant, and now you have fallen asleep there as a dead man."[64]

Not only does the lament embroider the usual contrasts of time, but it also

presents a particularly detailed description of the corpse. The Virgin makes a painful catalogue of each of the injured parts of Christ's body: the crown of his head, which thorns had pierced; his head, which rods had beaten; his jaws, which had received blows; his mouth, which had drunk the bitterest gall; his hands, which had been affixed to the cross; his side, which the lance had pierced; and, finally, his feet, which had walked on water.[65]

Another eloquent prose lament features in a sermon on Christ's burial by the thirteenth-century patriarch Germanos II.[66] The opening passage of Mary's speech, with its short antithetical clauses, is especially close to the style of the late antique character studies: "my good auspices change to ill auspices, the honor is dishonored, the sweetness becomes bitter, the joy makes me grieve."[67] In addition, the lament by Germanos contains the usual contrast of the present with the past: "how bright was the foundation of your arrival on earth! How dark is the roof over your end! It began from joy, and it ends in mourning. From a cave you shone forth to the world, into a cave you sink from the world. Then a cave was found for you 'when there was no room in the inn.' And now you are lodged in another cave when you lack a tomb. . . . Then the star set the kings of the Persians beside you, and they adored you and brought you gifts as to a king; now it is dishonor that you receive from the soldiers who will even take gifts [as bribes to lie] concerning your resurrection."[68]

Although the conventions of rhetoric had their strongest influence on prose laments, they also affected the composition of poetry. One of the hymns that was sung on Good Friday is closely related to the prose lament attributed to Symeon Metaphrastes and to Nikephoros Basilakes; in certain passages the correspondence is word for word.[69] Although some of the manuscripts ascribe the poem also to Symeon Metaphrastes, its authorship, like that of the prose lament, is uncertain; several manuscripts give the hymn to other writers.[70] The hymn was already in regular use by the eleventh century, for the typikon of the Evergetes Monastery says it should be sung on the evening of Good Friday.[71] In its verses, as in the prose laments, we can hear the Virgin recalling the Annunciation and her destroyed hopes for the future: "woe is me, Gabriel! Where are the good tidings; where is your greeting, 'Blessed'?"[72] Again, we hear Mary's memories of the nativity: "Lord, the kings of the Persians brought you gifts, adoring you as a god. But now, my child, Nicodemus brought you myrrh for a burial, as to a mortal."[73] Once more, the mother contrasts the care she gives the corpse with the care she gave the child: "I cannot bear, my child, to hold you without breath, whom I nursed as a child when you leaped in my arms. . . ."[74] I will wind you in a winding cloth, my son, instead of in swaddling clothes, I will place you in a dark tomb, my light, instead of in a

crib."[75] The Virgin even gives a brief description of the corpse, as she calls out: "come, friends, and weep with me over the body of the teacher who has labored much; come, see his voiceless mouth, his motionless lips, his closed eyes."[76] The verses of this hymn demonstrate that even when they came to compose liturgical poetry, some Byzantine authors remembered the rules of eloquence that they had learned in the schoolroom.

Because of its importance in the liturgy, mention should also be made of the *Epitaphios Thrēnos*, a liturgical lament that incorporates many of the conventions of the more rhetorical laments, though in a less structured form. The *Epitaphios Thrēnos* is sung during the early morning service of Holy Saturday;[77] its origins are obscure, but it was definitely incorporated into the liturgy by the first half of the fourteenth century.[78] At one point in this long lament, the Virgin bewails her lost hopes for her son whom, from Gabriel's promises, she had believed to be a king.[79] She also recalls the painless birth of her child,[80] and she movingly describes Christ's corpse, and the fading of his beauty: "seeing you laid on your back, Word, the all-holy one lamented you as befits a mother: 'O my sweet spring, my sweetest child, where did your beauty set?' "[81]

Before we leave the Byzantine laments of the Virgin, one final example must be mentioned here, because its author projected it onto a work of art. This lament is found in Constantine the Rhodian's description of the mosaics in the Church of the Holy Apostles at Constantinople, a verse composition that he wrote between 931 and 944.[82] In his account of the Crucifixion mosaic, which he said was "painted with feeling,"[83] Constantine described how the mother was portrayed "melting into tears" at the cross,[84] and he imagines the bitterness of her words: "Where are the promises of Gabriel's speech, which he gave me before your birth took place? Where are the sceptres of David and where is the exalted throne lasting, even as the light-bringing sun, until eternity and time without end? Everything has gone stale and has been said in vain."[85] Thus even as a Byzantine writer contemplated Christ's passion depicted on the walls of a church, he thought of how the Virgin would contrast her suffering with her earlier hopes for the future. In the following pages we shall see that the thinking of artists also conformed to similar patterns.

The Lament of the Virgin in Byzantine Art

In the centuries that followed the victory over iconoclasm, Byzantine artists added to their repertoire a new subject, the Lamentation of the Virgin.[86] This scene portrayed Mary mourning over the body of her son, between its depo-

sition from the cross and its placement in the tomb. The earliest surviving depictions of the Lamentation belong to the eleventh century. The basis for the scene was essentially literary; the lament over Christ's body is not described in the canonical Gospels, but only in the hymns, sermons, and apocrypha of the Byzantine church. Some of these hymns and sermons, as we have seen, became important elements of the regular liturgy. I shall try to show how the rhetorical devices of the literary laments were exploited also by artists, especially the juxtapositions of the present with the past and the future, and also the description of the corpse.

Just as in literary laments, the mourning Virgin in Byzantine art makes allusions to her role at her son's birth and infancy. These reminders of the Nativity are both internal and external. Internally, the association between the Virgin's present suffering and her past joy is made by the traditional composition of the Lamentation scene itself. By the eleventh century, Mary was often shown kneeling or sitting on the ground beside the tomb, with her son's body stretched out across her lap; she is depicted in such a fashion in the famous twelfth-century fresco in the church of St. Panteleimon at Nerezi, in Macedonia (Fig. 95).[87] There was no visual model in Byzantine art for this composition; the image of the mother with her son's body lying on her lap must have been inspired by the literary antithesis between the embraces that Mary gave her son as an infant and as a dead man. Already in the ninth century, George of Nicomedia had imagined the Virgin to say: "I am now holding him without breath whom lately I took in my arms as my own dearest one, whose sweetest words I heard."[88] In the fresco at Nerezi, and in many other Byzantine Lamentation scenes, the mother shows the intensity of her feeling by pressing her cheek against the face of the body in her arms (Figs. 95, 101, 111). It is possible that Byzantine artists first derived this motif from Old Testament illustrations of Joseph kissing his father Jacob on his deathbed.[89] However, Byzantine artists and their public must also have seen the last embrace of mother and child as a visual reference to icons of the *Eleousa* type, in which the Virgin tenderly holds her infant and touches her cheek against his. The relationship between the two images becomes apparent if we compare the fresco of the Lamentation at Nerezi with the equally famous icon of Our Lady of Vladimir in the Tretyakov Gallery in Moscow, the original version of which can also be dated back to the twelfth century (Figs. 95 and 97).[90] This parallel between the *Eleousa* and the Lamentation in Byzantine art is echoed in the language of literary laments, especially the one attributed to Symeon Metaphrastes or Nikephoros Basilakes: "I raised you in a mother's arms, but

leaping and jumping as children do. Now I raise you up in the same arms, but . . . lying as the dead. Then I dipped my lips in your honey-sweet and dewy lips. . . . Many times you slept on my breast as an infant, and now you have fallen asleep there as a dead man.''[91]

Byzantine artists not only recalled Christ's birth through the internal composition of the Lamentation scene, but they also created an external association between the two episodes through the device of juxtaposition. Painters who portrayed the cycle of the feasts sometimes went to considerable lengths to arrange a confrontation between the Lamentation and the Nativity. This concern is most strikingly demonstrated by the late twelfth-century paintings in the church of St. George at Kurbinovo, in Macedonia. This church has a longitudinal plan, without aisles; the frescoes are arranged on either side of the nave in such a way that a group of birth and infancy scenes, centered on the Nativity, faces a group of Passion and Resurrection scenes, centered on the Lamentation. The cycle of scenes starts with the Annunciation flanking the apse on the east wall (Fig. 100). Then it continues in a single strip on the south wall, beginning at the east and continuing to the west (Figs. 98 and 100). The first scene on the south wall is a conventional portrayal of the Visitation, which fills the narrow space between the east wall and the first of the windows in the south wall (Fig. 98). Here Mary and Elizabeth are depicted running together to greet each other with a joyful embrace. To the right of this Visitation scene another narrow space faced the designer of the frescoes, for the area was originally constricted on the left side by the window and on the right side by the choir screen and by the large frescoed icon of Christ that flanked the screen (Fig. 98).[92] The designer evidently judged this space to be too cramped and too inconspicuous for the portrayal of the Nativity, which ordinarily follows the Visitation in the cycle of the New Testament; he therefore devised an extra Visitation scene showing the two women sitting and talking in Elizabeth's house. This subject is without parallel in Byzantine wall painting, and was probably derived from a manuscript illustrating the life of the Virgin.[93] By means of the extra scene, the designer was able to reserve his painting of the Nativity for a more prominent location, to the right of the large icon of Christ and approximately in the center of the south wall (Figs. 100 and 103). The remaining spaces on the south wall he filled with the Presentation, the Baptism, and the Raising of Lazarus.[94] The cycle continues on the west wall with the Entry, the Dormition, and the Transfiguration (Fig. 73). It then turns the corner onto the north wall, where the episodes of Christ's passion follow in chronological sequence, going from west to east: first the Crucifixion, then the

Deposition from the Cross, the Lamentation, the Holy Women at the Tomb, and finally the Descent into Hell (Fig. 99).[95] The last two feasts, the Ascension and the Pentecost, are placed at a higher level than the other scenes, in the eastern and western gables of the church.[96]

The arrangement of the paintings at Kurbinovo gives to the Lamentation a particularly prominent location in the center of the north wall, directly opposite the Nativity (Figs. 99 and 100). The juxtaposition of the two scenes is emphasized by the similarity between their backgrounds; both are set against hilly landscapes,[97] the one containing the cave of Christ's birth, the other the cave of his burial (Figs. 101 and 103). The same antiphony can be heard in the lament by Germanos II: "from a cave you appeared to the world, into a cave you sink from the world."[98]

Because the painting of the Nativity at Kurbinovo is wider than the Lamentation, it also faces the narrow fresco of the Holy Women at the Tomb (Fig. 102). The latter scene is directly opposite the left-hand portion of the Nativity, which is now mostly lost, but which once showed the arrival of the Magi (Fig. 103). Thus on the north wall the women were shown proffering their spices in outstretched hands, as they came in terror toward the tomb and its guard of armed soldiers sleeping on the ground. Their actions were matched by the kings on the south wall, who likewise held their gifts in extended hands as they approached the manger. Because of the damaged state of the Nativity fresco, it is now only possible to see the jeweled casket offered by one of the Magi, at the extreme left of the picture (Fig. 103). This juxtaposition, of the women with their spices and the Magi with their gifts, also reflects the conventions of the literary laments. At the beginning of the prose piece attributed to Symeon Metaphrastes or Nikephoros Basilakes, for example, the Virgin exclaims, "so this, sweetest Jesus, is the [reason] that those who arrived at Bethlehem from Persia after your birth not only offered you gold, as to a king, and frankincense, as to a God, but also myrrh, as to a mortal."[99] And we have seen that the lament by Germanos II contrasts the adoration of the Magi with the corruption of the guards who were set to watch over Christ's tomb: "then the star set the kings of the Persians beside you, and they adored you and brought you gifts as to a king; now it is dishonor that you receive from the soldiers, who will even take gifts [as bribes to lie] concerning your resurrection."[100]

The normal scheme of decoration for medieval Byzantine churches with longitudinal plans was for the episodes to follow each other in simple chron-

ological succession from east to west on the south wall, and back once more from west to east on the north wall.[101] In the church at Kurbinovo the scenes were set out according to this system, but the arrangement shows an additional concern for reciprocity between the paintings on the north and the south walls, which corresponds to the antithetical structures of the laments recited in the liturgy. The artists who worked at Kurbinovo portrayed human emotion with an unusual intensity, through gestures, through facial expressions, through the rapid movements of the figures, and even through the rhythms of the landscapes in which they were set. The highly charged style of the paintings, which is characteristic of late twelfth-century Byzantine art, is heightened in this Macedonian church by the rhetorical juxtaposition of the Lamentation and the Nativity at the center of the nave, an opposition of past and present that creates the greatest possible dramatic effect.[102]

Another church in Macedonia, St. Clement's at Ohrid, illustrates in a different way the influence of literary laments on the layout of Byzantine wall paintings. The frescoes here were signed by the Greek artists Michael and Eutychios, who probably painted them in the last decade of the thirteenth century.[103] The paintings of St. Clement's church present one of the most striking examples of echoing in Byzantine art. In this case it is the contrast of Mary's present suffering with her dashed hopes for the future that is portrayed, for the designer went to considerable lengths to stage an expressive confrontation between the Lament over the dead Christ and the Annunciation to the Virgin Mary. The fresco of the Lamentation extends the entire width of the north wall of the nave (Figs. 106 and 107). The focus of the composition is the body of Christ, stretched naked on a marble slab, the lifeless center of a circle of agitated mourners. Some of the women display their grief by violently throwing up their hands or by pulling their hair, but the reaction of the Virgin herself is to swoon. She has stationed herself immediately behind the slab on which her dead son lies, near to his head, but she has been so overwhelmed by her sorrow that she falls to the left side, and has to be supported by a woman standing beside her. As she faints, the Virgin's face is turned upward toward the sky, where a choir of angels joins her in lamentation.

The fainting pose of the Virgin is unusual in the Lamentation scene, for this motif was more commonly associated with the Crucifixion.[104] The only earlier depiction of the Lamentation in which Mary swoons is a fresco in the lower church of St. Francis at Assisi; this painting, which dates to the third quarter of the thirteenth century, shows the Virgin falling into the arms of two of her

companions.[105] We find later portrayals of the Virgin supported by her fellow mourners in the fourteenth-century frescoes of the Lamentation at Gračanica and at Dečani, in Serbia.[106]

If it was unusual in Byzantine art for Mary to swoon during the Lamentation over Christ's death, it was even less usual for her to collapse in the course of the Annunciation of his birth. Yet, in the fresco immediately below the Lamentation scene, Mary is once again depicted falling to the left, and having to be supported by a woman on either side of her (Figs. 106 and 108). Here, too, she looks up at the angel approaching from the sky. The Virgin's posture in the Annunciation shows that she feels faint at the moment of the divine conception. In this context, the motif ultimately derives from classical images of childbirth that also showed a mother held up by two companions;[107] however, the swooning pose is extremely rare in the Annunciation in Christian art.[108]

There is a significant detail in the paintings on the north wall of St. Clement's church which suggests that the designer intentionally juxtaposed the images of the Virgin fainting at the Lamentation and at the Annunciation, one above the other. This detail is the shape of the well in the Annunciation scene, which is formed like a cross (Fig. 108). In nearly all other Byzantine versions of the Annunciation by the well, the basin is circular. It is round, for example, in the late twelfth-century fresco in the church of the Anargyroi at Kastoria (Fig. 32); it is also round in the church of St. George at Staro Nagoričino (Fig. 109), where the paintings were signed with the same names that occur at Ohrid, Michael and Eutychios.[109] The cruciform shape of the well in the Annunciation at Ohrid forecasts the passion of Christ, and it is a strong hint that the artist intended to relate the Annunciation to the Lamentation that was depicted immediately above. The swooning pose of the Virgin, presented in both scenes, illustrates such passages as that attributed to Symeon Metaphrastes or Nikephoros Basilakes, in which the Virgin compares the fire of the incarnate God in her womb with the pangs of her grief: "once things that cannot be mingled were mingled without harm, and an immaterial fire of divinity did not burn my womb; but now another fire feeds on all my insides, and injures me to the center of my heart. I received through the angel pledges of joy, and I took away all tears from the face of the earth, but [now] these tears are increased by my own tears."[110] The juxtaposition of the Lamentation with the Annunciation on the north wall of St. Clement's church at Ohrid is the visual equivalent of the antithesis between present sufferings and lost hopes for the future, which was a standard feature of the literary laments.

The final element of the literary laments that relates to Byzantine art is the

description of the corpse. In the early Byzantine illustrations of the Entomb-
ment of Christ, the body is shown wrapped in its grave clothes, as Joseph and
Nicodemus carry it into the tomb. The corpse is covered in this fashion in all
of the ninth- and tenth-century depictions of the scene, such as the miniature
in the Chloudoff Psalter in Moscow (Fig. 110).[111] However, when Byzantine
artists of the eleventh century came to portray the Lamentation of the Virgin,
they showed Christ's body clothed only in a loin cloth, as if it had just been
taken down from the cross.[112] On an ivory relief in the Deutsche Staatsbi-
bliothek at Berlin, for example, the Virgin sits crouched over the naked body
of her son, immediately beneath the Deposition scene that is carved above (Fig.
111).[113] Byzantine artists continued to show the corpse naked even in some
later paintings of the twelfth and thirteenth centuries which, in effect, combined
the Lamentation and the Entombment in one scene. In these images the Virgin
is depicted not sitting or kneeling on the ground, but walking, as she helps to
carry the body toward the tomb.[114] The fresco in the church at Kurbinovo
corresponds to this composite type (Fig. 101). The three principal mourners—
the Virgin, St. John, and St. Joseph of Arimathaea—walk or even run as they
carry the body toward the open mouth of the tomb; the body itself, however,
is still naked and not yet wrapped for burial.[115] This preference for showing
the corpse naked corresponds to the descriptions of the dead body in the literary
laments, such as the graphic passage in the prose lament attributed to Symeon
Metaphrastes or Nikephoros Basilakes. In this lament the Virgin described in
turn Christ's head, his hands, his sides, and his feet.[116] Thus she laid out the
whole corpse of her son to the veneration of the hearer, in the same manner
as the painters of icons and frescoes laid out Christ's body before the viewer.

The literary descriptions of the corpse also relate to Byzantine art through
the imagery of flowers. In some of the earliest versions of the Lamentation,
such as the eleventh-century ivory carving in the Deutsche Staatsbibliothek
of Berlin, the scene was placed in a landscape containing trees (Fig. 111);[117]
this setting is faithful to the Gospel narrative, which places the tomb in a
garden (John 19:41f.). But in some later versions of the Lamentation, the
plants in this garden have been decimated. The most dramatic case is the fresco
at Kurbinovo, where the bare hillside behind the corpse is strewn with cut
flowers (Figs. 101 and 104). It is clear that the flowers have been scattered on
the ground and are no longer blooming, because there is a pair of crossed stems
at the feet of the woman mourning on the right (Fig. 104). These are, in fact,
plants of the same type that can be seen in full bloom in the fresco of the
Nativity on the opposite wall, directly facing the Lamentation. At the birth

of Christ the flowers grow in luxuriant sprays beneath him as he lies in his crib (Fig. 105), and above him as he receives his first bath (Fig. 103, lower right); at the death of Christ the flowers lie scattered at the feet of his mourners. The imagery here is comparable to the Virgin's lament as recorded by George of Nicomedia: "may all the delight of the meadows look sad with me. For behold, he who adorned you with many-colored flowers, is suspended on the wood having suffered dishonor. He who beautified you with freshness and fragrance, is hung up without beauty and shapeless in his humanity—the pure beauty, the unchangeable bloom, and the perpetual delight of his mother."[118] The fallen flowers in the Lamentation scene at Kurbinovo also anticipate the metaphors of the *Epitaphios Thrēnos*: "Seeing you laid on your back, Word, the all-holy one lamented as befits a mother: 'O my sweet spring, my sweetest child, where did your beauty set?'"[119]

Although the fresco of the Lamentation at Kurbinovo is unusual in its explicit imagery of fallen flowers, other Byzantine paintings of the subject also use the landscape background as a metaphor to convey the sorrow of the occasion. In the fresco of the Lamentation at Nerezi, for example, the garden containing the tomb is completely bare (Fig. 95). The bleak, plantless outlines of its hills make a striking contrast with the mountains in the fresco of the Transfiguration, which bloom with a variety of vegetation (Fig. 96).

The literary laments, therefore, affected both the composition and the imagery of Lamentation scenes in Byzantine art. Not only did artists try to exploit the rhetorical contrasts of the present with the past and the future but they also illustrated the floral metaphors that described the dead body of Christ. The Lamentation is one of the scenes that best illustrates the humanistic tendencies of Byzantine art after iconoclasm; Mary was shown holding her son's body on her lap, kissing his head, or even succumbing to a swoon. Since these motifs were related to the conventions of the literary lament, they show us again how humanism in Byzantine art was nourished by the hidden currents of literary classicism, which flowed from the schoolroom into the hymns and sermons of the Byzantine church, and ultimately into its art.

Conclusion

The foregoing chapters have shown that Byzantine rhetoric influenced By-
zantine art in three principal ways. First, rhetoric helped artists to add vividness
to their art by filling out the bare narration of sacred texts with dramatic detail.
Second, rhetoric helped artists to structure their compositions, especially
through parallel scenes that were set off against each other in antithesis. Third,
rhetoric helped artists to enrich their work with images, so that a work of art
could become as flowery as a literary description of the springtime, or as
desolate as a lament.

We have seen in this book that certain genres and techniques of Byzantine
rhetoric had a particular affinity with the visual arts, and could readily be
transferred from speech to painting. The second chapter illustrated how the
rhetorical exercise of ekphrasis, or description, helped artists to embroider their
telling of three different stories, the Massacre of the Innocents, the Death of
the Forty Martyrs, and the Annunciation. The third chapter demonstrated that
the figure of antithesis had a double influence on Byzantine art; it not only
influenced the positioning of scenes in the decoration of Byzantine churches
but also affected the iconography and structure of the scenes themselves. Thus,
the Dormition of the Virgin was juxtaposed with the Birth of Christ, whereas
the image of Christ holding Mary's soul came to echo that of Mary holding
Christ as a child. Likewise, Christ entering Jerusalem was juxtaposed with God
in his glory, and the donkey became a throne. In scenes of Christ's ministry,
the miracles of the centurion's son and of the Canaanite's daughter were linked
visually in order to contrast Christ's treatment of the two suppliants. The
fourth chapter illustrated the dramatic effect of hyperbole on the Presentation
in Byzantine art; the figure affected both the iconography of the scene and,
on occasion, its location within a church. Finally, the fifth chapter showed how
Byzantine artists incorporated both the structure and the imagery of literary
laments into their portrayals of the lament of the Virgin, a subject that had

no basis in the text of the Gospels, but that was based on the hymns and sermons of the Byzantine church.

Rhetoric is only one element in the complex weave of Byzantine art, but it is an element that has received less attention than it deserves. For we have seen that some of the most moving and most striking images in Byzantine iconography were created under the influence of literary eloquence, and that the balance and harmony that was sought by rhetoricians was also an important ingredient in the aesthetic of Byzantine art. This book, moreover, only presents a small sampling of a rich and varied store of material. Many other scenes and subjects common to Byzantine art and literature await exploration.

I have tried to show in these pages that Byzantine artists borrowed several techniques from ancient rhetoric, but I wish to stress again that I do not believe that the artists themselves were conscious of the rhetorical origins of these methods. It is unlikely that many Byzantine artists received a formal education in rhetoric. If they exploited rhetorical techniques, it was only because these techniques had become part of the fabric of the literature, liturgy, and thought of the Byzantine church, to which both they and their patrons were exposed. It is true that Byzantine writers drew parallels between art and oratory, as has been shown in the first chapter. But there is no reason to believe that Byzantine artists consciously thought in these terms. It is only in the Italian Renaissance that we can find an artist, such as Leonardo da Vinci, making a conscious association between painting and rhetoric.[1] In all likelihood, Byzantine artists were unaware of the debt that they owed to late antique oratory, and to its survival in the schools of Constantinople. Yet, through the literature of the church, the methods of rhetoric helped Byzantine artists to give vividness to their narrative, to structure their compositions, and to embroider their art with images. These techniques were not confined to the art of the capital, but they were taken also to the provinces, and even to foreign lands such as Sicily, where Byzantine artists worked for alien masters.

Finally, a word must be said about chronology. It has consistently been shown in this book that ideas were expressed in writing before they were adopted in art; sometimes, even a period of several centuries intervened between the composition of the text and its illustration in an image. The question arises, then, whether there were any periods during the Middle Ages in which the influence of rhetorical models on Byzantine art was particularly strong, or whether the transfer of elements from the literary to the artistic tradition was a continual process. The answer appears to be that the influence of rhetoric on art was continual, but that there was an especially close relationship between

the two media in the twelfth century. We have found rhetorical forms and techniques in works of art dating from the ninth to the fourteenth centuries, but we have seen a concentration of parallels between art and oratory in the second half of the twelfth century. To this period, for example, belong the icon of the Annunciation at Sinai, with its description of spring (Fig. 42), the frescoes at Kurbinovo, with their characterization of the Virgin's lament (Fig. 101), and the mosaics at Monreale, with their eloquent antithesis of the Canaanite and the centurion (Figs. 83 and 85). It is tempting to relate this "rhetorical" phase of Byzantine art to the flourishing of the church schools in Constantinople during the twelfth century. We have seen in the first chapter that the church provided high-level instruction in rhetoric, and that its teachers, such as Nikephoros Basilakes, showed an equal facility in composing rhetorical exercises on Christian and pagan themes. This would have been fertile ground for the creation of works such as the icon of the Annunciation at Sinai, which in all likelihood was painted by an artist from the capital. Furthermore, although the professors at Constantinople were an elite, they were an elite who traveled, often to high ecclesiastical appointments in the provinces. It should not be assumed that they left their sophisticated tastes behind them as soon as they stepped outside the walls of Constantinople. An educated bishop, acting as a patron in a provincial center, could well have been one of the channels of communication between the intellectual life of the capital and the visual repertory of local artists.

Once the artifices of rhetoric had been translated into visual language, they could be understood by all, whatever their background or their level of education. As the Church Fathers were well aware, literary eloquence affected a few, but visual eloquence spoke to many.

Notes

Introduction

1. On the relative importance of rhetoric in medieval education in Byzantium and in the West see John Monfasani, *George of Trebizond; A Biography and a Study of His Rhetoric and Logic* (Leiden, 1976), pp. 248-55.

2. *Chronographia*, VI. 41, edited by E. Renauld (Paris, 1926).

3. τοῦ ῥητορικοῦ νέκταρος οὐκ ἐγεύσατο· οὐδ᾽ ἐκεῖθεν ὁ λόγος τούτῳ ἐφήρμοστο καὶ εἰς κάλλος ἐπέξεστο. . . . Καὶ συνενενεύκει ὁ λόγος αὐτῷ τὰς ὀφρῦς καὶ διόλου ἀπέπνει δριμύτητος. *Alexiad*, V.8.6, edited by B. Leib, II (Paris, 1943). See G. L. Kustas, *Studies in Byzantine Rhetoric* (Salonika, 1973), p. 156.

4. R.J.H. Jenkins, "The Hellenistic Origins of Byzantine Literature," *DOP*, 17 (1963), 45.

5. *Ibid.*, p. 42.

6. See especially: M. Baxandall, *Giotto and the Orators* (Oxford, 1971); D. Summers, "Contrapposto: Style and Meaning in Renaissance Art," *ArtB*, 59 (1977), 336-61, esp. pp. 344ff.

7. G. Millet, in his fundamental *Recherches sur l'iconographie de l'Évangile* (Paris, 1916 and 1960), was certainly aware of the importance of sermons and hymns, but the scope of his work did not allow him to explore their influence in detail. The influence of specific rhetorical forms on Byzantine art is briefly discussed by K. Onasch, *Die Ikonenmalerei, Grundzüge einer systema-tischen Darstellung* (Leipzig, 1967), pp. 152-64. The relationship between imperial art and medieval panegyrics has been alluded to by A. Grabar, *L'empereur dans l'art byzantin* (Strasbourg, 1936 and London, 1971), pp. 94-95.

8. A voluminous catalogue of these service books was assembled by A. Ehrhard, *"Überlieferung und Bestand der hagiographischen und homiletischen Literatur der griechischen Kirche*, 3 vols., Texte und Untersuchungen zur Geschichte der altchristlichen Literatur, 50-52 (Leipzig, 1937-1952).

9. D. Tasić, "The Fresco Paintings of Studenica Monastery," in M. Kašanin et al., *Studenica* (Belgrade, 1968), pp. 71ff. A Greek artist left a more conspicuous inscription in the apse of the church of St. Demetrius at Peć; V. R. Petković, "Un peintre serbe du XIVe siècle," *Mélanges Charles Diehl*, II (Paris, 1930), 135, fig. 3; A. Xyngopoulos, *Thessalonique et la peinture macédonienne* (Athens, 1955), pp. 64f.; V. Đurić, *Byzantinische Fresken in Jugoslawien* (Munich, 1976), pp. 83 and 269 n. 62.

10. See R. Cormack, "Painting after Iconoclasm," in *Iconoclasm*, edited by A. Bryer and J. Herrin (Birmingham, 1977), pp. 147-63, esp. pp. 160ff.

11. *Antapodosis*, III, 37; A. Bauer and R. Rau, eds., *Quellen zur Geschichte der sächsischen Kaiserzeit* (Darmstadt, 1971), p. 382.

12. I. Bekker, ed., *Corpus scriptorum historiae byzantinae* (Bonn, 1838), p. 450.

13. T. F. Mathews, "The Epigrams of Leo

Sacellarios and an Exegetical Approach to the Miniatures of Vat. Reg. Gr. 1," *Orientalia Christiana Periodica*, 43 (1977), 94-133, esp. pp. 122f.

14. C. Mango, "The Date of Cod. Vat. Regin. Gr. 1 and the «Macedonian Renaissance»," *Acta ad archaeologiam et artium historiam pertinentia*, 4 (1969), 121-26.

15. H. Buchthal and H. Belting, *Patronage in Thirteenth-Century Constantinople; An Atelier of Late Byzantine Book Illumination and Calligraphy* (Washington, D.C., 1978), pp. 93ff.

I. Rhetoric in the Byzantine Church

1. See G. Millet, *Recherches sur l'iconographie de l'Évangile* (Paris, 1916 and 1960), pp. 1-3.

2. For the use of *schēma* in the sense of a pose or posture, see Christopher of Mytilene's epigram on a painting of the death of the Forty Martyrs, quoted below in Chapter II, note 91.

3. See, for example, Quintilian, *Institutio Oratoria*, edited by H. E. Butler (London, 1966), II.13.8-14.·

4. ὡς ἐν βιβλίῳ τινὶ γλωττοφόρῳ. . . .οἶδε γὰρ καὶ γραφὴ σιωπῶσα ἐν τοίχῳ λαλεῖν. De S. Theodoro Martyre, PG, 46, cols. 737C-740A; translated in C. Mango, *The Art of the Byzantine Empire, 312-1453* (Englewood Cliffs, N.J., 1972), pp. 36-37.

5. προδείξαντες πᾶσιν, ὥσπερ ἐν γραφῇ, τὰς τῶν ἀνδρῶν ἀριστείας. Ἐπεὶ καὶ πολέμων ἀνδραγαθήματα καὶ λογογράφοι πολλάκις, καὶ ζωγράφοι διασημαίνουσιν, οἱ μὲν τῷ λόγῳ διακοσμοῦντες, οἱ δὲ τοῖς πίναξιν ἐγχαράττοντες, καὶ πολλοὺς ἐπήγειραν πρὸς ἀνδρίαν ἑκάτεροι. Ἃ γὰρ ὁ λόγος τῆς ἱστορίας διὰ τῆς ἀκοῆς παρίστησι, ταῦτα γραφικὴ σιωπῶσα διὰ μιμήσεως δείκνυσιν. *Homilia XIX. In sanctos quadraginta martyres*, para. 2, PG, 31, cols. 508C-509A.

6. *Epistola* IV, PG, 98, col. 172C-D.

7. συνεζευγμένην οἶδε τῷ λόγῳ τὴν διὰ τῶν χρωμάτων μορφήν. *De imaginibus oratio* I, PG, 94, col. 1265D.

8. Ὁρᾷς, ὡς ἐν εἰκόνος καὶ λόγου τὸ ἔργον; *Ibid.*

9. Τί τούτων τηλαυγέστερον πρὸς ἀπόδειξιν, ὅτι βίβλοι τοῖς ἀγραμμάτοις αἱ εἰκόνες; *Ibid.*, col. 1268A.

10. ὡς γραφὴν σύντομον καὶ εὐερμήνευτον. . . . Ὥστε καὶ λαλοῦσι, καὶ βωβαὶ οὐκ εἰσίν, ὡς τὰ εἴδωλα τῶν ἐθνῶν. Πᾶσα γὰρ γραφὴ ἀναγινωσκομένη ἐν τῇ ἐκκλησίᾳ, εἴτε συγκατάβασιν τοῦ Χριστοῦ, εἴτε τῆς Θεοτόκου τὰ θαύματα, εἴτε τῶν ἁγίων τοὺς ἄθλους καὶ τοὺς βίους, διὰ εἰκονικῆς ἱστορίας ἡμῖν διηγοῦνται. *Oratio adversus Constantinum Cabalinum*, PG, 95, col. 324B-C. See G. Millet, *Recherches*, p. 17.

11. E. Kitzinger, "The Cult of Images in the Age before Iconoclasm," *DOP*, 8 (1954), 137ff.

12. Ἀλλὰ καὶ τὰ ἀόρατα τοῦ Θεοῦ ἀπὸ κτίσεως κόσμου τοῖς ποιήμασι νοούμενα καθορᾶται. Ὁρῶμεν γὰρ εἰκόνας ἐν τοῖς κτίσμασι μηνυούσας ἡμῖν ἀμυδρῶς τὰς θείας ἐμφάσεις· ὡς ὅτε λέγομεν τὴν ἁγίαν Τριάδα, τὴν ὑπεράρχιον, εἰκονίζεσθαι δι'ἡλίου, καὶ φωτός, καὶ ἀκτῖνος· ἢ πηγῆς ἀναβλυζούσης, καὶ πηγαζομένου νάματος, καὶ προχοῆς· ἢ νοῦ, καὶ λόγου, καὶ πνεύματος τοῦ καθ'ἡμᾶς· ἢ ῥόδου φυτοῦ, καὶ ἄνθους, καὶ εὐωδίας. *De imaginibus oratio* I, PG, 94, col. 1241B-C.

13. *Antirrheticus* III, PG, 100, col. 380B-D.

14. Ἔτι ὁ σταυρὸς ἁπλοῦν πως καὶ ἀποίκιλον ἡμῖν εἰσφέρει τὸ Χριστοῦ πάθος· τοῖς δὲ ἀγροικοτέροις μόλις ἂν καὶ πάθους σύμβολον νοηθείη· τὰ δὲ ἱερὰ μορφώματα, οὐ τὸ πάθος μόνον ποικίλλουσι καὶ λεπτότερον διαγράφουσιν, ἀλλ'ἤδη καὶ τὰ θαύματα καὶ τὰ τεράστια, ἅπερ ὁ Χριστὸς ἐξειργάσατο, πλατύτερον καὶ σαφέστερον ἡμῖν διασημαίνουσι. . . . Ἔτι ὁ σταυρὸς πάθους σύμβολόν ἐστι καὶ τὸν τρόπον καθ'ὃν ὁ πεπονθὼς τὸ πάθος διήνεγκεν ὑπαινίσσεται· *Ibid.*, col. 429C-D.

15. For a discussion of the date of Eulalios and for further references, see H. Maguire, "Truth and Convention in Byzantine Descriptions of Works of Art," *DOP*, 28 (1974), 122f.

16. . . . τοσοῦτος Εὐλάλιος τὴν τέχνην,/ ὡς ἱστορεῖν πως τὰς γραφὰς φερωνύμως,/ λαλοῦντά τε χρώματα συγκεραννύειν./ Οὐ τῆς γραφικῆς ἐστὶ τὸ Χρῆμα, ξένε,/ ἀλλ' ἡ περιλάλητος ἀνθρώποις κόρη/ τὴν Εὐλαλικὴν ἰθύνασα γραφίδα,/ Εὔλαλον οὕτω καὶ τὸ χρῶμα δεικνύει. E. Miller, ed., "Poésies inédites de Théodore Prodrome," *Annuaire de l'Association pour l'encouragement des études grecques*, 17 (1883), 33; translated in Mango, *Art of the Byzantine Empire*, p. 231.

17. Ἡ Χριστὸς αὐτὸς καταβὰς οὐρανόθεν/ μορφῆς τύπον ἔδειξεν ἠκριβωμένον/ τῷ τὰς χεῖρας ἔχοντι μᾶλλον εὐλάλους,/ ἢ γοῦν πρὸς αὐτὸν ἀνιὼν τὸν αἰθέρα/ ὁ κλεινὸς Εὐλάλιος χειρὶ πανσόφῳ/ Χριστοῦ θέαν ἔγραψεν ἠκριβωμένως. A. Papadopoulos-Kerameus, ed., "Nikēphoros Kallistos Xanthopoulos," *BZ*, 11 (1902), 46; translated in Mango, *Art of the Byzantine Empire*, pp. 231f. See also C. Mango, "Antique Statuary and the Byzantine Beholder," *DOP*, 17 (1963), 66f.

18. τὴν δέ, οἷα τις ἦν, οὐκ ἔστιν ὑποδεῖξαι τῷ λόγῳ· οὐ γὰρ περιλέλειπταί τι αὐτῆς δι' ἀκριβείας παρὰ τῆς τέχνης ὁμοίωμα· ἀλλ' εἰ καί τι γέγονεν ἐν γραφαῖς ἢ ἐν πλάσμασι, πάντα τῆς ἀληθείας ἐστὶν ἐνδεέστερα. PG, 46, col. 881D.

19. Ποῦ δίκαιον τῇ τοῦ λόγου εὐτελείᾳ τὸ ἐκείνων κατασμικρύνειν μέγεθος; . . . ὅσα μὲν ὁ λόγος γράφοι, ὥσπερ εἰκόνα τινὰ ἢ σκιαγραφίαν ἐμφαίνεσθαι, αὐτοὺς δ' ἄπειρον ὑπερκεῖσθαι τῶν ἐκ τοῦ λόγου φαινομένων. A. Vogt and I. Hausherr, eds., *Oraison funèbre de Basile I par son fils Léon VI le Sage*, Orientalia Christiana 77 (Rome, 1932), 40.

20. T. Viljamaa, *Studies in Greek Encomiastic Poetry of the Early Byzantine Period* (Helsinki, 1968), p. 8; H.-G. Beck, "Antike

Beredsamkeit und byzantinische Kallilogia," *Antike und Abendland*, 15 (1969), 91-101, esp. p. 92.

21. Quibus artibus usi/ et quibus ingeniis! Quanto conamine nisi/ tunc phaleris phaleras et laudibus addere laudes! *In laudem Iustini Augusti minoris* IV, lines 162ff., edited by A. Cameron (London, 1976).

22. καί τινας λόγους ἀναπτύξεων τῶν πολιτικῶν ὑποθέσεων καὶ διαιρέσεων προβέβληται, καὶ κοσμεῖ τὴν γλῶτταν. *Chronographia* VI.41, edited by E. Renauld (Paris, 1926).

23. The works attributed to Hermogenes are edited by H. Rabe in *Rhetores graeci* VI (Leipzig, 1913). On the importance of Hermogenes in Byzantine rhetoric, see G. L. Kustas, *Studies in Byzantine Rhetoric* (Thessaloniki, 1973), pp. 5ff.

24. Edited by H. Rabe in *Rhetores graeci* X (Leipzig, 1926); see also Kustas, *Byzantine Rhetoric*, 22.

25. Ed. Rabe, X, 21-27.

26. *Ibid.*, pp. 27-31.

27. *Ibid.*, pp. 31-33.

28. *Ibid.*, pp. 34-36.

29. *Ibid.*, pp. 36-41.

30. See R. Browning, "The Patriarchal School at Constantinople in the Twelfth Century," *Byzantion*, 32 (1962), 181-82; H. Hunger, *Die hochsprachliche profane Literature der Byzantiner* I (Munich, 1978), 124.

31. Forty-eight were edited by C. Walz in *Rhetores graeci* I (Stuttgart, 1832), 423-525.

32. Τίνας ἂν εἴποι λόγους ἡ Δανάη ὑπὸ Διὸς εἰς χρυσὸν μεταβληθέντος διαπαρθενευθεῖσα. *Ibid.*, pp. 476-77. Τίνας ἂν εἴποι λόγους ἡ Θεοτόκος, ὅτε μετέβαλεν ὁ Χριστὸς τὸ ὕδωρ εἰς οἶνον εἰς τὸν γάμον. *Ibid.*, pp. 499-501. For recent discoveries, see A. Pignani, "Prolegomeni all' edizione critica dei Progimnasmi di Niceforo Basilace," *Bollettino del Comitato per la preparazione dell' edizione nazionale dei classici greci e latini*, n.s. 26 (1978), 41-56, esp. 44f.

33. Edited by L. Spengel, *Rhetores graeci* III (Leipzig, 1856), 329-446; on the attribu-

tion of the works, see Hunger, *Literatur*, p. 80.

34. Ed. Spengel, III, 331, line 15.

35. Many are published in Spengel, III, 7-256.

36. *De tropis poeticis*, ed. Spengel, III, 244-56. On the authorship of the treatise, see M. L. West, "Tryphon, *De tropis*," *Classical Quarterly*, 15 (1965), 232; on the dates of George Choeroboskos, see W. Bühler and Chr. Theodoridis, "Johannes von Damaskos *terminus post quem* für Choiroboskos," *BZ*, 69 (1976), 397-401.

37. Ὑπερβολή ἐστι φράσις ὑπερβαίνουσα τὴν ἀλήθειαν αὐξήσεως χάριν. Ed. Spengel, III, 252, lines 26-27.

38. *De tropis*, ed. Spengel, III, 198, lines 31-32. The attribution to Tryphon is doubtful; see C. Wendel, "Tryphon," in *Paulys Realencyclopädie der classischen altertumswissenschaft*, 2. reihe, edited by G. Wissowa and W. Kroll, VIIA (Stuttgart, 1939), 730.

39. λευκότεροι χιόνος, θείειν δ᾽ ἀνέμοισιν ὁμοῖοι. *Iliad*, X, line 437; cf. *De tropis poeticis*, ed. Spengel, III, 252, line 28 and 253, lines 1-2.

40. *De tropis*, ed. Spengel, III, 199, line 3.

41. *De tropis poeticis*, ed. Spengel, III, 245-46.

42. *Supra*, notes 11 and 12.

43. *Vita*, PG, 99, col. 117C-D; R. Browning, "Byzantine Scholarship," *Past and Present*, 28 (Oxford, 1964), 5; P. Lemerle, *Le premier humanisme byzantin* (Paris, 1971), p. 123.

44. See P. Lemerle, *Cinq études sur le XIe siècle byzantin* (Paris, 1977), p. 196; and R. Browning, "Literacy in the Byzantine World," *Byzantine and Modern Greek Studies*, 4 (1978), 39-54.

45. Lemerle, *Le premier humanisme byzantin*, pp. 256-57.

46. P. Speck, *Die Kaiserliche Universität von Konstantinopel*, Byzantinisches Archiv 14 (Munich, 1974), 34-35.

47. R. Browning, "The Correspondence of a Tenth-Century Byzantine Scholar," *Byzantion*, 24 (1954), 436; Speck, *Die Kaiserliche Universität*, p. 70.

48. Browning, "Correspondence," pp. 433-38. The letters have been edited by R. Browning and B. Laourdas, "To keimenon tōn epistolōn tou kōdikos BM 36749," *Epetēris Hetaireias Byzantinōn Spoudōn*, 27 (1957), 151-212.

49. See, most recently, U. Criscuolo, "Chiesa ed insegnamento a bisanzio nel XII secolo: sul problema della cosiddetta «Accademia Patriarcale»," *Siculorum gymnasium*, n.s. 28 (1975), 373-90.

50. Letter 162, edited by K. N. Sathas in *Mesaiōnikē bibliothēkē* V (Venice, 1876), 420-21; see Lemerle, *Cinq études*, pp. 230-42.

51. See R. Browning, "The Patriarchal School at Constantinople in the Twelfth Century," *Byzantion*, 32 (1962), 167-201 and 33 (1963), 11-40; *idem*, "Enlightenment and Repression in Byzantium in the Eleventh and Twelfth Centuries," *Past and Present*, 69 (1975), 3-23.

52. Browning, "Patriarchal School," p. 169.

53. *Ibid.*; Browning, "Enlightenment and Repression," p. 15.

54. Browning, "Patriarchal School," pp. 186-93; A. P. Kazhdan, "Vizantijskij publicist XIIv. Evstafij Solunskij," *Vizantijskij Vremennik*, 27 (1967), 87-106, esp. pp. 92f.

55. Browning, "Patriarchal School," p. 183.

56. Criscuolo, "Chiesa ed insegnamento," pp. 380-81; Browning, "Patriarchal School," pp. 170-78.

57. G. Downey, ed., "Nikolaos Mesarites: Description of the Church of the Holy Apostles at Constantinople," *Transactions of the American Philosophical Society*, n.s. 47:6 (1957), chaps. VII-XI and XLII-XLIII.

58. Browning, "Patriarchal School," p. 177.

59. Ed. Downey, X.

60. ἄλλου ἄλλό τι τῶν μαθητιώντων ἢ

καὶ τῶν διδασκόντων προθεμένου ἐπὶ συζήτησιν . . . ὡς καὶ . . . ἔστιν ὅτε .ˉ. . κατ᾽ ἀλλήλων τραχυτέροις χρῆσθαι τοῖς ῥήμασι καὶ τὸ ἀμαθὲς καὶ ἀφιλόσοφόν τε καὶ ἀφυσίκευτον κατὰ ῥοῦν ἐκ τοῦ στόματος αὐτῶν κατ᾽ ἀλλήλων πρὸς ἀλλήλους ἀποφυσᾶσθαι. *Ibid.*, XLIII.1.

61. σχεδάρια συνεχῶς ἀνελίττοντες καὶ ἄνω καὶ κάτω τὸν τῆς στοᾶς περίβολον βηματίζοντες. *Ibid.*, VIII.2.

62. Ἕτεροι οἱ καὶ πρὸς τὰ μείζω καὶ τελεώτερα πεφθακότες πλοκὰς συνείρουσι νοημάτων καὶ τὸν τῶν γεγραμμένων νοῦν ἐς τὸ γρῖφον μετασκευάζουσιν, ἄλλα μὲν λαλοῦντες γλώσσῃσιν, ἄλλα δὲ κεύθοντες ἐν φρεσίν. *Ibid.*, VIII.3.

63. *Ibid.*, XLII.1.

64. R. Browning, ''Unpublished Correspondence between Michael Italicus, Archbishop of Philippopolis, and Theodore Prodromos,'' *Byzantinobulgarica*, 1 (Sofia, 1962), 279.

65. R. Browning, ''Correspondence of a Tenth-Century Byzantine Scholar,'' *Byzantion*, 24 (1954), 434.

66. οὐ τὸ μυθῶδες, ἀλλὰ τὸ ὠφέλιμον κατασχών. *Vita*, PG, 99, col. 117C.

67. Μαθήμασι δὲ θείοις ἐπαγρυπνῶν οὐ διέλιπεν ἡμέρας καὶ νυκτὸς μελετῶν ἐν νόμῳ Κυρίου. . . . Ῥητορικῆς δὲ οὐκ ἐδεήθη ψευδολογίας, . . . οὐδὲ δεινότητι καὶ ἰδέαις καταποικίλλειν τὴν λέξιν, τὸ φυσικὸν δὲ τοῦ λόγου κάλλος φέρων τῇ ἀληθεῖ τῶν πραγμάτων ἐκβάσει τὸ πείθειν ἔχειν ἢ τῷ πιθανῷ τῆς φράσεως. Edited by P. van den Ven, ''La vie grecque de S. Jean le Psichaïte,'' *Le Muséon*, n.s. 3 (1902), 109; quoted in Fr. Dvornik, *Les légendes de Constantin et de Méthode vues de Byzance*, 2nd. ed. (Hattiesburg, Miss., 1969), p. 30.

68. C. Diehl, ''Le trésor et la bibliothèque de Patmos au commencement du XIIIe siècle,'' in *Études byzantines* (Paris, 1905), pp. 307-36, esp. pp. 322f.

69. *Ibid.*, p. 322 n.1.

70. The debt owed by the Gregories to ancient rhetoric is set out in two important studies: L. Méridier, *L'influence de la seconde sophistique sur l'oeuvre de Grégoire de Nysse* (Paris, 1906), and M. Guignet, *Saint Grégoire de Nazianze et la rhétorique* (Paris, 1911). See also H. Delehaye, *Les passions des martyrs et les genres littéraires* (Brussels, 1921).

71. Guignet, *Saint Grégoire de Nazianze*, pp. 29ff.; Delehaye, *Les passions des martyrs*, p. 189.

72. Méridier, *L'influence de la seconde sophistique*, p. 53.

73. Μηδεὶς δὲ τοὺς κομπωδεστέρους παρ᾽ ἡμῶν ἐπιζητείτω τῶν λόγων· ἔστι μὲν γὰρ οὐδὲ βουλομένοις ἡμῖν ἴσως δυνατὸν τὸ τοιοῦτον, ἀμελετήτοις οὖσι τῆς τοιαύτης λέξεως. Εἰ δὲ καὶ παρῆν τοῦ κομπάζειν ἡ δύναμις, οὐκ ἂν τοῦ κοινῇ λυσιτελοῦντος τὸ ἐν ὀλίγοις εὐδοκιμῆσαι προετιμήσαμεν. *De virginitate* II, PG, 46, col. 324D; quoted in Mérider, *L'influence de la seconde sophistique*, p. 61.

74. L. G. Westerink, ed., *Arethae scripta minora* I (Leipzig, 1968), 187, lines 5-7; cited in Kustas, *Byzantine Rhetoric*, pp. 84f.

75. Bibliothèque Nationale, MS. gr. 1208, folio lv.; *Bulletin de la Société Française de Reproductions de Manuscrits à Peintures*, 11 (1927), p1. I.

76. I. Hutter, ''Die Homilien des Mönches Jakobos und ihre Illustrationen,'' dissertation, Vienna, 1970, pp. 9 and 21.

77. P. Friedländer, ed., *Spätantiker Gemäldezyklus in Gaza*, ST 89 (Vatican City, 1939).

78. PG, 87, 1 and 2.

79. *Laudatio Marciani*, I, 17-76; II, 28-54, edited by R. Foerster and E. Richtsteig (Leipzig, 1929); translations in Mango, *Art of the Byzantine Empire*, pp. 60-72.

80. Browning, ''Patriarchal School,'' p. 168.

81. Ἔστι δ᾽ ὁ αὐτὸς οὐ μόνον τὰ θεῖα σοφὸς . . . ἀλλ᾽ ὡς καὶ τὴν κατὰ κόσμον πᾶσαν σοφίαν ἐπιστημονικώτατός τε καὶ ὑψηλότατος, δι᾽ ἧς γλῶττά τε πεπαι-

δευμένως καὶ ἀρίστως ἄγαν καταπλουτεῖ φθέγγεσθαι . . . γραμματικὸς ὑπὲρ τὸν Ἱστιαῖον καὶ Θεοδόσιον, ῥητορικὸς ὑπὲρ τὸν Δημοσθένην καὶ Ἑρμογένην. Ed. Downey, XLIII.5.

82. R.J.H. Jenkins, "The Hellenistic Origins of Byzantine Literature," DOP, 17 (1963), 42.

83. ἐξ ὧν ἡγούμεθα καὶ ποιητὰς καὶ συγγραφέας καὶ ῥήτορας πάντας ἀνυμνεῖν θεοὺς ἐντέχνως. Ed. Spengel, III, 344, lines 6f.

II. Description

1. G. Downey, "Ekphrasis," in Reallexikon für Antike und Christentum IV (1959), 921ff.; A. Hohlweg, "Ekphrasis," RBK II (Stuttgart, 1971), cols. 33ff.; H. Hunger, Die hochsprachliche profane Literatur der Byzantiner I (Munich, 1978), 170ff.

2. Γίνονται δὲ ἐκφράσεις προσώπων τε καὶ πραγμάτων καὶ καιρῶν καὶ τόπων καὶ χρόνων καὶ πολλῶν ἑτέρων. Progymnasmata, 10, ed. H. Rabe (Leipzig, 1913), p. 22, lines 9f.

3. Ibid., lines 7f.; Aphthonius, Progymnasmata, 12, ed. H. Rabe (Leipzig, 1926), 36, lines 21f.

4. ἡ μὲν τὰ καθόλου, ἡ δὲ τὰ κατὰ μέρος ἐξετάζει· οἷον διηγήσεως μέν ἐστιν εἰπεῖν· ἐπολέμησαν Ἀθηναῖοι καὶ Πελοποννήσιοι· ἐκφράσεως δέ, ὅτι τοιάδε καὶ τοιάδε ἑκάτεροι παρασκευῇ ἐχρήσαντο καὶ τῷδε τῷ τρόπῳ τῆς ὁπλίσεως. Progymnasmata, ed. L. Spengel, Rhetores graeci III (Leipzig, 1856), 492, lines 6ff.

5. οὐδὲ γὰρ φαυλότερα πάντως τῶν ζωγράφων οἱ μουσῶν παῖδες ἔχομεν φάρμακα. Edited by F. Halkin, Euphémie de Chalcédoine (Brussels, 1965), p. 5; translation in C. Mango, The Art of the Byzantine Empire, 312-1453 (Englewood Cliffs, N.J., 1972), p. 38.

6. See H. Maguire, "Truth and Convention in Byzantine Descriptions of Works of Art," DOP, 28 (1974), 113-40.

7. Τότε Ἡρώδης, ἰδὼν ὅτι ἐνεπαίχθη ὑπὸ τῶν μάγων, ἐθυμώθη λίαν· καὶ ἀποστείλας ἀνεῖλε πάντας τοὺς παῖδας τοὺς ἐν Βηθλεὲμ καὶ ἐν πᾶσι τοῖς ὁρίοις αὐτῆς, ἀπὸ διετοῦς καὶ κατωτέρω. Matthew 2:16.

8. See M. Guignet, Saint Grégoire de Nazianze et la rhétorique (Paris, 1911), pp. 188f.

9. Supra, Chapter I n. 5.

10. Recherches sur l'iconographie de l'Évangile (Paris, 1916 and 1960), pp. 159f.

11. Πρῶτον μὲν τὰ πρὸ τοῦ πολέμου ἐροῦμεν, τὰς στρατολογίας, τὰ ἀναλώματα, τοὺς φόβους, εἶτα τὰς συμβολάς, τὰς σφαγάς, τοὺς θανάτους, εἶτα τὸ τρόπαιον, εἶτα τοὺς παιᾶνας τῶν νενικηκότων, τῶν δὲ τὰ δάκρυα, τὴν δουλείαν. Progymnasmata, 10, ed. Rabe, 23, lines 1ff.

12. Sic et urbium captarum crescit miseratio. Sine dubio enim, qui dicit expugnatam esse civitatem, complectitur omnia quaecunque talis fortuna recipit, sed in adfectus minus penetrat brevis hic velut nuntius. At si aperias haec, quae verbo uno inclusa erant, apparebunt effusae per domus ac templa flammae et ruentium tectorum fragor et ex diversis clamoribus unus quidam sonus, aliorum fuga incerta, alii extremo complexu suorum cohaerentes et infantium feminarumque ploratus . . . ; tum . . . acti ante suum quisque praedonem catenati et conata retinere infantem suum mater et, sicubi maius lucrum est, pugna inter victores. Institutio oratoria VIII.3.67ff., ed. H. E. Butler, III (London, 1921).

13. Et trepidae matres pressere ad pectora natos. Ibid. VIII.3.70; cf. Aeneid VII, line 518.

14. Atque huius summae, iudicio quidem meo, virtutis facillima est via. Institutio oratoria VIII.3.71, ed. Butler, III.

15. Liberi partim e gremiis diripiuntur parentum, partim in sinu iugulantur, partim ante pedes constuprantur. Ad Herennium IV.51, ed. H. Caplan (London, 1968). For a Greek example of the description of war, see the ekphrasis of a battle attributed to Liba

nius, edited by R. Foerster, *Libanii opera* VIII (Leipzig, 1915), 460-64.

16. *Oratio* XXXVII, *De infantibus*, PG, 85, cols. 388-400.

17. A. Ehrhard, *Überlieferung und Bestand der hagiographischen und homiletischen Literatur der griechischen Kirche*, pt. I, vol. II, fasc. 1 (Leipzig, 1937), 58 (Turin, University Library, MS. gr. 135); *ibid.*, p. 70 (Jerusalem, Library of the Greek Patriarchate, MS. Sab. 103).

18. *De infantibus*, PG, 85, col. 389C.

19. Τότε ἐπληρώθη τὸ ῥηθὲν ὑπὸ Ἱερεμίου τοῦ προφήτου, λέγοντος· Φωνή ἐν Ῥαμᾷ ἠκούσθη, θρῆνος καὶ κλαυθμὸς καὶ ὀδυρμὸς πολύς· Ῥαχὴλ κλαίουσα τὰ τέκνα αὐτῆς, καὶ οὐκ ἤθελε παρακληθῆναι, ὅτι οὐκ εἰσί. Matthew, 2:16-18.

20. Σπεύσατε μόνον, ἐπισπεύσατε δίκην λεόντων τῇ πόλει. *De infantibus*, PG, 85, cols. 392A-393B.

21. *Ibid.*, cols. 389C-396A.

22. πρὸς τὴν τῆς μαχαίρας ἀποβλέπουσαν ἀστραπὴν. *Ibid.*, col. 389D.

23. ἀντερείδουσαι τὰς χεῖρας ταῖς ἀκμαῖς τῶν ξιφῶν. *Ibid.*, col. 393C.

24. *Ibid.*, cols. 396B-397B.

25. τὰς μητέρας γὰρ ἤλαυνεν, καὶ φθάνων ταύτας ἥρπαζεν/ ἐκ τῶν ἰδίων ἀγκαλῶν ὡς στρουθία νεοσσούς. . . . Str. 10, lines 9f., ed. J. Grosdidier de Matons, *Romanos le Mélode, hymnes* II (Paris, 1965), 216.

26. Τὰ μὲν ἐκεντήθησαν ἀπρεπῶς καὶ ἀπέψυξαν τὰ δὲ διεμερίσθησαν/ ἄλλα κάρας ἐτμήθη, τοὺς μασθοὺς τῶν μητέρων/ καθέλκοντα. . . . Str. 14, lines 3ff., ed. Grosdidier de Matons, II, 220.

27. For the sake of completeness, reference should also be made to the vivid descriptions of the Massacre of the Innocents in the sermons attributed to Gregory of Nyssa (PG, 46, cols. 1144D-1145C) and St. John Chrysostom (PG, 61, col. 702A-B).

28. *Sermo in Sanctos Innocentes*, PG, 96, cols. 1504B-1505A.

29. Homilia XXIV, *In Sanctos Innocentes*, ed. G. Rossi Taibbi, *Filagato da Cerami,*

Omelie per i vangeli domenicali e le feste di tutto l'anno I (Palermo, 1969), 156-61; the sermon was also published under the name of Theophanes Cerameus in PG, 132, cols. 917-28.

30. Rossi Taibbi, pp. XLIII-XLVIII and LI-LVI.

31. Ἐγέγραπτο γὰρ ὁ μὲν τύραννος ἐκεῖνος Ἡρώδης ἐφ᾽ ὑψηλοῦ τινος θρόνου σοβαρῶς ἐφεζόμενος, δριμύ τε καὶ θηριῶδες ὁρῶν κεχηνότι τῷ βλέμματι. . . . τὴν δεξιὰν προτείνων ἐπιτάττειν ἐῴκει τοῖς στρατιώταις ἀνηλεῶς θερίσαι τῶν νηπίων τὴν ἄρουραν. Οἱ δὲ θηριοπρεπῶς ἐπιθρώσκοντες, ἀφειδῶς τὰ δείλαια κατεμέλιζον. Ἔγραψεν ὁ ζωγράφος καὶ τὰς ἀθλίας μητέρας οἰκτρὸν συνιστώσας θρῆνον, καὶ τοῖς αἵμασι κιρνώσας τὰ δάκρυα. Καὶ ἡ μὲν ἔτιλλε τὰς κόμας, ἡ δὲ ταῖς ὄνυξι τὰς παρειὰς περιέδρυφεν. Ἄλλη διέρρησσε τὸν πέπλον, καὶ τὰ στέρνα παραγυμνοῦσα τὸν μαστὸν ὑπεδείκνυ καταλειφθέντα τοῦ θηλάζοντος ἔρημον· ἑτέρα δὲ τοῦ κατακοπέντος παιδίου τὰ διεσπαρμένα μέλη συνέλεγε· καὶ ἄλλη νεοσφαγὲς ἐν τοῖς γόνασι κρατοῦσα τὸ νήπιον, πικρῶς ὠλοφύρετο. *Homilia* XXIV, 9-10, ed. Rossi Taibbi, p. 159.

32. B. Brenk, *Die frühchristlichen Mosaiken in S. Maria Maggiore zu Rom* (Wiesbaden, 1975), pp. 30ff.

33. On the iconography of the Massacre of the Innocents in Early Christian and Byzantine art, see Millet, *Recherches*, pp. 158ff.; L. Kötzsche-Breitenbruch, "Zur Ikonographie des bethlehemitischen Kindermordes in der frühchristlichen Kunst," *Jahrbuch für Antike und Christentum*, 11/12 (1968/1969), 104-15; G. Schiller, *Iconography of Christian Art* I (Greenwich, Conn., 1971), 114ff.

34. Kötzsche-Breitenbruch, "Ikonographie des bethlehemitischen Kindermordes," p. 106, figs. 17a (sarcophagus in the Abbey Church of St-Maximin), 17b (sarcophagus from St-Martin at St-Remy), 18c (ivory diptych in Milan).

35. *Ibid.*, p. 106, fig. 18a.

36. On the gesture, see H. Maguire, "The Depiction of Sorrow in Middle Byzantine Art," *DOP*, 31 (1977), 158ff.

37. Biblioteca Laurenziana, MS. Plut. I. 56; C. Cecchelli, G. Furlani, and M. Salmi, *The Rabbula Gospels* (Olten and Lausanne, 1959), p. 55; Kötzsche-Breitenbruch, "Ikonographie des bethlehemitischen Kindermordes," p. 110, fig. 19b.

38. *Supra*, n. 31.

39. *Supra*, n. 20.

40. ὡς ἐφελκομένων τῶν τέκνων ἅπερ ἔτυχον μέλη περισφίγξασαι ταῖς χερσί. *De infantibus*, PG, 85, col. 393D.

41. *Supra*, n. 23.

42. Kötzsche-Breitenbruch, "Ikonographie des bethlehemitischen Kindermordes," p. 109, text fig. 5.

43. The motif occurs in the miniature of the Judgment of Solomon in the Manuscript of the Homilies of Gregory Nazianzen in Paris, Bibliothèque Nationale, gr. 510, fol. 215v.; H. Omont, *Miniatures des plus anciens manuscrits grecs de la Bibliothèque Nationale* (Paris, 1929), p. 23, pl. 39. See J. Lafontaine-Dosogne, "The Iconography of the Cycle of the Infancy of Christ," in P. A. Underwood, ed., *The Kariye Djami* IV (Princeton, 1975), 233 and n. 243.

44. Kötzsche-Breitenbruch, "Ikonographie des bethlehemitischen Kindermordes," p. 111, fig. 19c.

45. *Protevangelium* XXII, 3; translated by M. R. James, *The Apocryphal New Testament* (Oxford, 1966), p. 48. The flight of Elizabeth was also illustrated in two other pre-iconoclastic versions of the Massacre, a painting in the church at Deir Abu Hinnis (Lafontaine-Dosogne, "The Infancy of Christ," p. 230, fig. 57) and an ivory pyxis in the Louvre (W. F. Volbach, *Elfenbeinarbeiten der Spätantike und des frühen Mittelalters*, 3rd. ed. [Mainz, 1976], p. 115, pl. 93).

46. Bibliothèque Nationale, MS. gr. 510, fol. 137; Omont, *Miniatures*, p. 20, pl. 32.

47. Leningrad Public Library, MS. gr. 334; V. G. Pucko, "Dva fragmenta Konstantinopol'skih licev'ih rukopisej tret'ej četverti XI V. iz sobranija GPB (greč. 334 i 373)," *Vizantijskij Vremennik*, 31 (1971), 121-27, figs. 2 and 4.

48. On the problem of the relationship of this leaf to the manuscript of sermons in the Patriarchal Library at Jerusalem (MS. Taphou 14), see E. E. Granstrem, "Katalog grečeskih rykopisej," *Vizantijskij Vremennik*, 19 (1961), 220.

49. *Supra*, nn. 25 and 28.

50. *Supra*, n. 24.

51. G. and M. Sotiriou, *Icones du Mont Sinai* I (Athens, 1956), pls. 43-45; *ibid.*, II (1958), 59ff.; K. Weitzmann, M. Chatzidakis, K. Miatev, and S. Radojčić, *Frühe Ikonen* (Vienna and Munich, 1965), p. XIII, pls. 22-23.

52. *Supra*, n. 26.

53. The motif of the soldier's unkempt hair recurs in an eleventh-century miniature of a Gospel book in Paris, Bibliothèque Nationale, gr. 74, fol. 5; H. Omont, *Évangiles avec peintures byzantines du XIe siècle* I (Paris, n.d.), pl. 7.

54. P. A. Underwood, *The Kariye Djami* I (New York, 1966), 98ff.; *ibid.*, II, pls. 184-99; J. Lafontaine-Dosogne, "The Infancy of Christ," pp. 229f.

55. Millet, *Recherches*, pp. 161f.

56. The paintings of the Metropolis at Mistra (after 1291) anticipate the mosaics of the Kariye Camii in the use of this compositional device; G. Millet, *Monuments byzantins de Mistra* (Paris, 1910), pl. 66, 4. See Lafontaine-Dosogne, "The Infancy of Christ," p. 232 and n. 242.

57. *Supra*, n. 22.

58. Lafontaine-Dosogne, "The Infancy of Christ," p. 233.

59. F. B. Florescu, *Die Trajanssäule* (Bonn, 1969), pl. XXII, 72; U. Clemen, "De la colonne trajane à la mosaïque de Sainte-Marie-Majeure: le massacre des enfants," *L'Antiquité classique*, 44 (1975), 582f., fig. 2.

60. On the gesture, see Maguire, "Sorrow in Middle Byzantine Art," pp. 132ff.

61. *Supra*, n. 26.

62. Millet, *Mistra*, pl. 93, 3. Another de-

tailed portrayal of the Massacre of the Infants was painted in the monastery of Marko in Macedonia; G. Millet, *La peinture du moyen âge en Yougoslavie* IV (Paris, 1969), pl. 91, fig. 168; V. J. Đurić, *Byzantinische Fresken in Jugoslawien* (Munich, 1976), figs. 86-87. Equally dramatic was the painting in the Theoskepastos at Trebizond; see Millet, *Recherches*, p. 162 n. 4 and fig. 117; and G. Millet and D. Talbot Rice, *Byzantine Painting at Trebizond* (London, 1936), p. 49, pl. XIX.

63. *Supra*, n. 31.

64. Matthew 2:16.

65. *Controversiae* X.5, ed. M. Winterbottom (Cambridge, Mass., 1974).

66. Extincti sanguine refovebantur ignes; in hoc desinebatur torqueri aliquando ut saepius posset. Exquisita verbera, lamnae, eculeus, quidquid antiqua saevitia invenerat, quidquid et nova adiecerat—quid amplius dicam? *Ibid.* II.5.6. See also *ibid.* IX.6.18.

67. *Progymnasmata*, ed. Spengel, III, 492, lines 10ff.

68. Ed. Foerster, VIII, 511-16.

69. καὶ πρόσχημα μὲν ἔκαστος ἄλλο τι ἐπέδειξε, μίαν δὲ πάντες ὀδύνην ἐμφαίνουσι. *Ibid.*, p. 514, lines 16ff.

70. *Ibid.*, pp. 524-27.

71. See H. Delehaye, *Les passions des martyrs et les genres littéraires* (Brussels, 1921), pp. 216ff.

72. καὶ οὐδὲ ἐνταῦθα τῆς μανίας ἔστησαν οἱ αἱμοβόροι θῆρες ἐκεῖνοι, ἀλλὰ ἀπὸ τοῦ ξύλου καθελόντες ὑπὲρ τῶν ἀνθράκων ἐπὶ σιδηρᾶς κλίμακος ἔτεινον· καὶ ἦν ἰδεῖν πάλιν πικρότερα τῶν προτέρων θεάματα, διπλᾶς καταφερομένας σταγόνας ἐκ τῶν σωμάτων, τὰς μὲν τοῦ αἵματος ῥέοντος . . . οἱ δὲ ἅγιοι καθάπερ ἐπὶ ῥόδων κείμενοι τῶν ἀνθράκων, οὕτω μεθ᾽ ἡδονῆς τὰ γινόμενα ἐθεώρουν. *Laudatio SS. omnium qui martyrium toto terrarum orbe sunt passi*, PG, 50, col. 708. A similar description of varied tortures can be found in Gregory of Nazianzus, *Oratio XV, In Machabaeorum laudem*, PG, 35, col. 917A-B.

73. *Description of the All-praiseworthy St. Euphemia*, ed. Halkin, pp. 4-8; translated in Mango, *Art of the Byzantine Empire*, pp. 37-39.

74. Δακρύω δὲ τὸ ἐντεῦθεν καί μοι τὸ πάθος ἐπικόπτει τὸν λόγον· τὰς γὰρ τοῦ αἵματος σταγόνας οὕτως ἐναργῶς ἐπέχρωσεν ὁ γραφεὺς ὥστε εἴποις ἂν προχεῖσθαι τῶν χειλέων ἀληθῶς καὶ θρηνήσας ἀπέλθοις. *Ibid.*, Halkin, p. 7.

75. Εὐθὺς γοῦν καὶ μετ᾽ ὀλίγον πῦρ ἀλλαχοῦ σφοδρὸν ὁ ζωγράφος ἀνῆψεν, ἐρυθρῷ χρώματι ἔνθεν καὶ ἔνθεν ἐπιλαμφθέντι σωματοποιήσας τὴν φλόγα. Ἵστησι δὲ μέσην αὐτήν, τὰς μὲν χεῖρας πρὸς οὐρανὸν διαπλώσασαν, ἀχθηδόνα δὲ οὐδεμίαν ἐπιφαίνουσαν τῷ προσώπῳ, ἀλλὰ τοὐναντίον γεγηθυῖαν ὅτι πρὸς τὴν ἀσώματον καὶ μακαρίαν ἐξεδήμει ζωήν. *Ibid.*; Halkin, p. 8.

76. Vatican, MS. gr. 1613; on the date, see I. Ševčenko, "On Pantoleon the Painter," *Jahrbuch der Österreichischen Byzantinistik*, 21 (1972), 241ff.

77. On the artists, see I. Ševčenko, "The Illuminators of the Menologium of Basil II," *DOP*, 16 (1962), 245-76.

78. *Il Menologio di Basilio II*, Codices e Vaticanis selecti 8 (Turin, 1907), 5, pl. 9.

79. παρεδόθη πυρί. Καὶ οὕτως ἐν τῇ καμίνῳ, ὥσπερ οἱ τρεῖς ἅγιοι παῖδες, δοξάζων, καὶ μεγαλύνων τὸν Θεόν, τὸ μακάριον καὶ ποθούμενον τέλος ἐδέξατο, ἀπολαβὼν τὸν στέφανον τῆς ἀφθάρτου ζωῆς. . . . Ἡ δὲ ἁγία αὐτοῦ ψυχὴ ἀνελθοῦσα ἐν οὐρανοῖς, μετὰ τῶν ἁγίων εὐφραίνεται. PG, 117, col. 28C.

80. On page 4 one of a group of followers of St. Ammon raises her garment to her face as she suffers martyrdom in the flames (*Il Menologio di Basilio II*, pl. 4). On page 62 a fellow martyr of St. Herais awaits her execution holding her right wrist in her left hand (*Il Menologio di Basilio II*, pl. 62); for a discussion of this gesture as an expression of sorrow, see Maguire, "Sorrow in Middle Byzantine Art," pp. 153ff.

81. A Goldschmidt and K. Weitzmann, *Die*

byzantinischen Elfenbeinskulpturen II (Berlin, 1934), 27, pl. 3, no. 9.

82. See O. Demus, "Two Palaeologan Mosaic Icons in the Dumbarton Oaks Collection," *DOP*, 14 (1960), 87ff., esp. pp. 101f.

83. *Ibid.*, pp. 101f., fig. 6; J. Wilpert, *Die römischen Mosaiken und Malereien der kirchlichen Bauten vom IV.bis XIII. Jahrhundert* II (Freiburg, 1917), 724 and *ibid.* IV, pl. 199.

84. P. J. Nordhagen, "The Earliest Decorations in Santa Maria Antiqua and Their Date," *Acta ad archaeologiam et artium historiam pertinentia*, 1 (1962), 53ff., esp. p. 63.

85. πνοὰς ἀνέμων μὴ πτοηθέντες, τῷ πνεύματι θαρροῦντες·/ τὸν βυθὸν δὲ ἀφριῶντα ἐγελάσατε περῶντες. . . . *On the Forty Martyrs of Sebasteia I*, str. 2, ed. P. Maas and C. A. Trypanis, *Sancti Romani Melodi Cantica Genuina* (Oxford, 1963), p. 488.

86. οἱ δὲ ἀποδυσάμενοι γυμνοὶ ὥσπερ εἰς στάδιον/ εἰσῆλθοσαν ἐν αὐτῇ καὶ τὴν νύκτα τὰς εὐχὰς ἀνέπεμπον τῷ Χριστῷ· *On the Forty Martyrs of Sebasteia II*, str. 16, ed. Maas and Trypanis, p. 504. Another early writer, Gaudentius of Brescia, contrasts the physical tortures of the martyrs with their mental well-being; *Sermo XVII*, PL, 20, cols. 968B-969A.

87. The painting is at the south end of the left wall of the left aisle. See Wilpert, *Die römischen Mosaiken und Malereien* II, 709 and *ibid.* IV, pl. 177; Demus, "Two Palaeologan Mosaic Icons," pp. 101f.; P. J. Nordhagen, "S. Maria Antiqua: the Frescoes of the Seventh Century," *Acta ad archaeologiam et artium historiam pertinentia*, 8 (1978), 131f., pls. 57-59.

88. Wilpert, *Die römischen Mosaiken und Malereien* II, 710; Demus, "Two Palaeologan Mosaic Icons," p. 102. Another painting of the Forty Martyrs that may be of pre-iconoclastic date is preserved in the oratory of Santa Lucia at Syracuse; here, too, the martyrs stand in stiff frontal poses, their hands raised in prayer. See P. Orsi, *Sicilia bizantina* I (Rome, 1942), 80ff., pl. V.

89. Goldschmidt and Weitzmann, *Die byzantinischen Elfenbeinskulpturen* II, 27, pl. III, no. 10.

90. See D. Talbot Rice, "The Ivory of the Forty Martyrs at Berlin and the Art of the Twelfth Century," in *Mélanges Georges Ostrogorsky* I (*Zbornik Radova Vizantološkog Instituta* 8, part 1 [Belgrade, 1963]), 275-79.

91. [Ἄθρει ἄθλο] φόρους Θεοῦ ἐνθάδε τεσσαράκοντα,/ σχήματι ἄλλον ἐν ἄλλῳ ἐφεστάοτας κατὰ λίμνην·/ [εἰ δ' ἄρ]α καὶ ἐν σχήμασιν οἵδε μὴ εἶεν ὁμοῖοι,/ ἐν βασάνῳ παγέτοιο ὁμόφρονα θυμὸν ἔχουσιν. E. Kurtz, ed. *Die Gedichte des Christophoros Mitylenaios* (Leipzig, 1903), p. 90, no. 133. The title reads: Εἰς τοὺς ἁγίους τεσσαράκοντα ἐν διαλλάττουσι σχήμασι ζωγραφηθέντας.

92. *Supra*, n. 69.

93. P. Miljković-Pepek, "Materiali za Makedonskata srednovekovia umetnost," *Zbornik of the Archaeological Museum, Skopje*, 1 (1955-1956), 37ff., pls. 28-29.

94. D. C. Winfield and E.J.W. Hawkins, "The Church of Our Lady at Asinou, Cyprus. A Report on the Seasons of 1965 and 1966," *DOP*, 21 (1967), 262, fig. 9; Maguire, "Sorrow in Middle Byzantine Art," p. 152, fig. 56.

95. Χειμὼν τὸ λυποῦν, σὰρξ τὸ πάσχον ἐνθάδε·/ προσχὼν ἀκούσεις καὶ στεναγμοὺς μαρτύρων· On the reading of the inscription, see Maguire, "Sorrow in Middle Byzantine Art," p. 152 n. 156.

96. D. K. Treneff and N. P. Popoff, *Miniatures du ménologe grec du XIme siècle, no. 183 de la Bibliothèque Synodale à Moscou* (Moscow, 1911), pp. 5ff., pl. V, no. 18.

97. *Ibid.*, pl. VIII, no. 36.

98. Demus, "Two Palaeologan Mosaic Icons," pp. 103f.

99. See A. Grabar, *Ampoules de Terre Sainte* (Paris, 1958), pp. 30f., pls. 27 (Ampulla 14) and 29 (Ampulla 16).

100. K. Weitzmann, "The Survival of Mythological Representations in Early Christian and Byzantine Art and Their Impact on Christian Iconography," *DOP*, 14 (1960), 64f.

101. MS. Suppl. gr. 247, fol. 47; *ibid.*, p. 65, fig. 7.

102. *Ibid.*, pp. 65f., fig. 40.

103. C. Robert, *Die antiken Sarkophag-Reliefs* III, 3 (Berlin, 1919), pl. 100, no. 316. See also *ibid.*, pl. 101, no. 317. I am indebted to Mr. William Tronzo for suggesting this parallel.

104. St. Gregory of Nyssa, *In quadraginta martyres*, PG, 46, cols. 768D-769A; St. Basil the Great, *In sanctos quadraginta martyres*, PG, 31, col. 516A-B; see Delehaye, *Les passions des martyrs*, p. 217.

105. Demus, "Two Palaeologan Mosaic Icons," p. 105.

106. *Supra*, n. 69.

107. Σῶμα γὰρ κρύει παραπεσὸν πρῶτον μὲν ὅλον ἐστὶ πελιδνόν, πηγνυμένου τοῦ αἵματος· ἔπειτα κλονεῖται καὶ ἀναβράσσεται, ὀδόντων ἀρασσομένων, σπωμένων δὲ τῶν ἰνῶν, καὶ παντὸς τοῦ ὄγκου ἀπροαιρέτως συνελκομένου. Ὀδύνη δέ τις δριμεῖα, καὶ πόνος ἄρρητος αὐτῶν καθικνούμενος τῶν μυελῶν, δυσφορωτάτην ποιεῖται τοῖς πηγνυμένοις τὴν αἴσθησιν. Ἔπειτα ἀκρωτηριάζεται, ὥσπερ ἀπὸ πυρός, καιομένων τῶν ἄκρων. Ἀποδιωκόμενον γὰρ τὸ θερμὸν ἀπὸ τῶν περάτων τοῦ σώματος, καὶ συμφεῦγον ἐπὶ τὸ βάθος, τὰ μέν, ὅθεν ἀπέστη, νεκρὰ καταλείπει, τὰ δέ, ἐφ᾽ ἃ συνωθεῖται, ὀδύναις δίδωσι, κατὰ μικρὸν τοῦ θανάτου διὰ τῆς πήξεως προσιόντος. *Homilia XIX. In sanctos quadraginta martyres*, 5, PG, 31, col. 516A-B.

108. δυνάμεις τινὰς ἐξ οὐρανῶν κατιούσας, καὶ οἷον παρὰ βασιλέως δωρεὰς μεγάλας διανεμούσας τοῖς στρατιώταις. *Ibid.*, col. 520B. The appearance of Christ and his angels in heaven was also described by Romanos (*On the Forty Martyrs of Sebasteia II*, strs. 9-10, ed. Maas and Trypanis, 500) and by Gaudentius of Brescia (*Sermo XVII*, PL, 20, col. 969A).

109. *Supra*, Chapter I, n. 5.

110. *Supra*, Chapter I, nn. 6-9 and 13.

111. Τὸ δὲ ἔαρ . . . ἐλευθεροῖ γὰρ τὰς ἀκτῖνας τῶν νεφῶν. Καὶ τότε δὴ φαιδρός τε ἥλιος καὶ ἥμερος καὶ τερπνός. . . .

Ἡ γῆ δὲ τὰ παρ᾽ αὐτῆς ἐκφέρει, καὶ χλωρὰ τότε τὰ λήια γεωργοὺς εὐφραίνοντα ταῖς ἐλπίσιν. Ἀλλὰ καὶ δένδρα τὴν κόμην ἀπολαμβάνει καὶ πάντα ἐν ἐπαγγελίαις καρπῶν. . . . Ἀνοίγνυται τότε καὶ ἡ θάλαττα τοῖς πλωτῆρσιν. Οὐ γὰρ ὑψηλὰ τότε τὰ κύματα οὔτε ὄρεσιν ἐοικότα, ἀλλ᾽ ὕπτια μὲν αὐτῇ τὰ νῶτα. . . . Ποταμοὶ δὲ οἱ μὲν ἀέναοι καθαροί, οἱ δὲ χείμαρροι σωφρονέστεροι. Καὶ αἱ πηγαὶ δὲ πολὺ βελτίους ἢ τοῦ χειμῶνος. . . . Ἐοίκασι δ᾽ ἀναβεβιωκόσιν οἱ ἄνθρωποι . . . τρυφῶντες ἐν ὀρνίθων τε ᾠδαῖς καὶ ἀνθέων ὀδμαῖς. Ἄιδει μὲν ἐν ἔαρι χελιδών, ᾄδει δὲ καὶ ἀηδών. . . . Ἀλλὰ καὶ τὰ ἄλλα τῶν ὀρνίθων γένη φαίνεται πανταχοῦ πετόμενα. . . . Ἀγροὶ δὲ ἥδιστοι φωνῇ τε ἀρνῶν καὶ ὅπερ ἔφην ἤδη, τοῖς ἄνθεσι, τῷ ῥόδῳ, τῷ ἴῳ, τῷ κρίνῳ, τοῖς ἄλλοις ἃ ἡδὺ μὲν ἰδεῖν, ἡδὺ δὲ καὶ εἰς χεῖρας λαβεῖν. Ed. Foerster, VIII, 479 ff.

112. *Oratio XLIV, In novam Dominicam*, PG, 36, cols. 608-21; on the ekphrasis, see M. Guignet, *Saint Grégoire de Nazianze et la rhétorique* (Paris, 1911), p. 194.

113. See. G. Galavaris, *The Illustrations of the Liturgical Homilies of Gregory Nazianzenus* (Princeton, 1969), p. 10.

114. Νῦν οὐρανὸς διαυγέστερος· νῦν ἥλιος ὑψηλότερος καὶ χρυσοειδέστερος. . . . Νῦν πηγαὶ διαυγέστερον νάουσι· νῦν δὲ ποταμοὶ δαψιλέστερον, τῶν χειμερίων δεσμῶν λυθέντες . . . καὶ περισκιρτᾷ δελφίς, ἀναφυσῶν ὡς ἥδιστον καὶ ἀναπεμπόμενος, καὶ παραπέμπει πλωτῆρας σὺν εὐθυμίᾳ. . . . Ἄρτι δὲ καλιὰν ὄρνις πήγνυται, καὶ ὁ μὲν ἐπανέρχεται, ὁ δὲ εἰσοικίζεται, ὁ δὲ περιίπταται, καὶ καταφωνεῖ τὸ ἄλσος, καὶ περιλαλεῖ τὸν ἄνθρωπον. *In novam Dominicam*, PG, 36, cols. 617C-620B.

115. Sermon on the dedication of the church in the Monastery of Kauleas, ed. Akakios, *Leontos tou Sophou panēgyrikoi logoi* (Athens, 1868), p. 247; translated by A. Frolow, "Deux églises byzantines," *Etudes byzantines*, 3 (1945), 48f.

116. P. A. De Lagarde, ed., *Iohannis Euchaitorum Metropolitae quae in Codice va-*

ticano graeco 676 supersunt (Göttingen, 1882), p. 51, no. 100.

117. Galavaris, *Illustrations of the Liturgical Homilies*, p. 151, fig. 103. The miniature illustrating this passage of Gregory's ekphrasis in Mount Athos, Panteleimon Monastery, MS. 6 (fol. 37) also shows a leaping dolphin accompanying a boat; *ibid.*, fig. 140.

118. *Ibid.*, pp. 156f., fig. 108. The trees and birds are also illustrated in a manuscript in Paris, Bibliothèque Nationale, gr. 533 (fol. 35); *ibid.*, fig. 239.

119. *In Annuntiationem*, PG, 89, cols. 1380C-1384B.

120. παντὸς δὲ τοῦ κόσμου γενέσιον· ὅτι πάντα εἰς τάξιν μετεποιήθη· καὶ κόσμον ἡ πρὶν ἀκοσμία ἐδέξατο, ὅτι δι' ἡμᾶς γέγονε καθ' ἡμᾶς ὁ πλάσας ἡμᾶς, ἀνακαινίζων τὴν παλαιωθεῖσαν αὐτοῦ καὶ φθαρεῖσαν εἰκόνα, καὶ ἀναμορφῶν αὐτὴν εἰς κάλλους περιουσίαν. *Ibid.*, col. 1384D.

121. ἑορτὴν ἑορτῶν ἐαρινὴν. In Annuntiationem, PG, 98, col. 320C.

122. τοῦ τῆς εἰδωλολατρείας χειμῶνος ἤδη που λήξαντος, τὸ τῆς θεοφανείας ἔαρ λάμπειν ἀπήρξατο. *In Annuntiationem*, PG, 132, col. 932A.

123. τῇ παρ' ἑαυτῆς καλλονῇ σπεύδει τρανῶς διαγγέλλειν ὡς οὗτός ἐστιν ὁ καιρός, καθ' ὃν ἡ παγκόσμιος ἐπέστη χαρά. *In Annuntiationem*, PG, 139, col. 112D.

124. Χαῖρε, βλαστοῦ ἀμαράντου κλῆμα·
χαῖρε, καρποῦ ἀκηράτου κτῆμα . . .
PG, 92, col. 1337D.
χαῖρε, φυτουργὸν τῆς ζωῆς ἡμῶν φύουσα . . .
Ibid.
χαῖρε, ὅτι λειμῶνα τῆς τρυφῆς ἀναθάλλεις. . . .
Ibid., col. 1340A.
χαῖρε, τὸ ἄνθος τῆς ἀφθαρσίας . . .
Ibid., col. 1341C.
χαῖρε, δένδρον ἀγλαόκαρπον, ἐξ οὗ τρέφονται πιστοί·

χαῖρε, ξύλον εὐσκιόφυλλον, ὑφ' οὗ σκέπονται πολλοί·
Ibid., col. 1341C-D.

125. S. Eustratiades, *Theotokarion* I (Chennevières-sur-Marne, 1931), pp. 39-42.

126. *In sanctissimae Deiparae Annuntiationem*, PG, 85, col. 436.

127. *Ibid.*, col. 441.

128. ὁ ἀμάραντος τῆς ἁγνείας παράδεισος, ἐν ᾧ φυτευθὲν τὸ ξύλον τῆς ζωῆς, βλαστήσει πᾶσι σωτηρίας καρπούς. *Ibid.*, col. 444. The homily was ascribed to Basil of Seleucia in PG, 85, cols. 425-52, but it is probably the work of Proclus; see J. Quasten, *Patrology* III (Utrecht, 1960), 527.

129. *In Annuntiationem*, PG, 96, col. 656C.

130. *In Annuntiationem*, PG, 107, cols. 24D-25B.

131. *Exodus* 17:6.

132. *Isaiah* 11:1.

133. *Song of Songs* 2:2.

134. Ἵνα δὲ ἐκ τῶν Πατέρων βεβαιώσωμεν τὰ ἡμέτερα, καὶ ὥσπερ τινὰ κόσμον ἐπιθῶμεν, δι' οὗ τὸ ἐπιχαρὲς ἕξουσιν. *In Annuntiationem*, PG, 89, 1386A.

135. *In Annuntiationem*, PG, 106, col. 841B-D.

136. *Sermo III, In Annuntiationem*, PG, 139, cols. 112D-113C.

137. *Protevangelium* XI.1; trans. James, *Apocryphal New Testament*, p. 43.

138. *Ibid.* XI.2.

139. S. Pelekanidis, *Kastoria*, I, *Byzantinai toichographiai* (Salonika, 1953), pl. 14a.

140. *Ibid.*, pl. 15a. The two stages of the Annunciation had also been illustrated in the eleventh-century mosaics and frescoes of the Cathedral of St. Sophia at Kiev; V. Lazarev, *Old Russian Murals and Mosaics* (London, 1966), fig. 16 (mosaic of the Virgin spinning) and fig. 33 (fresco of the Virgin by the well).

141. A.H.S. Megaw and E.J.W. Hawkins, "The Church of the Holy Apostles at Perachorio, Cyprus, and Its Frescoes," *DOP*, 16 (1962), 313f., fig. 29.

142. G. P. Bognetti, G. Chierici, and A.

De Capitani D'Arzago, *Santa Maria di Castelseprio* (Milan, 1948), pp. 544ff., pl. 38a.

143. K. Weitzmann, *Aus den Bibliotheken des Athos* (Hamburg, 1963), p. 71.

144. See, for example, S. Der Nersessian, "A Psalter and New Testament Manuscript at Dumbarton Oaks," *DOP*, 19 (1965), frontispiece and fig. 22 (Dumbarton Oaks, MS. 3, fol. 80v.); Sotiriou, *Icones* I, pl. 57 and *ibid*. II. 75ff. (icon of the Deesis and the twelve feasts); Goldschmidt and Weitzmann, *Die byzantinischen Elfenbeinskulpturen*, p. 30, pl. VI, no. 22b (ivory triptych in the Staatsbibliothek, Munich).

145. Megaw and Hawkins, "Perachorio," p. 314 and n. 76.

146. L. Hadermann-Misguich, *Kurbinovo. Les fresques de Saint-Georges et la peinture byzantine du XIIe siècle* (Brussels, 1975), p. 102, fig. 37.

147. Sotiriou, *Icones* I, pl. 76 and *ibid*. II, 91; K. Weitzmann, "Eine spätkomnenische Verkündigungsikone des Sinai und die zweite byzantinische Welle des 12. Jahrhunderts," in *Festschrift für Herbert von Einem*, edited by G. von der Osten and G. Kauffmann (Berlin, 1965), plate opposite p. 304.

148. Gardens are depicted in the Annunciation paintings at Nerezi (Hadermann-Misguich, *Kurbinovo*, p. 102), in the Mavriotissa at Kastoria (N. K. Moutsopoulos, *Kastoria, Panagia ē Mavriotissa* [Athens, 1967], pl. 91), and in the church of Our Lady at Studenica (M. Kašanin, V. Korać, D. Tasić and M. Šakota, *Studenica* [Belgrade, 1968], pp. 77-78). In the mosaic of the Cappella Palatina in Palermo, the Virgin's house is flanked by a large plant growing from a vase (O. Demus, *The Mosaics of Norman Sicily* [London, 1949], fig. 12).

149. W. F. Volbach et al., *La Pala d'Oro* (Florence, 1965), no. 52, pl. 28.

150. *Ibid*., p. 3.

151. I am grateful to Dr. Anna Kartsonis for information about this fresco.

152. On the dating see E. Kitzinger, *The Mosaics of Monreale* (Palermo, 1960), pp. 17ff.

153. Kitzinger, *Mosaics of Monreale*, fig. 53.

154. C. Stornajolo, *Miniature delle omilie di Giacomo Monaco e dell' Evangeliario Greco Urbinate* (Rome, 1910), pl. 2. A similar plant precedes the sermon on the Visitation, on folio 134; *ibid*., pl. 59.

155. Weitzmann, "Eine spätkomnenische Verkündigungsikone des Sinai," pp. 299-312.

156. H. Stern, "Les mosaïques de l'église de Sainte-Costance à Rome," *DOP*, 12 (1958), 166ff., fig. 1.

157. Weitzmann, "Eine spätkomnenische Verkündigungsikone des Sinai," pp. 301f.

III. Antithesis

1. See, especially, L. Méridier, *L'influence de la seconde sophistique sur l'oeuvre de Grégoire de Nysse* (Paris, 1906), pp. 171ff. and M. Guignet, *Saint Grégoire de Nazianze et la rhétorique* (Paris, 1911), pp. 95 and 121.

2. Ἐν φάτνῃ μὲν ἀνεκλίθη, ἀλλ' ὑπ' ἀγγέλων ἐδοξάσθη, καὶ ὑπὸ ἀστέρος ἐμηνύθη, καὶ ὑπὸ Μάγων προσεκυνήθη. . . . Ἐπείνησεν, ἀλλ' ἔθρεψε χιλιάδας. . . . Ἐκοπίασεν, ἀλλὰ τῶν κοπιώντων καὶ πεφορτισμένων ἐστὶν ἀνάπαυσις. . . . Μεμαλάκισται, καὶ τετραυμάτισται, ἀλλὰ θεραπεύει πᾶσαν νόσον, καὶ πᾶσαν μαλακίαν. . . . Ἀποθνήσκει, ζωοποιεῖ δὲ, καὶ καταλύει τῷ θανάτῳ τὸν θάνατον. *Oratio theologica tertia*, PG, 36, cols. 100B-101B.

3. Ταῦτα τοῖς αἰνιγματισταῖς παρ' ἡμῶν, οὐχ ἑκόντων μὲν (οὐ γὰρ ἡδὺ τοῖς πιστοῖς ἀδολεσχία καὶ λόγων ἀντίθεσις . . .) πλὴν ἀναγκαίως διὰ τοὺς ἐμπίπτοντας . . . ἵν' εἰδῶσι μὴ πάντα ὄντες σοφοί, μηδὲ ἀήττητοι τὰ περιττά, καὶ κενοῦντα τὸ Εὐαγγέλιον. *Ibid*., col. 101C.

4. Πολλοὶ τῷ μὲν δοκεῖν ἐξ' ἀνθρώπων εἰσί, τῇ δ' ἀληθείᾳ παρὰ τοῦ θεοῦ πέμπονται . . . καὶ γὰρ Ἡρακλῆς ἐνομίζετο μὲν Ἀμφιτρύωνος, τῇ δ'

ἀληθείᾳ ἦν Διός· οὕτω καὶ βασιλεὺς ὁ ἡμέτερος τῇ μὲν δόξῃ ἐξ ἀνθρώπων, τῇ δ' ἀληθείᾳ τὴν καταβολὴν οὐρανόθεν ἔχει. Ed. L. Spengel, Rhetores graeci III (Leipzig, 1856), 370.

5. Προῆλθε τοίνυν ὁ Ἐμμανουὴλ εἰς τοῦτον ὃν καὶ πάλαι πεποίηκε κόσμον, παιδίον μὲν πρόσφατον, Θεὸς δὲ προαιώνιος· ἐν φάτνῃ ἀνακλινόμενος, ἐν καταλύματι τόπον οὐχ εὑρίσκων, καὶ τὰς αἰωνίους σκηνὰς ἡτοιμακώς· In sanctissimae Deiparae Annuntiationem, PG, 85, col. 445C.

6. Χρόνων ἀρχὴν λαμβάνων, ὁ χρόνων Ποιητής, καὶ ὑπάρχων πρὸ τῶν αἰώνων. Ἄνθρωπος ἐγένετο ὁ τῶν ἀνθρώπων Δημιουργός· In Annuntiationem, PG, 89, col. 1388D.

7. Χαῖρε, ὅτι γεγέννηκας βρέφος, τὸν τῶν βρεφῶν τεχνουργόν, καὶ συνοχέα τῶν ὅλων. . . . Χαίροις, ὦ Κυρία Θεοτόκε, δι' ἧς ὁ ἄκτιστος κτίζεται. In Annuntiationem, PG, 96, cols. 652A-653B. The attribution to John of Damascus is doubtful; see H.-G. Beck, Kirche und theologische Literatur im byzantinischen Reich (Munich, 1977), p. 483.

8. Ἴδον παῖδες Χαλδαίων ἐν χερσὶ τῆς παρθένου/ τὸν πλάσαντα Χειρὶ τοὺς ἀνθρώπους· PG, 92, col. 1340C.

9. Παρθένος μήτηρ, ἁγναῖς ἀγκάλαις τὸν κοινὸν φέρουσα πλάστην, εἰς κοινὴν τοῦ γένους σωτηρίαν ὡς βρέφος ἀνακλινόμενον. Homilia XVII, ed. B. Laourdas (Salonika, 1959), p. 167; translated in C. Mango, The Homilies of Photius (Cambridge, Mass., 1958), p. 290. C. Mango and E.J.W. Hawkins have argued that the description refers to the mosaic still to be seen in the apse of St. Sophia; see "The Apse Mosaics of St. Sophia at Istanbul," DOP, 19 (1965), 115ff., esp. pp. 142f.

10. Ὁ οὐρανὸς, θρόνος σοι ὑπάρχει, καὶ ὁ ἐμός σε κόλπος βαστάζει. In sanctissimae Deiparae Annuntiationem, PG, 85, col. 448B.

11. πτωχεύει ὁ πλούσιος, καὶ νηπιάζει ὁ ὕψιστος . . . καὶ βαστάζεται ὁ βαστάζων τὰ πάντα. In Annuntiationem, PG, 96, col. 653B.

12. Συνέλαβες ἐν γαστρὶ τὸν ἐπειλημμένον ἁπάντων . . . ἐβάστασας, οὗ πάντα βαστάζεται τῷ νεύματι. In Annuntiationem, PG, 107, col. 21C-D.

13. Ὅλος, φησίν, ὁ οὐρανὸς καὶ ὁ πύρινος θρόνος/ οὐ χωρεῖ μου τὸν δεσπότην,/ καὶ ἡ εὐτελὴς αὕτη πῶς ὑποδέχεται;/ Ἄνω φρικτός, καὶ κάτω πῶς ὁρατός; Str. 2, lines 5ff., edited by J. Grosdidier de Matons, Romanos le Mélode, Hymnes II (Paris, 1965), 22.

14. Ὁ ἐν ὑψίστοις
 ἀκατάληπτος ὢν
 ἐκ Παρθένου τίκτεται.
 Ὁ ἔχων θρόνον τὸν οὐρανὸν
 καὶ ὑποπόδιον τὴν γῆν
 ἐν μήτρᾳ χωρεῖται γυναικός.
Mēnaia tou holou eniautou IV (Rome, 1898), 185. the hymn is attributed to the Monk John.

15. Ἔχον τὰ πάντα κόλπον ὡς θρόνῳ πέλει/ βρέφος παλαιὸν τέξαν αἰῶνας μόνον/ ποθεῖ βροτείαις χερσὶν ἠγκαλισμένον/ τὸ χειρὶ τὴν σύμπασαν ἑδράζον κτίσιν· Edited by R. Browning, "An Unpublished Corpus of Byzantine Poems," Byzantion, 33 (Brussels, 1963), 297.

16. ὁ συνέχων τὰ πάντα παντοδυνάμῳ δρακὶ ὑπὸ χειρὸς ἀνάλκιδος βασταζόμενος. XXIII.2, edited by G. Downey, "Nikolaos Mesarites: Description of the Church of the Holy Apostles at Constantinople," Transactions of the American Philosophical Society, n.s. 47:6 (1957).

17. The distinction is made, for example, in Ad Herennium IV.58, edited by H. Caplan (London, 1968).

18. τὸ σκότος λύεται, πάλιν τὸ φῶς ὑφίσταται. De schematibus, ed. Spengel, III, 186.

19. τιμῶσι μᾶλλον τοὺς ἀδίκους πλουτοῦντας, ἢ τοὺς δικαίους πενομένους. Ibid.

20. See D. Winfield, "Hagios Chrysostomos, Trikomo, Asinou. Byzantine Painters at Work," Praktika tou prōtou diethnous

Kyprologikou Synedriou, 2 (Nicosia, 1972), 285-91.

21. W. H. Buckler, "The Church of Asinou, Cyprus, and Its Frescoes," *Archaeologia*, 83 (1933), 327-50, esp. pp. 334ff.; M. Sacopoulo, *Asinou en 1106 et sa contribution à l'iconographie* (Brussels, 1966), p. 11, pls. 3f.

22. Ὦ πῶς ὁ πάντων συνεχὴς τῶν κριμάτων βρεφοκρατεῖται παρθενικαῖς ὠλέναις; Buckler, "Asinou," p. 336.

23. *Supra*, n. 16.

24. On the interpretation of this iconography of the Virgin, see A. Grabar, "Iconographie de la Sagesse Divine et de la Vierge," *Cahiers archéologiques*, 8 (1956), 259f.; idem, *L'iconoclasme byzantin* (Paris, 1957), pp. 252ff.

25. Buckler, "Asinou," p. 338.

26. A. Xyngopoulos, "Les fresques de l'église des Saints-Apôtres à Thessalonique," *Art et Société à Byzance sous les Paléologues*, Bibliothèque de l'Institut Hellénique d'Études Byzantines et Post-Byzantines de Venise 4 (Venice, 1971), 85f., figs. 1 and 18.

27. For a general discussion of the iconography of this motif, with further references, see S. Der Nersessian, "Program and Iconography of the Frescoes of the Parecclesion," in P. A. Underwood, ed., *The Kariye Djami* IV (Princeton, 1975), 331f. The hand of God appears in association with the Last Judgment in the paintings at Gračanica, in the Kariye Camii, in the Cathedral of the Dormition at Vladimir, and in the church of Voronet in Rumania. It is associated with the Creation in the Serbian Psalter of Munich and at Suceviça.

28. *Supra*, n. 7.

29. Another fourteenth-century cycle of frescoes that juxtaposed the Hand of God with the Virgin and Child existed in the Church of the Dormition at Volotovo, in Russia. The program included a portrayal of the souls of the righteous massed in God's hand, which was placed on the eastern wall of the church directly above the painting in the apse of the enthroned Virgin holding her child; to a spectator looking eastward the two images would have appeared juxtaposed, one above the other. See V. Lazarev, *Old Russian Murals and Mosaics* (London, 1966), pp. 156ff. and fig. 134; M. V. Alpatov, *Frescoes of the Church of the Assumption at Volotovo Polye* (Moscow, 1977), pl. 64 and diagram 6.

30. Ὦ πῶς ψυχὴν ἱερὰν τοῦ θεοδόχου διαιρουμένην σκηνώματος, οἰκείαις χερσὶν ὁ παντουργὸς ὑποδέχεται, τιμῶν νομίμως, ἣν τῇ φύσει δούλην ὑπάρχουσαν . . . οἰκονομικῶς μητέρα ἑαυτοῦ ἐποιήσατο, ὁ ἀληθείᾳ σαρκωθείς, οὐ φενακίσας τὴν ἐνανθρώπησιν. *First Homily on the Dormition*, 10, edited by P. Voulet, *S. Jean Damascène, Homélies sur la Nativité et la Dormition* (Paris, 1961), pp. 106ff.

31. Κάτιθι κάτιθι δέσποτα, τῇ μητρὶ κατάχρεως ἀποτιννὺς τὰ ὀφειλόμενα θρέπτρα. *Third Homily on the Dormition*, 4, ed. Voulet, p. 190. See also the *Second Homily on the Dormition*, 15, ed. Voulet, p. 162.

32. Ἐμοὶ τὸ σῶμά σου πίστευσον, ὅτι κἀγὼ τῇ κοιλίᾳ σου τὴν ἐμὴν παρεκατεθέμην θεότητα. . . . Εὐφρᾶναί σε βούλομαι τεκνοχρέως· ἀποδοῦναί σοι τὰ τῆς μητρικῆς κοιλίας ἐνοίκια· τῆς γαλακτοτροφίας τὸν μισθόν· τῆς ἀνατροφῆς τὴν ἀντάμειψιν· τοῖς σπλάγχνοις σου τὴν πληροφορίαν. *In Dormitionem B. Mariae*, III, PG, 98, col. 361B-C.

33. τεκοῦσα δὲ τὴν ὄντως ζωὴν
πρὸς τὴν ζωὴν μεθέστηκας
τὴν θείαν καὶ ἐνυπόστατον.

3rd. ode, edited by W. Christ and M. Paranikas, *Anthologia graeca carminum christianorum* (Leipzig, 1871), p. 229; *Mēnaia* VI (Rome, 1901), 413.

34. Ἐξίσταντο ἀγγέλων αἱ δυνάμεις,
ἐν τῇ Σιὼν σκοπούμεναι
τὸν οἰκεῖον Δεσπότην
γυναικείαν ψυχὴν χειριζόμενον·
τῇ γὰρ ἀχράντως τεκούσῃ
υἱοπρεπῶς προσεφώνει·
Δεῦρο, Σεμνή,
τῷ Υἱῷ καὶ Θεῷ συνδοξάσθητι.

9th. ode, ed. Christ and Paranikas, 183; Mēnaia VI, 418f.

35. Ὅτι ἐβάστασας θεὸν σάρκα ἠμφιεσμένον, βαστάζῃ θεοῦ παλάμαις ἀπαμφιασαμένη τὴν σάρκα. *In B. Mariae Assumptionem*, PG, 107, col. 164A.

36. Σαῖς ἠγκαλίζου πρίν με χερσί, Παρθένε,/ θηλῆς δὲ σῆς ἔσπασα μητρικὸν γάλα./ Τὸ πνεῦμά σου νῦν αὐτὸς ἠγκαλισμένος,/ τὸ σῶμα πέμπω πρὸς τρυφῆς τὸ χωρίον. PG, 106, col. 907.

37. For a general survey of the iconography of the Dormition in Byzantine art, see L. Wratislaw-Mitrovic and N. Okunev, "La Dormition de la Sainte Vierge dans la peinture médievale orthodoxe," *Byzantinoslavica* III (1931), 134-80.

38. M. Restle, *Die byzantinische Wandmalerei in Kleinasien* II (Recklinghausen, 1967), plan X, figs. 98-120.

39. *Ibid.*, fig. 61; G. de Jerphanion, *Une nouvelle province de l'art byzantin, les églises rupestres de Cappadoce* I, part 2 (Paris, 1932), 321.

40. See de Jerphanion, *Les églises rupestres de Cappadoce* II, plates (1928), pls. 81, 3 and 83, 1.

41. *Supra*, n. 32.

42. L. Hadermann-Misguich, *Kurbinovo. Les fresques de Saint-Georges et la peinture byzantine du XIIe siècle* I (Brussels, 1975), 17.

43. *Ibid.*, I, 64, and II, fig. 9.

44. A. Goldschmidt and K. Weitzmann, *Die byzantinischen Elfenbeinskulpturen* (Berlin, 1934), II, 25, pl. 1.

45. Another early example of the motif is the fresco of the Dormition in the church of the Panagia Mavriotissa near Kastoria; N. K. Moutsopoulos, *Kastoria, Panagia hē Mauriotissa* (Athens, 1967), pl. 62.

46. Underwood, *Kariye Djami* I, 164 and II, pl. 321. See also the late thirteenth-century fresco in St. Clement's church at Ohrid (G. Millet, *La peinture du moyen âge en Yougoslavie* III [Paris, 1962], pl. 12, 3) and the early fourteenth-century frescoes in the church of the Savior at Žiča (V. J. Đurić,

Byzantinische fresken in Jugoslawien [Munich, 1976], fig. 44), in the church of St. Nikita, near Čučer (Millet, *La peinture III*, pl. 45, 3), in the church of St. George at Staro Nagoričino (Millet, *La peinture III*, pl. 99, 1), and in the church of Mary's Dormition at Gračanica (R. Hamann-Mac Lean and H. Hallensleben, *Die Monumentalmalerei in Serbien und Makedonien vom 11. bis zum frühen 14. Jahrhundert*, plates [Giessen, 1963], fig. 333).

47. S. Pelekanidis, *Kastoria I, Byzantinai toichographiai* (Salonika, 1953), pl. 51.

48. V. Lazarev, *Storia della pittura bizantina* (Turin, 1967), p. 368, fig. 490.

49. Underwood, *Kariye Djami* I, 168ff. and II, pl. 329. For other early fourteenth-century portrayals of the Dormition in which Christ turns toward the soul sitting in his arms, see the frescoes at Ohrid, Čučer, and Staro Nagoričino cited in note 46 above.

50. See Wratislaw-Mitrovic, Okunev, "La Dormition de la Sainte Vierge," p. 166, and R. Hamann-Mac Lean, *Die Monumentalmalerei in Serbien und Makedonien, Grundlegung zu einer Geschichte der mittelalterlichen Monumentalmalerei in Serbien und Makedonien* (Giessen, 1976), p. 26.

51. A. and J. Stylianou, *The Painted Churches of Cyprus* (Nicosia, 1964), pp. 70ff., fig. 43; D. C. Winfield, "Reports on Work at Monagri, Lagoudera, and Hagios Neophytos, Cyprus, 1969/70," *DOP*, 25 (1971), 259-64, fig. 16.

52. A.H.S. Megaw and E.J.W. Hawkins, "The Church of the Holy Apostles at Perachorio, Cyprus, and Its Frescoes," *DOP*, 16 (1962), 289 n. 29.

53. This variant of the traditional composition of the Dormition is discussed by S. Boyd, "The Church of the Panagia Amasgou, Monagri, Cyprus, and Its Wallpaintings," *DOP*, 28 (1974), 308.

54. Restle, *Die byzantinische Wandmalerei in Kleinasien*, I, 50.

55. *Ibid.*, II, plan 25, fig. 280.

56. *Ibid.*, fig. 286.

57. *Ibid.*, fig. 284.

58. A. W. Epstein, "Rock-cut Chapels in Göreme Valley," *CahArch*, 24 (1975), 117ff.

59. Restle, *Die byzantinische Wandmalerei in Kleinasien* II, plan 2, fig. 26.

60. *Ibid.*, fig. 27.

61. The same confrontation of the Koimesis at the south end of the west wall and of the Nativity at the west end of the south wall can be found in the frescoes of the cave church of Kırk Dam Altı Kilise, at Belisırama, which date to 1283-1295; N. and M. Thierry, *Nouvelles églises rupestres de Cappadoce, région du Hasan Dağı* (Paris, 1963), p. 204, pl. 93b; Restle, *Die byzantinische Wandmalerei in Kleinasien* III, plan 60, pl. 510.

62. O. Demus, *The Mosaics of Norman Sicily* (London, 1949), p. 73.

63. *Ibid.*, p. 81.

64. *Ibid.*, p. 81, pl. 56.

65. *Ibid.*, p. 80, pl. 55.

66. *Supra*, n. 35.

67. On the date and program of the frescoes, see V. Lazarev, *Old Russian Murals and Mosaics* (London, 1966), pp. 99ff. and 247f.

68. D. Tasić, "The Fresco Paintings of Studenica Monastery," in M. Kašanin et al., *Studenica* (Belgrade, 1968), plate on p. 75.

69. *Ibid.*, 72, and plates on pp. 90-93.

70. Millet, *La peinture*, II, pls. 49 (3), 52, 56 (3), and 58.

71. D. Bošković and S. Nenadović, *Gradac* (Belgrade, 1951), p. 9.

72. Τῷ θρόνῳ ἐν οὐρανῷ τῷ πώλῳ ἐπὶ τῆς γῆς ἐποχούμενος, Χριστὲ ὁ Θεός. Proïmion 1, ed. Grosdidier de Matons, IV, 30. The verse is sung during matins in the liturgy for Palm Sunday; *Triōdion katanyktikon* (Rome, 1879), p. 609.

73. καὶ ἦν θεάσασθαι τοῖς νώτοις τοῦ πώλου τὸν ἐπὶ ὤμων χερουβίμ. Str. 2, ed. Grosdidier de Matons, IV, 32.

74. καὶ νῦν τῷ πώλῳ ἐπέβης, οὐρανὸν θρόνον κεκτημένος· *Ibid.*, p. 40.

75. See A. Ehrhard, *Überlieferung und Bestand der hagiographischen und homiletischen Literatur der griechischen Kirche*, part I, vol. I (Leipzig, 1937), pp. 176, 188,

262, 272; vol. II (1938), 15, 77, 99, 128, 278; and vol. III (1943), 266.

76. Τί γὰρ εὐτελέστερον ὄνου, τί δὲ ταπεινότερον ὑποζυγίου; αὐτὸς δὲ οὐκ ἀπησχύνθη πλούσιος ὤν, καὶ νώτοις χερουβικοῖς ἐποχούμενος, πῶλον ὡς θρόνον ἐπικαθίσαι. *In ramos palmarum*, PG, 97, col. 989C. See also *ibid.*, col. 1000B.

77. " Ὁ ἐπιβεβηκὼς ἐπὶ τὸν οὐρανὸν τοῦ οὐρανοῦ," πώλῳ ἐπιβιβάζεται· καὶ ὁ ἐπὶ τῶν χερουβὶμ καθήμενος, ἀλόγου νώτοις καθίζει. *In festum palmarum*, PG, 107, col. 62C. See also *ibid.*, col. 69B.

78. Luke 19:37f.

79. Luke 2:13f.

80. Καὶ τοσαύτην πτωχείαν οἱ ὄχλοι θεωρήσαντες, ὡς ἐν οὐρανῷ ἁρπαγέντες, καὶ τὰ ἄνω κατανοοῦντες, καὶ ἀγγέλοις συγχορεύοντες, οἱ τῶν σεραφὶμ τὰ στόματα δανεισάμενοι, τὰς ὁμοιοφθόγγους ἐκείνας ἔβαλλον φωνάς, λέγοντες· Εὐλογημένος ὁ ἐρχόμενος ἐν ὀνόματι Κυρίου, βασιλεὺς τοῦ Ἰσραήλ. *In ramos palmarum*, PG, 65, col. 773C-D.

81. Τίς ὁ τὴν ὁμοφωνίαν διδάξας; Ἄνωθεν ἡ χάρις· τοῦ ἁγίου Πνεύματος ἡ ἀποκάλυψις. Διὸ καὶ μετὰ παρρησίας ἐβόων· "Εὐλογημένος ὁ ἐρχόμενος ἐν ὀνόματι Κυρίου, βασιλεὺς τοῦ Ἰσραήλ·" οἱ κοσμικοὶ στρατιῶται, οἱ οὐράνιοι ἄγγελοι· οἱ θνητοὶ, ἀθάνατοι· οἱ ἐπὶ γῆς βαδίζοντες, καὶ ἐν οὐρανῷ χοροβατοῦντες. *Ibid.*, col. 776A.

82. *In ramos palmarum*, PG, 61, cols. 715-20. On the question of authorship, see Beck, *Kirche und theologische Literatur*, pp. 456f.

83. Ehrhard lists fourteen manuscripts; *Überlieferung*, vol. I, 208, 262, 272; vol. II, 5, 8, 24, 55, 62, 70, 73, 77, 99, 111, 148.

84. Ὦ ὄχλου θεογνωσία ἀγγελικῆς διακονίας μετεσχηκότος! Γῆν πατοῦντες, καὶ οὐρανὸν χοροβατοῦντες· σῶμα περικείμενοι, καὶ τὰ τῶν ἀσωμάτων μετερχόμενοι. *In ramos palmarum*. PG, 61, col. 715.

85. Μετὰ τῶν ἀγγέλων τὰ τῶν ἀγγέλων ἀνύμνησαν· μετὰ τῶν χερουβὶμ ἐδόξασαν· μετὰ τῶν σεραφὶμ ἤνεσαν, οὐ

πυρίνοις, πηλίνοις δὲ χείλεσι τὸν φοβερὸν ἐκεῖνον ὕμνον προσανατείναντες τῷ δι' ἡμᾶς ἄνωθεν πρὸς ἡμᾶς ἐλθόντι. . . . Βλέπεις οὐρανωθέντας τοὺς γηγενεῖς καὶ τὰ ἴσα τοῖς σεραφὶμ θεολογοῦντας; Καὶ τί γὰρ παραδοξότερον τοῦ τὴν ἔμφρικτον ἐκείνην ἐκφαντορίαν ἐπὶ γῆς ᾆσαι τοὺς ἀμαθεῖς μετὰ τῆς ἄνω χορείας, ἵνα καὶ ἀγγέλοις ἐπὶ γῆς περιχορεύωσιν ἄνθρωποι; *In ramos palmarum*, PG, 97, cols. 996D-997A.

86. καὶ τῶν Ἀγγέλων τὴν αἴνεσιν, καὶ τῶν παίδων ἀνύμνησιν/ προσεδέχου βοώντων σοι· Εὐλογημένος εἶ/ ὁ ἐρχόμενος τὸν Ἀδὰμ ἀνακαλέσασθαι. Proïmion 1, ed. Grosdidier de Matons, IV, 30; *Triōdion katanyktikon* (Rome, 1879), p. 609.

87. Ἅρμα φωτὸς ὁ ἥλιος καὶ οὗτός σοι δεδούλωται·/ φαιδρὸς μὲν εἰς ὄχημα καὶ οὗτος ὑπόκειται/ τῇ κελεύσει σου ὡς πλάστου καὶ Θεοῦ·/ καὶ πῶλός σε νῦν ἔτερψε. . . . Str. 7, ed. Grosdidier de Matons, IV, 38.

88. Διὸ οὐκ ἐζήτουν ἐπὶ τοῦ Κυρίου διάδημα κοσμικόν· ἔγνωσαν γὰρ αὐτὸν ἀνάρχως βασιλεύοντα· οὐκ ἐζήτουν ἁλουργίδα· ἐθεώρουν γὰρ αὐτὸν ἀναβαλλόμενον φῶς, ὡς ἱμάτιον· οὐ περιεβλέποντο πλῆθος στρατιωτῶν, πεισθέντες τῷ εἰρηκότι προφήτῃ· "Μύριαι μυριάδες ἐλειτούργουν αὐτῷ, καὶ χίλιαι χιλιάδες ἀρχαγγέλων παρειστήκεισαν αὐτῷ." *In ramos palmarum*, PG, 61, col. 716.

89. F. Gerke, *Der Sarkophag des Iunius Bassus* (Berlin, 1936), pls. 3ff.; E. Lucchesi Palli, "Einzug in Jerusalem," *Lexikon der Christlichen Ikonographie*, ed. E. Kirschbaum, I (Rome, 1968), col. 593.

90. Lucchesi Palli, "Einzug in Jerusalem," pp. 594ff. Early Byzantine works of art that depict Christ riding side-saddle include Maximian's throne in Ravenna (G. Schiller, *Iconography of Christian Art* II [Greenwich, Conn., 1972], 19f., fig. 32), the Rossano Gospels (*ibid.*, fig. 34), and the Rabbula Gospels (*ibid.*, fig. 36).

91. G. and M. Sotiriou, *Icones du Mont Sinaï* I (Athens, 1956), figs. 112ff., and II (Athens, 1958), 111f.; K. Weitzmann, "Byzantium and the West around the Year 1200," *The Year 1200: A Symposium* (New York, 1975), pp. 60f.

92. Regnator caeli fit vilis sessor aselli; P. Metz, *Das Goldene Evangelienbuch von Echternach* (Munich, 1956), p. 70, pl. 83.

93. See G. Millet, *Recherches sur l'iconographie de l'Évangile* (Paris, 1960), pp. 271ff. Christ is depicted in a completely frontal pose on another beam at Mount Sinai, which was painted in the early twelfth century. See Sotiriou, *Icones* I, fig. 88, and II, 102; K. Weitzmann, "A Group of Early Twelfth-Century Sinai Icons Attributed to Cyprus," *Studies in Memory of David Talbot Rice*, edited by G. Robertson and G. Henderson (Edinburgh, 1975), p. 51. The early Byzantine version of the Entry in the Rabbula Gospels also portrays Christ in this manner; see Schiller, *Iconography of Christian Art* II, fig. 36.

94. Hadermann-Misguich, *Kurbinovo*, pp. 542ff.

95. As the cycle of feast scenes moves around the church from the south wall to the north, it will be seen that the Transfiguration, which follows the Entry on the west wall, is out of sequence. The reason for this displacement of the Transfiguration was probably practical; the position that it should occupy, at the west end of the south wall, is broken by a small central window that would have interfered with the central figure of the transfigured Christ. Thus the Raising of Lazarus, which could be composed with a void in its center, replaced the Transfiguration at the west end of the south wall. The designer then set the Entry at the south end of the west wall, adjoining the Raising of Lazarus, probably because the two feasts immediately follow each other in the liturgy. The Transfiguration was placed at the north end of the west wall, in the next available location after the Dormition, which had to occupy the center of the west wall. See Hadermann-Misguich, *Kurbinovo*, pp. 130f.

96. *Ibid.*, p. 176.

97. *Ibid.*, pp. 191f.

98. Οἱ τὰ χερουβὶμ μυστικῶς εἰκονίζοντες καὶ τῇ ζωοποιῷ τριάδι τὸν τρισάγιον ὕμνον προσάδοντες, πᾶσαν νῦν βιωτικὴν ἀποθώμεθα μέριμναν ὡς τὸν βασιλέα τῶν ὅλων ὑποδεξόμενοι ταῖς ἀγγελικαῖς ἀοράτως δορυφορούμενον τάξεσιν. Edited by R. Engdahl, *Beiträge zur Kenntnis der byzantinischen Liturgie* (Berlin, 1908), p. 19.

99. Εὐχαριστοῦμεν σοὶ καὶ ὑπὲρ τῆς λειτουργίας ταύτης, ἣν ἐκ τῶν χειρῶν ἡμῶν δέξασθαι κατηξίωσας, καίτοι σοι παρειστήκεισαν χιλιάδες ἀρχαγγέλων καὶ μυριάδες ἀγγέλων, τὰ χερουβὶμ καὶ τὰ σεραφὶμ ἑξαπτέρυγα, πολυόμματα, μετάρσια, πτερωτά, τὸν ἐπινίκιον ὕμνον ᾄδοντα, βοῶντα, κεκραγότα καὶ λέγοντα. " Ἅγιος, ἅγιος, ἅγιος κύριος σαβαώθ, πλήρης ὁ οὐρανὸς καὶ ἡ γῆ τῆς δόξης σου, ὡσαννὰ ἐν τοῖς ὑψίστοις, εὐλογημένος ὁ ἐρχόμενος ἐν ὀνόματι κυρίου." *Ibid.*, p. 24.

100. See Hadermann-Misguich, *Kurbinovo*, p. 539.

101. *Supra*, n. 88.

102. Matthew 8:5-8. The story is also recorded by St. Luke, 7:1-10.

103. Matthew 15: 21-28. The story is also told by St. Mark, 7:25-30.

104. *In dimissionem Chananaeae*, PG, 52, cols. 449-60. On the date, see A. Wilmart, "La collection des 38 homélies latines de Saint Jean Chrysostome," *Journal of Theological Studies*, 19 (1918), 305ff., esp. p. 318; J. A. De Aldama, *Repertorium pseudochrysostomicum* (Paris, 1965), p. 161.

105. Ἐλέησόν με. . . . Πῶς ἴδω ὀφθαλμοὺς διαστρεφομένους; χεῖρας στραγγαλουμένας; πλοκάμους λυομένους; ἀφρὸν προϊέμενον; τὸν δήμιον ἔνδον ὄντα καὶ μὴ φαινόμενον; τὸν μαστίζοντα μὴ ὁρώμενον, τὰς δὲ μάστιγας φαινομένας; Ἕστηκα θεωρὸς τῶν ἀλλοτρίων κακῶν, ἕστηκα τῆς φύσεώς με κεντριζούσης· Ἐλέησόν με. Χαλεπὸν τὸ κλυδώνιον, πάθος καὶ φόβος· πάθος φύσεως, καὶ φόβος δαίμονος. Προσελθεῖν οὐ δύναμαι, οὐδὲ

κατασχεῖν. Ὠθεῖ με τὸ πάθος, καὶ διακρούεταί με ὁ φόβος. *In dimissionem Chananaeae*, PG, 52, col. 452.

106. " Ὁ δὲ οὐκ ἀπεκρίνατο αὐτῇ λόγον." Καινὰ πράγματα. Παρακαλεῖ, δέεται, κλαίει τὴν συμφοράν, αὔξει τὴν τραγῳδίαν, διηγεῖται τὸ πάθος· καὶ ὁ φιλάνθρωπος οὐκ ἀποκρίνεται· ὁ Λόγος σιωπᾷ, ἡ πηγὴ κλείεται, ὁ ἰατρὸς τὰ φάρμακα συστέλλει. Τί τὸ καινόν; τί τὸ παράδοξον; Ἄλλοις ἐπιτρέχεις, καὶ ταύτην ἐπιτρέχουσαν ἐλαύνεις; *Ibid.*, col. 453.

107. Ἐπειδὴ οὐκ ἔτυχεν ἡ γυνὴ ἀποκρίσεως, προσελθόντες αὐτῷ λέγουσιν· " Ἀπόλυσον αὐτήν, ὅτι κράζει ὄπισθεν ἡμῶν." . . . θέατρον περιέστησε, δῆμον συνήγαγε· τὴν ὀδύνην ἐθεώρουν τὴν ἀνθρωπίνην ἐκεῖνοι. *Ibid.*

108. Καὶ ὅτε ἦλθεν ἡ ἀθλία, ἡ ταλαίπωρος, ὑπὲρ θυγατρὸς παρακαλοῦσα, συμφορὰν δεομένη λῦσαι, τότε λέγεις· "Οὐκ ἀπεστάλην εἰ μὴ εἰς τὰ πρόβατα τὰ ἀπολωλότα οἴκου Ἰσραήλ." Καὶ ὅτε μὲν ἑκατόνταρχος προσῆλθε, λέγεις " Ἐγὼ ἐλθὼν ἰάσομαι αὐτόν·" *Ibid.*, col. 454.

109. Προλαμβάνει ταῖς εὐεργεσίαις τὰς ἱκεσίας. Τί οὖν, εἰπέ μοι, Δέσποτα; μὴ τῆς αὐτῆς ἑτοιμότητος ἢ τῆς Χαναναίας θυγάτηρ ἔτυχε, καὶ τὰ αὐτὰ διὰ μητρὸς ἱκετεύουσα; Ἀλλ᾽ ἐκείνη μὲν δεομένη, τοῖς κυσὶ συγκατατάττεται, καὶ λιμένα ζητοῦσα κυμάτων πειρᾶται, καὶ πρὸς τῇ πληγῇ τῆς ψυχῆς, καὶ διὰ τῆς σῆς φωνῆς ἐπιπλήττεται· "Οὐκ ἔστι καλὸν λαβεῖν τὸν ἄρτον τῶν τέκνων καὶ βαλεῖν· τοῖς κυναρίοις." Οὑτοσὶ δὲ μικροῦ πρὸ τῆς ἱκεσίας τὴν θεραπείαν κομίζεται. *Oratio XIX, In centurionem*, PG, 85, cols. 237D-240A.

110. Βούλεται γὰρ τὴν τῶν ἐθνῶν πίστιν ὀφθαλμοῖς Ἰουδαίων δημοσιευθῆναι, καὶ τῆς ἐθνικῆς εὐγνωμοσύνης θεατὰς παραστῆσαι τοὺς ἀγνώμονας Ἰουδαίους. Διὰ τοῦτο τὴν μὲν Χαναναίαν ἱκετεύουσαν ὑπερτίθεται, ἵνα ἡ μὲν διὰ τὴν ὑπέρθεσιν ἀναβοήσῃ·

"Κύριε, καὶ τὰ κυνάρια ἐσθίει ἀπὸ τῶν ψιχίων τῆς τραπέζης'" ὁ δὲ διὰ τὴν ἑτοιμότητα φθέγξηται· "Κύριε, οὐκ εἰμὶ ἱκανὸς ἵνα μου ὑπὸ τὴν στέγην εἰσέλθῃς." Πῆ μὲν ταχύτητα, πῆ δὲ βραδύτητα πρὸς τὰς χρείας μεταχειρίζεται. . . . οὕτως ὁ τῶν ὅλων Δεσπότης πίστιν ἐν ψυχαῖς κρυπτομένην ἀπογυμνῶσαι βουλόμενος, πῆ μὲν ἀναστέλλει τὸ δῶρον, πῆ δὲ συντρέχει τῷ κάμνοντι. *Ibid.*, col. 240A.

111. Οὐ φέρω τῆς θεωρίας τὸν πόνον. Ἐκπηδᾷ τῆς οἰκίας φοιτῶσα διὰ τῆς πόλεως, εἰς αἰθέρα τὰς χεῖρας ἐκτείνουσα, βλέμμα διάστροφον, κόμην γεγυμνωμένην. Δαίμονι καταγώγιον τὸ τέκνον ἔτεκον. . . . ᾿Αφίησιν ὀλολυγὰς κατὰ τὰς τῶν κυνῶν ὑλακάς· βλέπεται μὴ βλέπουσα, φέρεται δρόμῳ, ἐλεεινὰ σιωπᾷ καὶ δεινότερα φθέγγεται. Οὐκ ἔχει προθεσμίαν ἡ τιμωρία, νύκτας ἀγρύπνως ἀναλίσκουσα· νυκτῶν δὲ τὰς ἡμέρας χαλεπωτέρας εὑρίσκουσα, ἐκπηδῶσα τῆς εὐνῆς, ἀθρόως ἀναβοῶσα τὴν συμφοράν. *Oratio XX, In Chananaeam*, PG, 85, col. 249A.

112. " Ὁ δὲ οὐκ ἀπεκρίθη αὐτῇ λόγον." Ὦ φιλανθρώπου σιωπῆς ἐν ἀπανθρωπίας προσχήματι! ὦ σιωπὴ μεγαλόφωνος Ἰουδαίων κατήγορος! . . . Τὸν Θεὸν ἠρνήσω μετὰ θαύματα, καὶ τούτῳ πρὸ θαυμάτων ἐπίστευσεν. *Ibid.*, col. 249B.

113. Λέγει αὐτῷ ὁ Ἰησοῦς· " Ἐγὼ ἐλθὼν θεραπεύσω αὐτόν." Διὰ τί οὕτω ῥαδίως ὑπήκουσε, καὶ τὴν θεραπείαν εὐθὺς ἐπήγαγε, καίτοι οὐκ εἰωθὼς ἐν ἄλλοις τοῦτο ποιεῖν; . . . καὶ τῇ Χαναναίᾳ περιπαθῶς ἀντιβολούσῃ περὶ τῆς θυγατρός· "Οὐκ ἔξεστιν," εἶπε, "λαβεῖν τὸν ἄρτον ἀπὸ τῶν τέκνων, καὶ δοῦναι τοῖς κυναρίοις." Ἐν δὲ τῷ παρόντι ὁμοῦ τε ἤκουσεν, ὅτι " Ὁ παῖς μου βέβληται ἐν τῇ οἰκίᾳ παραλυτικὸς," καὶ πρὸς τὴν θεραπείαν ἐπείγεται. *Homilia XLIV, De centurione*, PG, 132, col. 829C-D.

114. See H. Belting, "Byzantine Art among Greeks and Latins in Southern Italy," *DOP*,

28 (1974), 9; K. Weitzmann, *The Miniatures of the Sacra Parallela, Parisinus Graecus 923* (Princeton, 1979), pp. 20ff.

115. PG, 95, cols. 1444C-1452B.

116. On these illustrations, see now Weitzmann, *The Miniatures of the Sacra Parallela*, pp. 166f., figs. 420-24.

117. *Supra*, n. 105.

118. T. Velmans, *Le Tétraévangile de la Laurentienne, Florence, Laur. VI. 23* (Paris, 1971), p. 28, pl. 19 (fig. 69).

119. *Ibid.*, p. 36, pl. 35 (fig. 150).

120. On this gesture see H. Maguire, "The Depiction of Sorrow in Middle Byzantine Art," *DOP*, 31 (1977), 158ff.

121. On the role of Greek artists at Monreale, see E. Kitzinger, *The Mosaics of Monreale* (Palermo, 1960), pp. 69ff., esp. pp. 86 and 102.

122. Demus, *Mosaics of Norman Sicily*, p. 277.

123. *Ibid.*, pp. 120 and 167 (n. 393); Matthew 8:6.

124. P. A. Underwood, "Some Problems in Programs and Iconography of Ministry Cycles," in P.A. Underwood, ed., *The Kariye Djami* IV (Princeton, 1975), 245-302, esp. pp. 253 and 267f.

125. G. Rossi Taibbi, *Filagato da Cerami, Omelie per i vangeli domenicali e le feste di tutto l'anno* I (Palermo, 1969), LVI.

126. *Ibid.*; Ehrhard, *Überlieferung* III, 672f.

127. Underwood, "Programs and Iconography of Ministry Cycles," p. 253.

128. *Ibid.*, pp. 267f. The passage was also cited by Millet, *Recherches*, pp. 57f.

129. Τοῦ κορυβαντιᾷν ἐκ δαιμόνων πλείστους ἀπέσπασεν· ἀλλὰ καὶ τὸ τῆς Χαναναίας θυγάτριον ὑπὸ δαιμόνων ὀχλούμενον ἐθεράπευσε. . . . ᾿Αλθαίνει τὸν τοῦ ἑκατοντάρχου παῖδα ἀπαλλάξας αὐτὸν τοῦ νοσήματος· ἀλλὰ καὶ τῷ πυρετῷ ἐπιτιμήσας σφοδρῶς τὴν πενθερὰν Σίμωνος φλέγοντι. *Homilia XLIV, De centurione*, PG, 132, cols. 828D-829A.

130. *Supra*, n. 113.

131. Matthew 8:8.

132. Matthew 15:23.

133. *Supra*, n. 111.

134. Demus, *Mosaics of Norman Sicily*, pp. 120 and 166 (n. 371); Matthew 15:28.

IV. Hyperbole

1. *Iliad*, 10, line 437.

2. Ὑπερβολή ἐστι φράσις ὑπερβαίνουσα τὴν ἀλήθειαν αὐξήσεως χάριν, ὡς ὅταν τις τὸν γοργῶς τρέχοντα εἴπῃ, ὅτι τρέχει ὡς ὁ ἄνεμος· ἢ ὑπερβολή ἐστι λόγος ὑπεραίρων τὴν ἀλήθειαν ἐμφάσεως ἢ ὁμοιώσεως ἕνεκα. Ἐμφάσεως, οἷον "ἄκρον ἐπ' ἀνθερίκων καρπὸν θέον οὐδὲ κατέκλων" . . . ἐμφαίνουσι γὰρ τὸ λίαν ἐν τῷ τρέχειν μετέωρον. L. Spengel, *Rhetores graeci* III (Leipzig, 1856), 252f. Other treatises that cite Homer's description of the horses of King Rhesus include the handbooks attributed to Tryphon (*ibid.*, p. 199) and Gregory of Corinth (*ibid.*, p. 222).

3. The sermon is attributed to Methodius in PG, 18, cols. 348-81. On the date, see R. Laurentin, "Bulletin sur la Vierge Marie," *Revue des sciences philosophiques et théologiques*, 52 (1968), 540.

4. A. Ehrhard listed nineteen manuscripts; *Überlieferung und Bestand der hagiographischen und homiletischen Literatur der griechischen Kirche*, part I, vol. I (Leipzig, 1937), 186, 189, 357, 568; vol. II (1938), 8, 14, 51, 80, 120, 122, 125, 136, 196, 198, 201; and vol. III (1943), 105, 234, 504, 512.

5. Ὅθεν ἀπεκδυσάμενος τὸ ἄτονον τῆς ἡλικίας ὁ πρεσβύτης Συμεών, καὶ τὸ εὔτονον τῆς ἐλπίδος ἐπενδυσάμενος, ἀπολαβεῖν ἔσπευδεν εἰς πρόσωπον τοῦ νόμου τὸν τοῦ νόμου πάροχον. . . . Ὅλος γέγονε τῆς ἐφέσεως· ὅλος γέγονε τῆς ἐλπίδος· ὅλος γέγονε τῆς χαρᾶς. . . . Τὸ Πνεῦμα τὸ ἅγιον εὐηγγελίσατο, καὶ πρὶν ἢ κατειληφέναι τὸν ναόν, τοῖς τῆς διανοίας ὀφθαλμοῖς ἀναπτερούμενος, ὡς ἔχων ἤδη τὸ ποθούμενον ἐγεγήθει. . . . καὶ μετεωροπορῶν τοῖς διαβήμασιν ὠκυτάτως, τὸν πάλαι ἱερὸν καταλαμβάνει σηκόν, καὶ . . . τῷ τοῦ ἱεροῦ πρυτάνει τὰς ἱερὰς ὠλένας ἐφήπλωσε. *Sermo de Symeone et Anna*, PG, 18, cols. 360C-361A.

6. *Ibid.*, col. 364A.

7. *Oratio in Symeonem*, PG, 86, cols. 237-52. On the date and authorship, see M. Jugie, *La mort et l'assomption de la Sainte Vierge*, Studi e testi 114 (Vatican, 1944), 71; H.-G. Beck, *Kirche und theologische Literatur im byzantinischen Reich* (Munich, 1977), p. 400.

8. "Ἐξεγείρου, πρεσβῦτα, τί καθεύδεις; . . . βάδιζε θᾶττον· ἦλθεν ὁ ἀπολύων σε. . . ." Ἔνθεν ὁ Συμεὼν ἀνακαινισθεὶς τῷ ὀξυτάτῳ τῆς ἐπιθυμίας πτερῷ, ὡς ὑπὸ τοῦ Πνεύματος κουφιζόμενος, προέλαβεν τὸν Ἰωσὴφ καὶ τὴν Παρθένον εἰς τὸ ἱερόν . . . καὶ προλαβὼν ἔστη πλησίον τῶν θυρῶν περιμένων τὴν ἀποκάλυψιν τοῦ ἁγίου Πνεύματος. Ἐν δὲ τῷ ἱερῷ ὁ Συμεὼν καταστὰς ἑώρα μὲν πολλὰς μητέρας μετὰ τῶν ἰδίων νηπίων εἰσιούσας εἰς τὸ ἱερὸν τὴν θυσίαν τῶν καθαρσίων ἐκτελέσαι, μεθ' ὧν ἀνὰ μέσον ἦν καὶ ἡ τὸν ἀκοινώνητον τόκον βαστάζουσα. Ὁ δὲ Συμεὼν ὧδε κἀκεῖσε τὰς ὄψεις περιφέρων, ὡς ἑώρα πολλὰς μητέρας ἐν τῷ ἰδιωτικῷ τῆς ἀνθρωπότητος σχήματι, μόνην δὲ τὴν Παρθένον ἀπείρῳ καὶ Θεϊκῷ φωτὶ περιτειχισθεῖσαν, καταδραμὼν ὁ Συμεών, ἐχώρισεν τὰς λοιπὰς μητέρας κράζων ἐπὶ πάντων· "Δότε μοι τόπον, ἵνα κατάσχω τὸν ποθούμενον." *Oratio in Symeonem*, PG, 86, cols. 241B-244A.

9. *Homilia in occursum Domini*, PG, 28, cols. 973-1000; on the attribution, see H. Maguire, "The Iconography of Symeon with the Christ Child in Byzantine Art," *DOP*, 34 (1980).

10. *In SS. Mariam assistentem cruci*, PG, 100, cols. 1457-89. On the influence of this sermon on Byzantine art, see R. Cormack, "Painting after Iconoclasm," in *Iconoclasm*, edited by A. Bryer and J. Herrin (Birmingham, 1977), p. 153, and H. Maguire, "The Depiction of Sorrow in Middle Byzantine Art," *DOP*, 31 (1977), 162ff.

11. Δὸς τοιγαροῦν τῷ γήρᾳ Χεῖρα, Παράκλητε, δός. Ὑπόθες μοι τὴν παρὰ σοῦ Χάριν, ὑπόθες. Τὸ γὰρ σῶμά μοι κέκμηκεν ἤδη, καὶ βαδίζειν ἐξατονεῖ. Βάστασον αὐτός, ὦ φύσις παντουργὲ καὶ ἀκάματε, βάστασόν με τὸν ἀσθενῆ, τὸν γέροντα, καὶ πρὸς ἐκεῖνα τὸ τάχος ἀπάγαγε. Ἐὰν γὰρ θελήσω ποσὶν οἰκείοις πρὸς βάδισιν χρήσασθαι, χρονίζω πάντως ἐν τῇ ὁδῷ, κἀκεῖνα παρέρχεται, καὶ οὐ θεωρῶ αὐτά. Καὶ οἴ μοι τῶν σκυθρωπῶν, εἰ ξένος τούτων γενήσομαι, ὧν τὰς ἐμφάσεις πόρρωθεν ἔλαβον! *Homilia in occursum Domini*, PG, 28, col. 985B-C.

12. Ὦ τοῦ θαύματος. Οὐδὲ ποσὶν οἰκείοις πρὸς τὴν τοῦ μυστηρίου διακονίαν κέχρηται· ἅρμα δὲ τούτῳ τὸ Πνεῦμα τὸ ἅγιον γίνεται καὶ οἷον ὑπόπτερόν τινα, καὶ αἰθεροδρόμον Ἀμβακοὺμ ἄλλον, πρὸς τὸν ναὸν εἰσάγει. *Ibid.*, col. 984D.

13. ἡ δὲ μικρὸν μὲν ἐπέσχεν· οὐ γάρ πω σαφῶς ᾔδει τὴν ἐν Πνεύματι πρὸς τὸ ἱερὸν τοῦ γέροντος ἄφιξιν· ἔπειτα δ᾽, ὡς τὸ θεῖον βρέφος ταῖς ταύτης ἀγκάλαις ἑώρα περισκιρτῶν καὶ πρὸς τὰς ἐκείνου παλάμας παρεκπηδῆσαι φιλονεικοῦν, θᾶττόν τε γινώσκει τοῦ μυστηρίου τὴν δύναμιν· καὶ τῷ πρεσβύτῃ χειραπλοῦντι τοῦτο προσεπιδίδωσι· *Ibid.*, cols. 985D-988A.

14. Ἰσχύσατε, χεῖρες Συμεὼν
 τῷ γήρᾳ ἀνειμέναι, καὶ κνῆμαι
 παρειμέναι δὲ Πρεσβύτου
 εὐθυβόλως κινεῖσθε
 Χριστοῦ πρὸς ὑπαντήν.
W. Christ and M. Paranikas, *Anthologia graeca carminum christianorum* (Leipzig, 1871), p. 173; *Mēnaia tou holou eniautou* III (Rome, 1896), 482.

15. For a different identification of the mosaic, see Suzanne Spain, "The Promised Blessing: the Iconography of the Mosaics of S. Maria Maggiore," *Art B*, 61 (1979), 535f.

16. B. Brenk, *Die frühchristlichen Mosaiken in S. Maria Maggiore zu Rom* (Wiesbaden, 1975), 19ff. D. C. Shorr, "The Icon-

ographic Development of the Presentation in the Temple," *Art B*, 28 (1946), 20.

17. C. Caprino et al., *La colonna di Marco Aurelio* (Rome, 1955), p. 98, pl. 30, fig. 61.

18. C. L. Striker and Y. D. Kuban, "Work at Kalenderhane Camii in Istanbul: Third and Fourth Preliminary Reports," *DOP*, 25 (1971), 256, fig. 11.

19. See the description of the mosaic by E. Kitzinger, *Byzantine Art in the Making* (London, 1977), p. 116.

20. See, for example, the Presentation scene on an ivory diptych in Milan, in which Symeon stands motionless; A. Goldschmidt and K. Weitzmann, *Die byzantinischen Elfenbeinskulpturen* II (Berlin, 1934), 37, pl. 18.

21. F. Stohlman, *Gli smalti del Museo Sacro Vaticano* (Rome, 1939), pp. 16ff., 47f., pls. 24ff.

22. Νῦν δὲ ἀνὴρ τρυχόμενος ὑπὸ γήρως τὸ νήπιον ἀγκαλίζεται· ἔννοιά σοι, τοῦτον θεωμένῳ, παρίσταται μάχης γήρους καὶ νεανικῆς προθυμίας, ᾗ τὸν πρεσβύτην ἐκ περιχαρείας εἰσέρχεται· δι᾽ ἥν, καίτοι σπεύδων λαθεῖν τὸ βαρὺ γῆρας καὶ ὡς ἔχει τάχους, εἰς ὑποδοχὴν τοῦ βρέφους τὰς χεῖρας ἁπλῶν, ὅμως ἐλέγχεται τῆς προθυμίας ἔχων αὐτὰς ἀτονωτέρας. Sermon 34, edited by Akakios, *Leontos tou Sophou, panēgyrikoi logoi* (Athens, 1868), p. 277; translated by C. Mango, *The Art of the Byzantine Empire, 312-1453* (Englewood Cliffs, N.J., 1972), p. 204.

23. MS. gr. 183, page 8; D. K. Treneff and N. P. Popoff, *Miniatures du ménologe grec du XIme siècle No. 183 de la bibliothèque synodale à Moscou* (Moscow, 1911), p. 6, pl. II, 2.

24. V. Lazarev, *Old Russian Murals and Mosaics* (London, 1966), fig. 101. The church was destroyed in the Second World War.

25. V. J. Đurić, *Sopoćani* (Leipzig, 1967), pl. 12.

26. G. and M. Sotiriou, *Icones du Mont Sinaï* I (Athens, 1956), pl. 209, and II (Athens, 1958), pp. 189f.

27. M. Restle, *Die byzantinische Wand-*

malerei in Kleinasien II (Recklinghausen, 1967), fig. 12.

28. On the date, see O. Demus, *The Mosaics of Norman Sicily* (London, 1949), pp. 46ff., and E. Kitzinger, "The Mosaics of the Cappella Palatina in Palermo," *Art B*, 31 (1949), 286f.

29. Demus, *Mosaics of Norman Sicily*, p. 214.

30. It occurs in the tenth century at El Nazar; *supra*, n. 27. In the late thirteenth century, the Presentation was painted on either side of the arch opening into the sanctuary of the monastery church at Arilje; G. Millet, *La peinture du moyen âge en Yougoslavie* II (Paris, 1957), pls. 68 (1), 73 (1).

31. The mosaics of both Symeon and the angel have been restored, the angel at the end of the eighteenth century and Symeon at the end of the nineteenth century; see Demus, *Mosaics of Norman Sicily*, pp. 34 and 63 nn. 83 and 85. It is, of course, possible that the restorers invented the detail of the foot overlapping the frame. However, this distinctive feature occurs in two figures that underwent independent restorations separated by one hundred years; this strongly suggests that the protruding foot reproduces the design of the original mosaics.

32. τὴν φύσιν ἄνθρωπος, ἀλλὰ τὴν ἀρετὴν ἄγγελος. . . . ἄνθρωπος ἀνθρώποις μὲν τῇ σαρκὶ συναναστρεφόμενος, ἀγγέλοις δὲ τῷ πνεύματι συμπολιτευόμενος· *Homilia in occursum Domini*, PG, 28, col. 981C.

33. On the foundation, see Demus, *Mosaics of Norman Sicily*, p. 74. On the relationship between the Presentation mosaics in the Palace Chapel and in the Martorana, see Kitzinger, "Mosaics of the Cappella Palatina," 286 n. 107.

34. Demus, *Mosaics of Norman Sicily*, 80, pl. 49f.

35. Vatican Library, MS. gr. 1633; Ehrhard, *Überlieferung* II, 134ff.

36. Messina, University Library, MS. gr. 63; Ehrhard, *Überlieferung* II, 189ff.

V. Lament

1. . . . τέχνη . . . τὰ τῆς ψυχῆς τυποῦσα ταῖς ὕλαις πάθη. Edited by E. Miller, *Manuelis Philae carmina* I (Paris, 1855), 11, no. 25.

2. See M. Alexiou, *The Ritual Lament in Greek Tradition* (Cambridge, 1974), pp. 133, 165.

3. *Iliad*, 24, lines 723-30.

4. *Ibid.*, lines 731-39.

5. Οὐ γάρ τίς μοι ἔτ' ἄλλος ἐνὶ Τροίῃ εὐρείῃ/ ἤπιος οὐδὲ φίλος, πάντες δέ με πεφρίκασιν. *Ibid.*, lines 761-75.

6. Πρῶτον μὲν οὖν μοι τἀγάθ' ἐξᾶσαι φίλον·/ τοῖς γὰρ κακοῖσι πλεῖον' οἶκτον ἐμβαλῶ. *The Daughters of Troy*, lines 472f., edited by A. S. Way, *Euripides* I (London, 1930).

7. *Ibid.*, lines 474-78.

8. *Ibid.*, lines 489-97.

9. See G. L. Kustas, *Studies in Byzantine Rhetoric* (Salonika, 1973), pp. 33, 45; H. Hunger, *Die hochsprachliche profane Literatur der Byzantiner* I (Munich, 1978), 108ff.

10. Edited by R. Foerster, *Libanii opera* VIII (Leipzig, 1915), 379-81.

11. *Ibid.*, pp. 391-94.

12. *Ibid.*, pp. 417-19.

13. *Ibid.*, pp. 419-21.

14. Ed. C. Walz, *Rhetores graeci* I (Stuttgart, 1832), 471-73, 476-77, 477-80, 499-501, 506-508, 513-19.

15. *Ibid.*, pp. 477-80.

16. *Ibid.*, pp. 499-501.

17. Καὶ διαιρήσεις ἀντὶ κεφαλαίων τοῖς τρισὶ χρόνοις, ἐνεστῶτι, παρῳχηκότι καὶ μέλλοντι. *Progymnasmata*, edited by H. Rabe (Leipzig, 1926), p. 35, lines 13f.

18. Τίνας ἂν εἴποι λόγους Νιόβη κειμένων τῶν παίδων. *Ibid.*, p. 35, lines 15f.

19. Οἵαν ἀνθ' οἵας ἀλλάσσομαι τύχην ἄπαις ἡ πρὶν εὔπαις δοκοῦσα; *Ibid.*, p. 35, lines 17f.

20. Πρὶν εἰς πεῖραν ἀφικέσθαι Λητοῦς ζηλωτοτέρα μήτηρ ὑπῆρχον. *Ibid.*, p. 36, lines 9f.

21. Ποῖ τράπωμαι; Τίνων ἀνθέξομαι; Ποῖος ἀρκέσει μοι τάφος πρὸς ὅλων παίδων κειμένων ὄλεθρον; Ibid., p. 36, lines 14f.

22. Ἀρξόμεθα οὖν ἀπὸ τοῦ ἐνεστῶτος, καὶ ἀναδραμούμεθα ἐπὶ τὸν παρεληλυθότα χρόνον, εἶτ᾽ ἐκεῖθεν πάλιν ἀναστρέψομεν ἐπὶ τὸν ἐνεστῶτα· οὐ γὰρ ἀμέσως ἥξομεν ἐπὶ τὸν μέλλοντα, ἀλλὰ μνημονεύσομεν διὰ βραχέων τῶν ἐνεστώτων, καὶ οὕτως ἐξετάσομεν τὰ μέλλοντα. Οἷον ἡ ἠθοποιΐα, ποίους ἂν εἴποι λόγους Πηλεύς, τὸν θάνατον ἀκούσας τοῦ Ἀχιλλέως; Οὐκ εὐθὺς ἀναμνησθήσεται τῆς παλαιᾶς εὐδαιμονίας, ἀλλὰ πρότερον θρηνήσας τὴν παροῦσαν τύχην, ἀντιπαραθήσει τὰ πάλαι αὐτῷ συμβεβηκότα ἀγαθά, τὸν γάμον τῆς θεᾶς, τὴν παρὰ τῶν θεῶν τιμήν, τὰς πολλὰς ἀριστείας, εἶτα δὲ δακρύσει τὰ νῦν προστιθείς, οἷα ἐξ οἵων αὐτὸν περιέστηκε, καὶ οὕτως οἷον μαντεύσεται, πόσοις εἰκὸς αὐτὸν περιπεσεῖν κακοῖς δι᾽ ἐρημίαν τοῦ βοηθήσοντος. Progymnasmata, edited by J. Felten (Leipzig, 1913), p. 65, lines 16ff.

23. Χρὴ δὲ τὴν ἀπαγγελίαν κομματικωτέραν εἶναι μᾶλλον . . . ἴδιον δὲ καὶ χαιρόντων καὶ θρηνούντων τὸ συντόμως καὶ διὰ βραχέων ἕτερα ἐφ᾽ ἑτέροις ἐπάγειν. Ibid., p. 66, lines 9ff.

24. See L. Méridier, L'influence de la seconde sophistique sur l'oeuvre de Grégoire de Nysse (Paris, 1906), pp. 226, 252, 272f.; M. Guignet, Saint Grégoire de Nazianze et la rhétorique (Paris, 1911), pp. 286ff.; J. Soffel, Die Regeln Menanders für die Leichenrede in ihrer Tradition dargestellt, herausgegeben, übersetzt und kommentiert, Beiträge zur klassischen Philologie 57 (Meisenheim am Glan, 1974).

25. Edited by L. Spengel, Rhetores graeci III (Leipzig, 1856), 434-37.

26. Ibid., pp. 413-18.

27. Ibid., pp. 418-22.

28. T. Viljamaa, Studies in Greek Encomiastic Poetry of the Early Byzantine Period (Helsinki, 1968), pp. 21, 118.

29. Ed. Spengel III, 434, lines 11ff.

30. Ibid., p. 435, lines 16ff.

31. Ὦ γένος λαμπρὸν καὶ εὐδόκιμον ἄχρι τῆς παρούσης ὥρας, κομᾷς μὲν ἐπὶ χρυσῷ καὶ ὄλβῳ καὶ εὐγενείᾳ τῇ θρυλουμένῃ, ἀλλ᾽ ἅπαντα συνέχεεν καὶ ἀνεσκεύασεν ὁ πεσών. Ibid., p. 435, lines 30ff.

32. Εἶτα μετὰ τοὺς τρεῖς χρόνους διαγράψεις τὴν ἐκφοράν, τὴν σύνοδον τῆς πόλεως. . . . Εἶτα διατυπώσεις τὸ εἶδος τοῦ σώματος, οἷος ἦν ἀποβεβληκὼς τὸ κάλλος, τὸ τῶν παρειῶν ἐρύθημα, οἷα γλῶττα συνέσταλται, οἷος ἴουλος ἐφαίνετο μαρανθείς, οἷοι βόστρυχοι κόμης οὐκέτι λοιπὸν περίβλεπτοι, ὀφθαλμῶν δὲ βολαὶ καὶ γλῆναι κατακοιμηθεῖσαι, βλεφάρων δὲ ἕλικες οὐκέτι ἕλικες, ἀλλὰ συμπεπτωκότα πάντα. Ibid., p. 436, lines 11ff.

33. Ibid., p. 420, lines 9ff.

34. Εἶτα μετὰ τὸ γένος τὰ περὶ τὴν γένεσιν αὐτοῦ ἐρεῖς· ὦ ματαίων μὲν ἐκείνων συμβόλων, ματαίων δὲ ὀνειράτων ἐπ᾽ ἐκείνῳ φανέντων ὅτε ἐτίκτετο . . . ὁ δεῖνα δὲ προεφήτευσεν αὐτὰ κάλλιστα, τῶν δὲ οἰκείων καὶ τῶν φίλων εὔελπις ἦν ἕκαστος, ἔθυον δὲ θεοῖς γενεθλίοις, βωμοὶ δὲ ἡμάττοντο, ἦγε δὲ πανήγυριν ὁ σύμπας οἶκος· δαίμων δέ, ὡς ἔοικεν ἐπετώθασε τοῖς γινομένοις . . . κρείττους εἶχον ἐν τούτῳ τὰς ἐλπίδας οἱ τρέφοντες. Ἀλλ᾽ οἴμοι τῶν κακῶν, καὶ τοίνυν οὗτος ἀνήρπασται. Ibid., p. 419, lines 24ff.

35. See Méridier, L'influence de la seconde sophistique, p. 271.

36. Χήρα . . . ἦν τοῦ τεθνηκότος ἡ μήτηρ. . . . Τί γάρ ἐστι τὸ λεγόμενον; ὅτι οὐκ ἦν αὐτῇ παιδοποιΐας ἐλπίς, τὴν ἐπὶ τῷ ἐκλείποντι συμφορὰν θεραπεύουσα· χήρα γὰρ ἡ γυνή. De hominis opificio, PG, 44, cols. 218D-220A.

37. Μόνον ἐν ὠδῖσιν ἐκεῖνον ἐγνώρισε, μόνον ταῖς θηλαῖς ἐτιθηνήσατο· μόνος αὐτῇ φαιδρὰν ἐποίει τὴν τράπεζαν· μόνος ἦν τῆς κατὰ τὸν οἶκον φαιδρότητος ἡ ὑπόθεσις· παίζων, σπουδάζων, ἀσκούμενος, φαιδρυνόμενος, ἐν προόδοις, ἐν

παλαίστραις, ἐν συλλόγοις νεότητος·
Ibid., col. 220A.

38. Ἤδη τοῦ γάμου τὴν ὥραν ἄγων, ὁ
τοῦ γένους ὄρπηξ, ὁ τῆς διαδοχῆς κλάδος,
ἡ βακτηρία τοῦ γήρους. *Ibid.*

39. Ἀλλὰ καὶ ἡ τῆς ἡλικίας προσθήκη,
ἄλλος θρῆνος ἦν. Ὁ γὰρ νεανίαν εἰπών,
τὸ ἄνθος εἶπε τῆς μαρανθείσης ὥρας,
ἄρτι τοῖς ἰούλοις ὑποχλοάζοντα, οὔπω
τοῦ πώγωνος διὰ βάθους ὑποπιμπλάμενον,
ἔτι τῷ κάλλει τῶν παρειῶν ὑποστίλβοντα.
Ibid., col. 220B.

40. *Homilia VI*, 5-6; edited by G. Rossi
Taibbi, *Filagato da Cerami, Omelie per i van-
geli domenicali e le feste di tutto l'anno* I
(Palermo, 1969), 38f.

41. See M. Alexiou, "The Lament of the
Virgin in Byzantine Literature and Modern
Greek Folk-Song," *Byzantine and Modern
Greek Studies*, 1 (1975), 111-40; B. Bouvier,
*Le mirologue de la Vierge, chansons et
poèmes grecs sur la Passion du Christ* I, *La
chanson populaire du vendredi saint*, Bi-
bliotheca Helvetica Romana 16 (Rome, 1976).

42. *Oratio in Symeonem*, PG, 86, cols.
237-52. On the date and authorship, see
Chapter IV n. 7.

43. *Oratio in Symeonem*, PG, 86, col. 248.

44. Οἴμοι τῆς συμφορᾶς, ὅτε τὴν
εὐπορίαν προσεδόκησα, τότε τὴν ζημίαν
κατενόησα. Οἴμοι, τίς ὁ συλήσας τὸν
θησαυρόν; τίς ὁ ἀποβουκολήσας μου τὸ
κειμήλιον; τίς ὁ κατακρύψας μου τὴν
ἐλπίδα; *Ibid.*, col. 249A.

45. Οἴμοι οὐκέτι, "Εὐλογημένη ἐν γυ-
ναιξίν," ἀκούσω· οὐκέτι ἐροῦσιν αἱ
λέγουσαι, "Μακαρία ἡ κοιλία ἡ
βαστάσασά σε·" ἐμαράνθη, οὐκ
ἐμακαρίσθην. . . . Ποῦ τοῦ ἀρχαγγέλου
Γαβριὴλ ὁ ἀσπασμός; *Ibid.*

46. ποῦ τοῦ ἀστέρος ὁ φωτισμός; ποῦ
τῶν μάγων ἡ προσκύνησις; ποῦ τῶν
ποιμένων τὰ σκιρτήματα; ποῦ ἡ τῶν
ἀγγέλων δοξολογία; ὅτε βασιλεύειν
προσεδόκησα, τότε ἐν πτωχείᾳ κατα-
λέλειμμαι. *Ibid.*

47. In SS. Mariam assistentem cruci, PG,
100, cols. 1457-89.

48. A. Ehrhard, *Überlieferung und Be-
stand der hagiographischen und homile-
tischen Literatur der griechischen Kirche*,
part I, vol. I (Leipzig, 1937), 216; vol. II
(1938), 24, 26, 123, 284, 298; vol. III (1943),
98, 283.

49. MS. Ottob. gr. 14, fols. 214-17; E.
Feron and F. Battaglini, *Codices manuscripti
graeci Ottoboniani Bibliothecae Vaticanae*
(Rome, 1893), p. 18; A. Ehrhard, *Über-
lieferung* I, 216.

50. D. I. Pallas, *Die Passion und Bestat-
tung Christi in Byzanz, der Ritus - das Bild*,
Miscellanea Byzantina Monacensia 2 (Mu-
nich, 1965), 30, 56, 106. On the dating of the
typikon, see G. Bertonière, *The Historical
Development of the Easter Vigil and Related
Services in the Greek Church*, Orientalia
Christiana Analecta 193 (Rome, 1972), 168f.

51. τούτῳ περιπεσοῦσα, αὐτὸ μὲν θερ-
μοτάτοις κατέλουε δάκρυσι· πραείᾳ δὲ
φωνῇ καὶ συμπαθεστάτοις προσεφθέγγετο
ῥήμασιν. In SS. Mariam assistentem cruci,
PG, 100, col. 1488A.

52. Ἄπνουν νῦν κατέχω, ὃν πρώην ὡς
οἰκεῖον ἐνηγκαλιζόμην φίλτατον· οὗ τῶν
ἡδίστων ἐπήκουον ῥημάτων· *Ibid.*, col.
1488B.

53. Συσκυθρώπαζέ μοι, πᾶσα τερπνότης
λειμώνων. Ἰδοὺ γὰρ ὁ τοῖς ποικίλοις σε
κατακοσμήσας ἄνθεσιν, ἠτιμωμένος ἐπὶ
ξύλου κρέμαται· ὁ ταῖς μυριπνόοις
εὐχροίαις σε περικαλλύνας, ἀκαλλὴς
καὶ ἀνείδεος ἀνήρτηται τῷ ἀνθρωπίνῳ·
τὸ ἀνόθευτον κάλλος, ἡ ἀναλλοίωτος
ὡραιότης, καὶ τῆς τεκούσης διηνεκὴς
τερπνότης. *Ibid.*, col. 1472C.

54. *Homilia in occursum Domini*, PG, 28,
cols. 973-1000; see Chapter IV n. 9.

55. Τίνος χάριν τὴν ἐμὴν ψυχὴν
ἡ ῥομφαία διαδραμεῖται; Ὅτι τὸ
Σάββατον ἔλυσα; Ὅτι τὸν νόμον παρέβην;
. . . Τί τοίνυν ἐστὶν ἢ μικρὸν ἢ μεῖζον,
ὁ τοῦ νόμου παρέλυσα . . . ; Φράσον τὸ
τάχος, μήπως ὡς ὑπερβεβηκότα καὶ πολλῷ
τῷ βίῳ καταγηράσαντα ὑποπτεύωμεν.
Ibid., col. 996A.

56. *Ibid.*, col. 996C.

57. See Alexiou, "The Lament of the Vir-
gin," p. 122.

58. Vatican Library, MS. gr. 1587, fols. 73-77; C. Giannelli, *Codices Vaticani graeci, codices 1485-1683*, Bibliothecae Apostolicae Vaticanae codices manuscripti recensiti (Vatican, 1950), p. 200; A. Turyn, *Codices graeci Vaticani saeculis XIII et XIV scripti annorumque notis instructi* (Vatican, 1964), pp. 176f. The text is printed in PG, 114, cols. 209-18.

59. The manuscript is numbered gr. 508 in the Library of the Academy of the Socialist Republic of Rumania in Bucharest; A. Pignani, ''Un etopea inedita di Niceforo Basilace,'' *Bollettino del Comitato per la preparazione dell' edizione nazionale dei classici greci e latini*, n.s. 19 (1971), 131ff.

60. Τίνας ἂν εἴπῃ λόγους ἡ Θεοτόκος περιπλακεῖσα κηδευομένῳ τῷ ταύτης Υἱῷ τῷ Θεῷ καὶ Σωτῆρι Χριστῷ. *Ibid.*, p. 134.

61. Μικρὸν πρὸς τοὐναντίον μοι περιίσταται καὶ ὁ τοῦ Γαβριὴλ ἀσπασμός. Οὐ γὰρ καὶ νῦν ''ὁ Κύριος μετ' ἐμοῦ,'' καθὼς ἐκεῖνός μοι ἐπηγγείλατο· ἀλλὰ σὺ μὲν ἄπνους ἐν νεκροῖς καὶ ᾅδου ταμεῖα φοιτᾷς τὰ ἐνδότερα. PG, 114, col. 209A.

62. Ἀβλαβῶς μὲν ἐμίχθη πάλαι τὰ ἄμικτα, καὶ πῦρ θεότητος ἀΰλον, σπλάγχνον ἐμὸν οὐ κατέφλεξεν· ἄρτι δ' ἕτερον πῦρ τὰ ἐντός μου βόσκεται ἅπαντα, καὶ μέσην τὴν καρδίαν λυμαίνεται. Χαρᾶς ἐγγύας δι' ἀγγέλου παρέλαβον καὶ ἀφειλόμην δάκρυον πᾶν ἀπὸ προσώπου τῆς γῆς πλὴν ἀλλὰ τοῦτο μόνον τοῖς ἐμοῖς πιαίνεται δάκρυσιν. *Ibid.*, col. 212B-C.

63. Ὢ οἷα ἀνθ' οἵων ὁρῶ. Ἀστὴρ ἡμεροφαὴς τῷ τοκετῷ σου παρὰ τῆς σῆς ἐκαινουργήθη μεγαλειότητος . . . ἀλλὰ σήμερον καὶ αὐτὸν τὸν αἰσθητὸν ἔκρυψας ἥλιον, καὶ νύκτα ἐν ἡμέρᾳ μέσῃ παρήνεγκας. . . . Πέρσας ἐκεῖ γονυπετοῦντας ὁ ἀστὴρ μετεστείλατο, ὧδε καὶ γνωστούς τε καὶ φίλους ὁ τῶν θεοκτόνων φόβος ἀπεμακρύνατο. Ἐκεῖσε δώρων προσαγωγὴ καὶ προσκύνησις, ἐνταῦθα χιτώνων μερισμὸς καὶ χλευασμός, καὶ στέφανος ὕβρεων. *Ibid.*, col. 213D. For the

opening words, compare n. 19, above. The Virgin recalls the adoration of the Kings in two other passages of the lament; *ibid.*, cols. 209A and 213B.

64. Μόνος Νικόδημος . . . ἐμαῖς ἀγκάλαις ἐπωδύνως ἐντέθεικεν, αἵ σε καὶ πρώην ὄντα βρέφος χαρμοσύνως ἐβάστασαν. . . . Ὠλέναις μητρικαῖς ἐνεκούφιζον, ἀλλὰ σκιρτῶντα καὶ κατὰ νηπίους ἁλλόμενον. Ἀνακουφίζω σε καὶ νῦν ταῖς αὐταῖς, ἀλλ' ἄπνουν, καὶ κατὰ νεκροὺς ἀνακείμενον. Ἐνέβαπτόν μου τότε τὰ χείλη τοῖς μελιχροῖς σου καὶ δροσώδεσί σου χείλεσι. . . . Βρεφοπρεπῶς μοι πολλάκις ἐν τοῖς στέρνοις ἀφύπνωσας, καὶ νῦν νεκροπρεπῶς ἐν τούτοις κεκοίμησαι. *Ibid.*, col. 216B-C.

65. *Ibid.*, col. 212C-D.

66. *In Dominici corporis sepulturam*, PG, 98, cols 244-89; on the attribution, see H.-G. Beck, *Kirche und theologische Literatur im byzantinischen Reich* (Munich, 1977), p. 668.

67. Τὰ εὔφημά μοι, πρὸς δυσφημίαν μεταχωρεῖ, ἀδοξοῦσι τὰ ἔνδοξα· πικραίνουσι τὰ γλυκέα· λυποῦσί με τὰ χαρμόσυνα. *In Dominici corporis sepulturam*, PG, 98, col. 269D.

68. Ὡς λαμπρὸς ὁ θεμέλιος τῆς ἐν γῇ παρουσίας σου! Ὡς στυγνὸς ὁ ὄροφός σου τῆς τελευτῆς! Ἀπὸ χαρᾶς ἤρξατο, καὶ εἰς τὸ πένθιμον τελευτᾷ. Ἔφανας ἀπὸ σπηλαίου τῷ κόσμῳ, εἰς δὲ σπήλαιον δύνεις ἀπὸ τοῦ κόσμου. Εὕρηταί σοι τότε σπήλαιον, ''τόπου μὴ ὄντος ἐν τῷ καταλύματι''· καὶ νῦν ἑτέρῳ σπηλαίῳ ξενοδοχῇ μνήματος ἀπορῶν. . . . Πλὴν ὁ ἀστὴρ βασιλεῖς Περσῶν σοι παρίστα, καὶ προσεκύνουν καὶ ἐδωροφόρουν ὡς βασιλεῖ· ἄτιμα δέ σοι νῦν τὰ ἐκ στρατιωτῶν, οἳ δὲ ἀλλὰ καὶ δωροληπτήσουσι κατὰ τῆς σῆς ἀναστάσεως. *Ibid.*, col. 272B.

69. The canon is edited in *Roma e l'Oriente*, 5 (1913), 302-13.

70. It is attributed to Andrew of Crete, Theophanes, Theodore of Stoudios, Anastasios Quaestor, and Germanos, as well as to Symeon Metaphrastes. See *ibid.*, pp.

305f.; P. Canart, *Codices Vaticani graeci, codices 1745-1962* I, Bibliothecae Apostolicae Vaticanae codices manuscripti recensiti (Vatican, 1970), p. 6.

71. Pallas, *Die Passion und Bestattung Christi*, pp. 31ff.

72. Οἴμοι, Γαβριήλ,/ ποῦ τὰ εὐαγγέλια, ποῦ μου τὸ "χαῖρε," ποῦ τὸ "εὐλογημένη"; *Roma e l'Oriente*, 5 (1913), 311, verse 25.

73. Δῶρα προσήνεγκάν σοι, Δέσποτα, οἱ Περσῶν βασιλεῖς/ ὡς Θεῷ προσκυνοῦντες· νῦν δὲ ταφῆς σμυρνίσματα,/ τέκνον, ὡς θνητῷ ὁ Νικόδημος ἦγε. *Ibid.*, p. 309, verse 13.

74. Οὐ φέρω, τέκνον, ἄπνουν σε κατέχειν/ ὃν ἐθήλαζον βρέφος ἀγκάλαις μου σκιρτῶντα· *Ibid.*, p. 309, verse 14.

75. Ἀντὶ σπαργάνων, Υἱέ μου, ἐν σινδόνι εἰλήσω,/ ἀντὶ δὲ φάτνης, φῶς μου, τάφῳ θήσω σκοτεινῷ· *Ibid.*, p. 312, verse 31.

76. . . . δεῦτε φίλαι καὶ συγκλαύσατέ μοι/ τοῦ διδασκάλου σῶμα τὸ πολύαθλον· δεῦτε ἴδετε ἄφωνον στόμα,/ χείλη ἀκίνητα, μύοντας ὀφθαλμούς. . . . *Ibid.*, p. 310, verse 19.

77. Pallas, *Die Passion und Bestattung Christi*, p. 2.

78. *Ibid.*, pp. 61ff.; N. B. Tomadakes, *Eisagōgē eis tēn byzantinēn philologian*, 3rd. ed., II (Athens, 1965), 77; A. M. Talbot, *The Correspondence of Athanasius I Patriarch of Constantinople* (Washington, D.C., 1975), p. 363.

79. Stasis 2, *Triodion* (Athens, 1960), p. 421.

80. Stasis 2, *ibid.*, p. 419.

81. Ὕπτιον ὁρῶσα, ἡ πάναγνός σε, Λόγε, μητροπρεπῶς ἐθρήνει·/ Ὦ γλυκύ μου ἔαρ· γλυκύτατόν τέκνον, ποῦ ἔδυ σου/ τὸ κάλλος; Stasis 3, *ibid.*, p. 423.

82. Edited by E. Legrand in "Description des oeuvres d'art et de l'église des Saints-Apôtres de Constantinople: poème en vers iambiques par Constantin le Rhodien," *Revue des Études Grecques*, 9 (1896), 36-65. On the date of the poem, see G. Downey,

"Constantine the Rhodian, His Life and Writings," *Late Classical and Mediaeval Studies in Honor of A. M. Friend, Jr.*, edited by K. Weitzmann (Princeton, 1955), 212-21.

83. . . . Πάθος/ Χριστοῦ κατίδοις συμπαθῶς γεγραμμένον. . . . Ed. Legrand, p. 63, line 918.

84. . . . αὐτῆς δὲ μητρὸς συμπαθῶς μυρομένης/ δακρυρροούσης καὶ βοώσης ἀσχέτως· *Ibid.*, p. 64, line 944.

85. Ποῦ Γαβριὴλ ῥημάτων ὑποσχέσεις,/ ἃς εἶπε πρός με πρὶν γενέσθαι σὸν τόκον;/ ποῦ σκῆπτρα Δαβὶδ καὶ θρόνος τ' ἐπηρμένος/ μένων καθώσπερ ἥλιος σελασφόρος/ αἰῶνος ἄχρι κατελευτήτων χρόνων;/ ἕωλα πάντα καὶ μάτην λελεγμένα. *Ibid.*, p. 64, line 950ff.

86. On the iconography of the Lamentation see K. Weitzmann, "The Origin of the Threnos," in *De artibus opuscula XL, Essays in Honor of Erwin Panofsky*, edited by M. Meiss (New York, 1961), 476-90; M. G. Sotiriou, "Entaphiasmos—Thrēnos," *Deltion tēs Christianikēs Archaiologikēs Hetaireias*, Ser. 4, 7 (1973-1974), 139-48; H. Maguire, "The Depiction of Sorrow in Middle Byzantine Art," *DOP*, 31 (1977), 161ff.; T. Velmans, *La peinture murale byzantine à la fin du Moyen Âge* (Paris, 1977), pp. 102ff.

87. Velmans, *La peinture murale byzantine*, p. 104.

88. *Supra*, n. 52.

89. See T. Velmans, "Les valeurs affectives dans la peinture murale byzantine au XIIIe siècle et la manière de les representer," *L'art byzantin du XIIIe siècle, Symposium de Sopoćani* (Belgrade, 1967), p. 49; Maguire, "Sorrow in Middle Byzantine Art," pp. 161, 164, figs. 54, 75.

90. On the Vladimir Madonna, see H. P. Gerhard, *Welt der Ikonen* (Recklinghausen, 1972), pp. 76ff., and Pallas, *Die Passion und Bestattung Christi*, pp. 167ff., 310f., which lists the earlier bibliography. On the relationship between the Lamentation and the *Eleousa*, see Maguire, "Sorrow in Middle Byzantine Art," 166 n. 240a, and now H. Belting, "An Image and Its Function in the

Liturgy: The Man of Sorrows at Byzantium,"
DOP, 34 (1980).

91. *Supra*, n. 64.

92. L. Hadermann-Misguich, *Kurbinovo. Les fresques de Saint-Georges et la peinture byzantine du XIIe siècle* (Brussels, 1975), p. 104.

93. *Ibid.*, pp. 103ff.

94. *Ibid.*, figs. 48, 53, 57.

95. *Ibid.*, figs. 68, 72, 74, 78,79.

96. *Ibid.*, figs. 81ff., 88.

97. *Ibid.*, 539.

98. *Supra*, n. 68.

99. Τοῦτο ἐκεῖνο, γλυκύτατε Ἰησοῦ, τὸ τοὺς ἐκ Περσίδος ἀφιγμένους εἰς Βηθλεέμ, οὐ μόνον χρυσὸν ὡς βασιλεῖ, καὶ λίβανον ὡς Θεῷ, ἀλλὰ καὶ σμύρναν ὡς θνητῷ προσενεγκεῖν γεννηθέντι σοι. PG, 114, col. 209A.

100. *Supra*, n. 68.

101. For a discussion of the decoration of longitudinal churches, see O. Demus, *Byzantine Mosaic Decoration* (New York, 1976), pp. 62f.

102. A similar juxtaposition of the Lamentation and the Nativity was created in the church of the Hagioi Anargyroi at Kastoria, where the principal master of the Kurbinovo frescoes also worked; Maguire, "Sorrow in Middle Byzantine Art," pp. 165f. On the career of the "Kurbinovo Master," see Hadermann-Misguich, *Kurbinovo*, pp. 565 and 582f.

103. V. J. Đurić, *Byzantinische Fresken in Jugoslawien* (Munich, 1976), pp. 23f.; Velmans, *La peinture murale byzantine*, p. 167.

104. For a discussion of the motif in Byzantine Crucifixion scenes, see A. K. Orlandos, *Hē architektonikē kai hai Byzantinai toichographiai tēs Monēs tou Theologou Patmou* (Athens, 1970), pp. 219ff. The literary sources have recently been discussed in Bouvier, *Le mirologue de la Vierge*, pp. 160ff.

105. G. Millet, *Recherches sur l'iconographie de l'Évangile* (Paris, 1916 and 1960), p. 508, fig. 549; B. Kleinschmidt, *Die Wandmalereien der Basilika San Francesco in Assisi* (Berlin, 1930), pp. 20ff., fig. 4.

106. Millet, *Recherches*, p. 508, fig. 551; V. Petković and Dj. Bošković, *Manastir Dečani* (Belgrade, 1941), pl. 214.

107. See the discussions by G. Babić, "Les fresques de Sušica en Macédoine," *Cahiers archéologiques*, 12 (1962), 318ff., and by A. Grabar, *Christian Iconography: A Study of Its Origins* (Princeton, 1968), pp. 128f.

108. The only close parallel to the composition at Ohrid is a fresco at Sušica, also in Macedonia, which dates after 1282; Babić, "Les fresques de Sušica," pp. 307ff., fig. 3.

109. H. Hallensleben, *Die Malerschule des Königs Milutin* (Giessen, 1963), pp. 31ff. The well is also round in the Annunciation fresco of St. Sophia at Kiev (V. Lazarev, *Old Russian Murals and Mosaics* [London, 1966], fig. 33); in the mosaic of St. Mark's Basilica at Venice (J. H. Emminghaus, "Verkündigung an Maria," in *Lexikon der Christlichen Ikonographie*, edited by E. Kirschbaum, IV [Rome, 1972], fig. 5); in the mosaic of the Kariye Camii in Istanbul (P. A. Underwood, *The Kariye Djami* II [New York, 1966], pl. 147); in the fresco at Dečani (Petković, *Dečani*, pl. 251); and in the fresco at Mateič (G. Millet, *La peinture du moyen âge en Yougoslavie* IV [Paris, 1969], fig. 74).

110. *Supra*, n. 62.

111. Moscow, Historical Museum, MS. Add. gr. 129, fol. 87; Weitzmann, "Threnos," p. 478, fig. 2. See also the miniatures of Mount Athos, Pantocrator Monastery, MS. 61, fol. 122 (*ibid.*, fig. 1), of Paris, Bibliothèque Nationale, MS. gr. 510, fol. 30v. (*ibid.*, fig. 4), and of Leningrad, Public Library, MS. 21, fol. 8v. (*ibid.*, fig. 5).

112. Weitzmann, "Threnos," p. 484, figs. 10, 12ff.

113. *Ibid.*, p. 485, fig. 14; A. Goldschmidt and K. Weitzmann, *Die byzantinischen Elfenbeinskulpturen* II (Berlin, 1934), 75, no. 207, and pl. 68.

114. See M. Sotiriou, "Entaphiasmos—Thrēnos," pp. 144ff., figs. 49, 2-4.

115. Similar composite illustrations of the Entombment and the Lamentation can be found in the church of the Hagioi Anargyroi

at Kastoria (Hadermann-Misguich, *Kurbinovo*, fig. 76) and in a Gospel book in the British Library, MS. Harley 1810, fol. 205v. (Weitzmann, "Threnos," fig. 11).

116. *Supra*, n. 65.

117. See also the eleventh-century ivory in the Rosgarten-Museum at Constance; Weitzmann, "Threnos," fig. 10.

118. *Supra*, n. 53.

119. *Supra*, n. 81. During the Epitaphios ceremony the image of the dead Christ was strewn with flowers; see Pallas, *Die Passion und Bestattung Christi*, pp. 2f., 10 n. 22. In the fresco at Kurbinovo, however, the flowers are scattered on the hillsides, not on the corpse. This suggests that the painter derived the idea from literary metaphor rather than from liturgical practice.

Conclusion

1. See D. Summers, "Contrapposto: Style and Meaning in Renaissance Art," *Art B*, 59 (1977), 336-61, esp. p. 348 n. 61.

Index

Figures

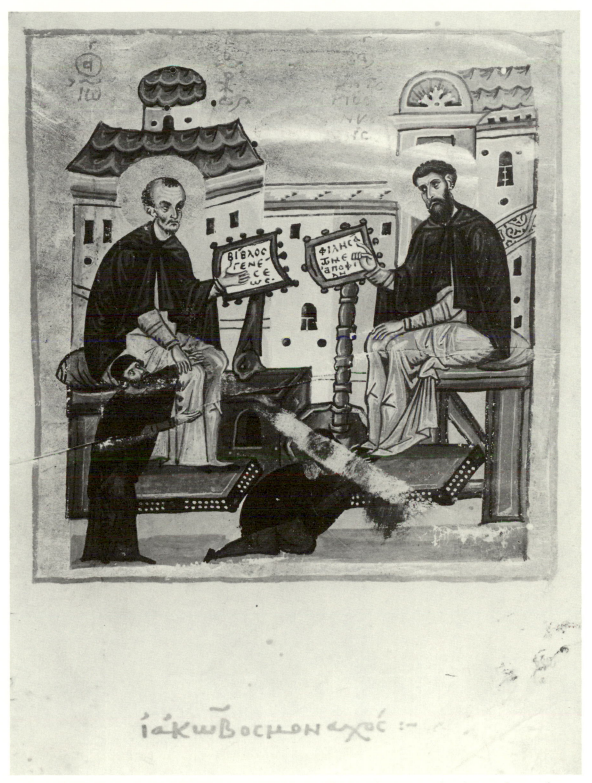

1. Paris, Bibliothèque Nationale, MS. gr. 1208, fol. 1v. The Monk James under the Guidance of St. John Chrysostom and St. Gregory of Nyssa.

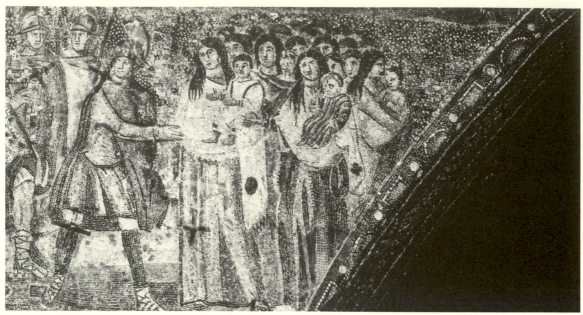

2. Rome, S. Maria Maggiore, mosaic. The Massacre of the Innocents.

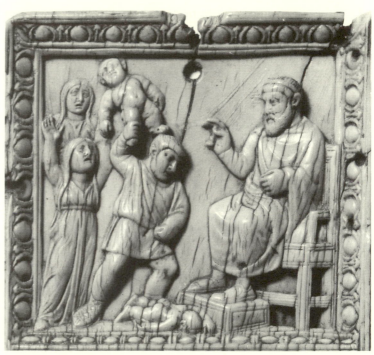

3. Berlin-Dahlem, Staatliche Museen, ivory, detail.
The Massacre of the Innocents.

4. Florence, Biblioteca Lauren-
ziana, MS. Plut. I. 56 (Rabbula
Gospels), fol. 4v., detail. The Mas-
sacre of the Innocents.

5. Bobbio, Abbey of St. Columban,
earthen medallion. The Flight of
Elizabeth.

6. Paris, Bibliothèque Nationale,
MS. gr. 510, fol. 137, detail. The
Massacre of the Innocents.

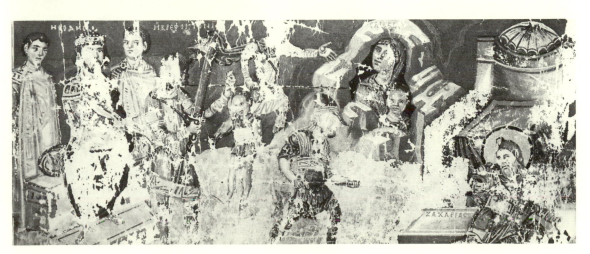

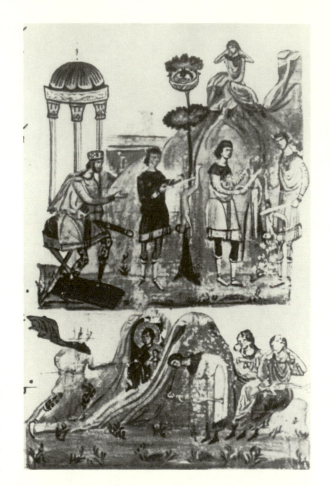

7. *Leningrad, Public Library, MS. gr. 334. The Massacre of the Innocents.*

8. *Mount Sinai, icon, detail. The Massacre of the Innocents.*

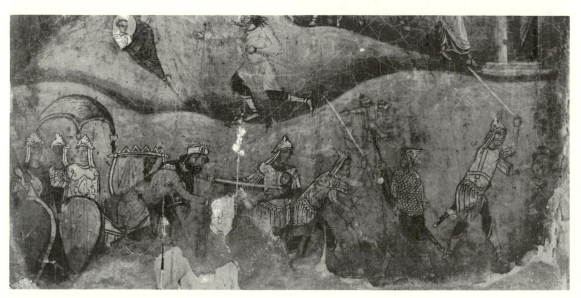

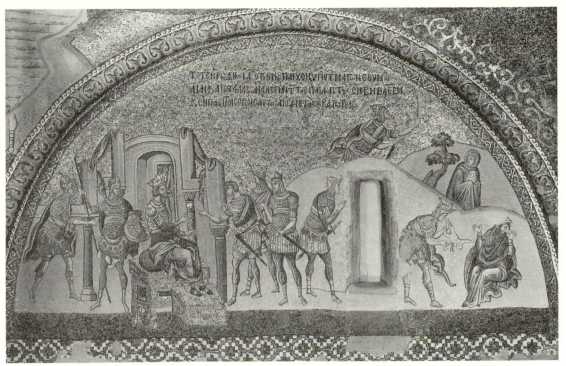

9. *Istanbul, Kariye Camii, mosaic. Herod Gives Orders for the Massacre of the Innocents.*

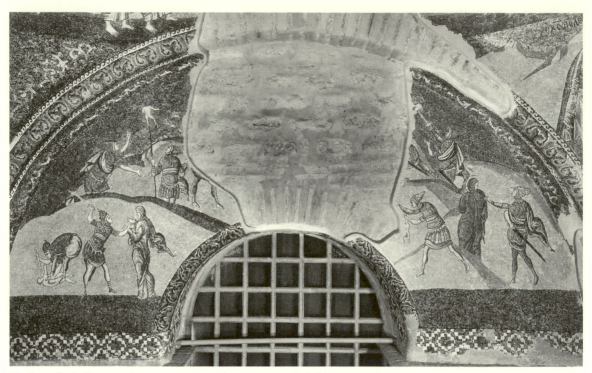

10. Istanbul, Kariye Camii, mosaic. The Massacre of the Innocents.

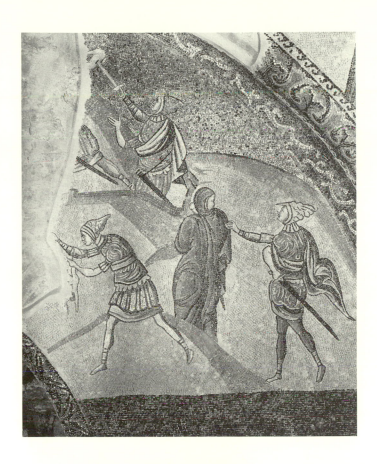

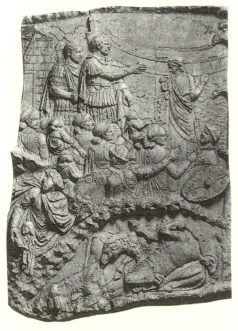

11. *Istanbul, Kariye Camii, mosaic. The Massacre of the Innocents, detail.*

12. *Rome, Trajan's Column, detail. The Taking of Dacian Captives.*

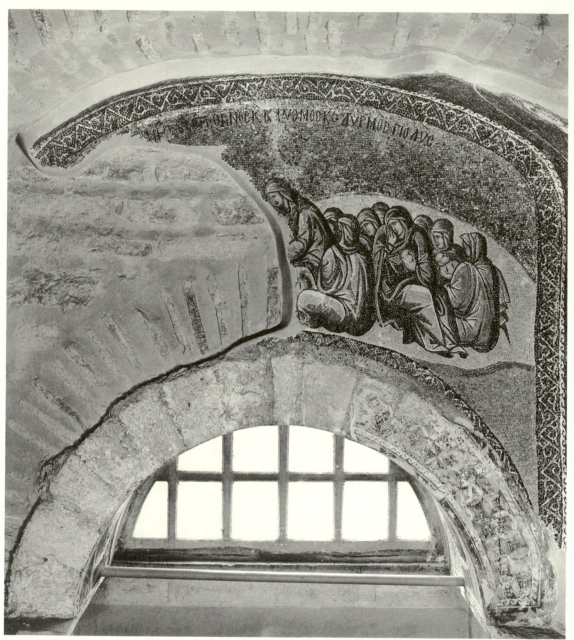

13. *Istanbul, Kariye Camii, mosaic. The Mothers Mourn Their Children.*

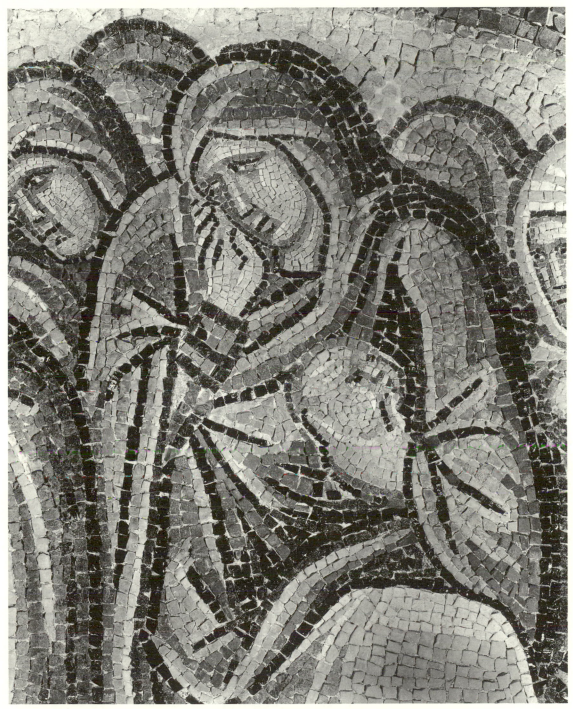

14. Istanbul, Kariye Camii, mosaic. The Mothers Mourn Their Children, detail.

15. Mistra, Church of the Brontochion, fresco. The Massacre of the Innocents, detail.

16. Mistra, Church of the Brontochion, fresco. The Massacre of the Innocents, detail.

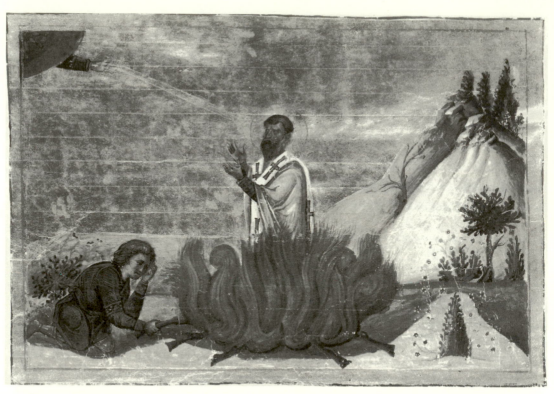

17. Rome, Biblioteca Vaticana, MS. gr. 1613, page 9. The Martyrdom of St. Aristion.

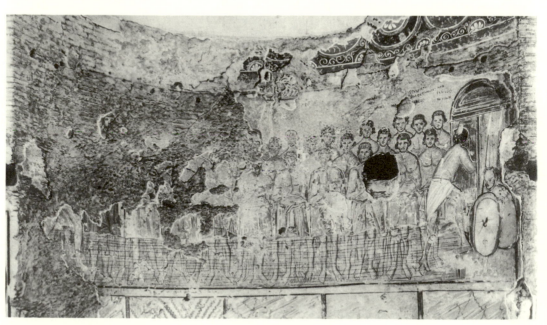

18. Rome, S. Maria Antiqua, fresco. The Forty Martyrs.

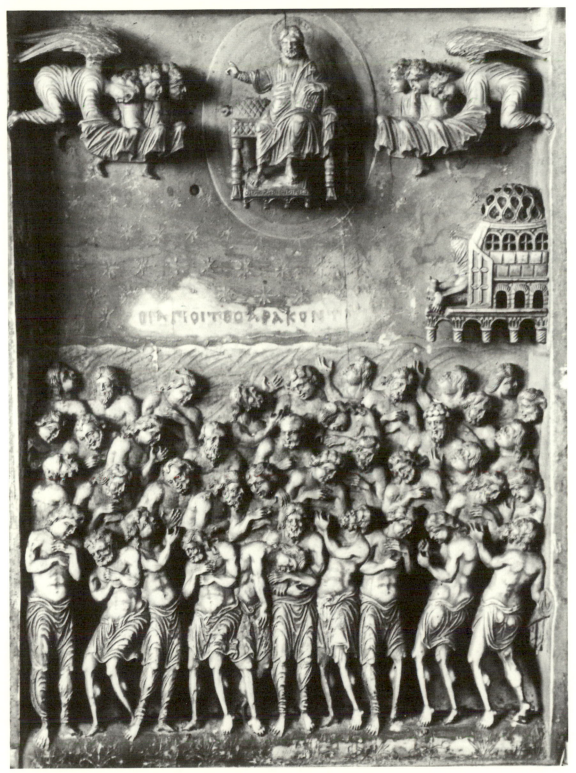

19. *Leningrad, Hermitage Museum, ivory, detail. The Forty Martyrs.*

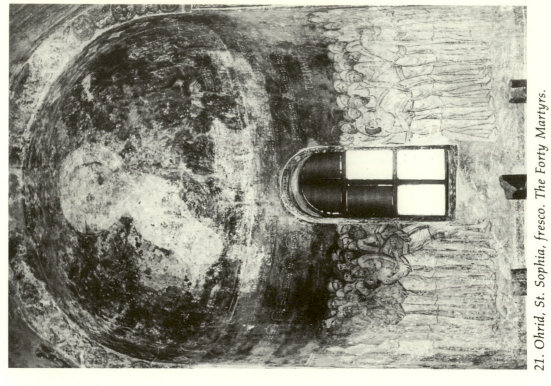

21. Ohrid, St. Sophia, fresco. The Forty Martyrs.

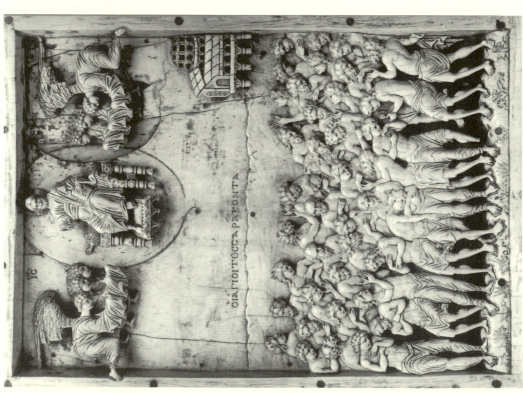

20. Berlin-Dahlem, Staatliche Museen, ivory. The Forty Martyrs.

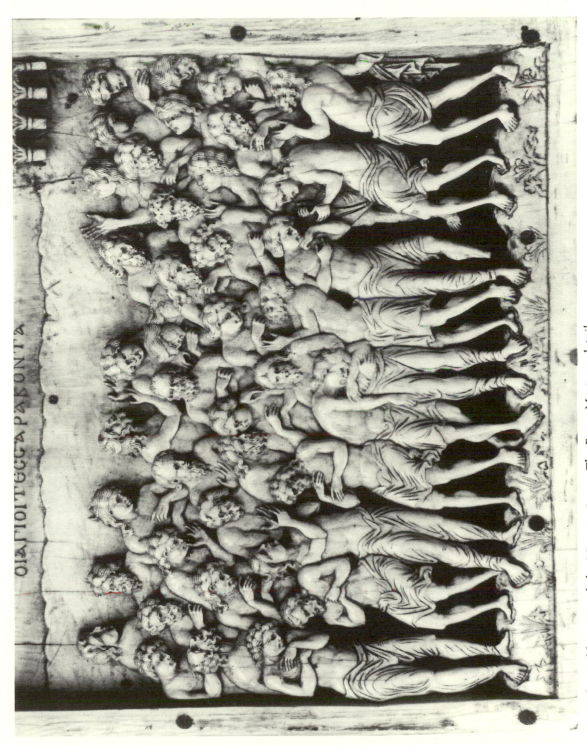

22. Berlin-Dahlem, Staatliche Museen, ivory. The Forty Martyrs, detail.

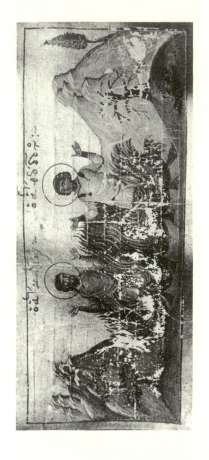

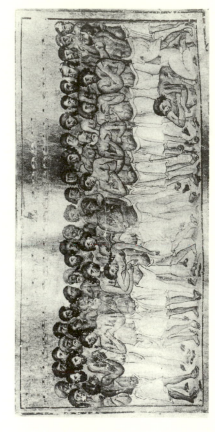

23. Asinou, Panagia Phorbiotissa, fresco. The Forty Martyrs.

24. Moscow, State Historical Museum, MS. gr. 183, page 91. Martyrdom of Saints Maximus and Theodotus.

25. Moscow, State Historical Museum, MS. gr. 183, page 179. The Forty Martyrs.

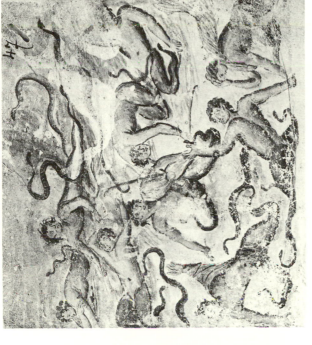

27. *Paris, Bibliothèque Nationale, MS. Suppl. gr. 247, fol. 47, detail. Giants.*

28. *Venice, Archaeological Museum, Roman sarcophagus, detail. The Slaughter of the Niobids.*

26. *Monza, Cathedral, ampulla. The Ascension.*

29. *Jerusalem, Greek Patriarchal Library, MS. Taphou, 14, fol. 33. Springtime Scenes.*

30. *Jerusalem, Greek Patriarchal Library, MS. Taphou, 14, fol. 34, detail.*
Springtime Scenes.

31. *Kastoria, Hagioi Anargyroi, fresco. The Annunciation.*

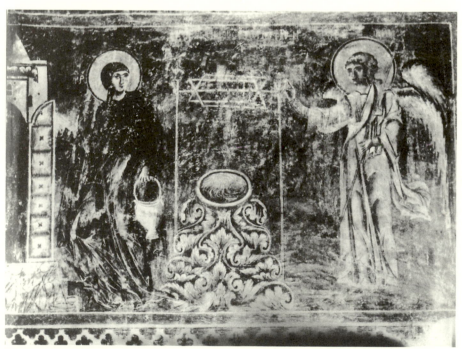

32. *Kastoria, Hagioi Anargyroi, fresco. The Annunciation by the Well.*

33. *Perachorio, Holy Apostles, fresco. The Annunciation: Gabriel.*

34. *Perachorio, Holy Apostles, fresco. The Annunciation: Mary, detail.*

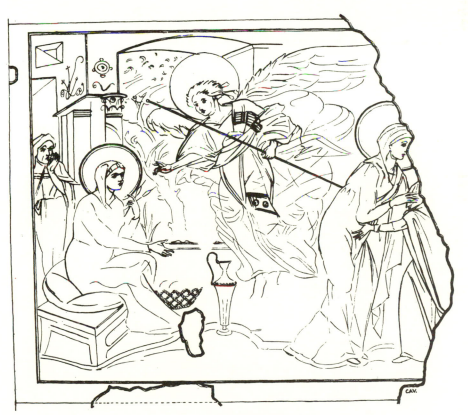

35. *Castelseprio, S. Maria, fresco. The Annunciation.*

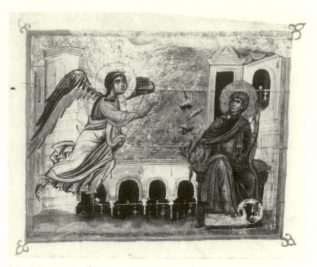

36. Mount Athos, Dionysiu Monastery, MS.
587, fol. 150. The Annunciation.

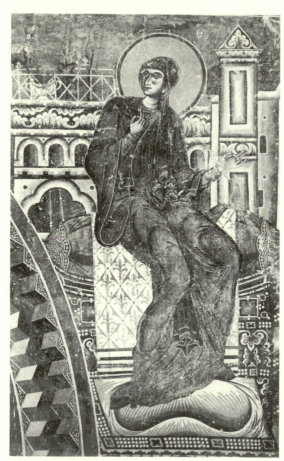

37. Kurbinovo, St. George, fresco. The An-
nunciation, detail.

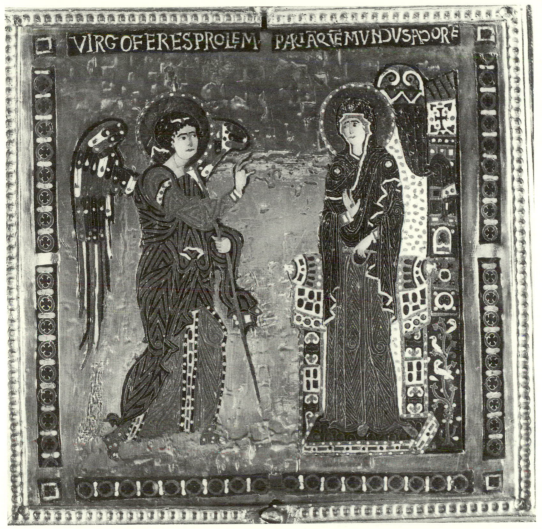

38. Venice, S. Marco, the Pala d'Oro, detail. The Annunciation.

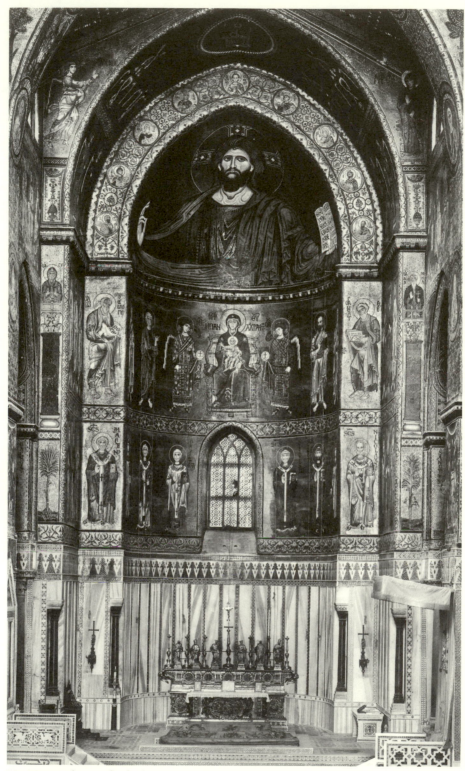

39. Monreale, Cathedral, main apse.

40. Monreale, Cathedral, mosaic. Ornament under the Virgin of the Annunciation.

41. Rome, Biblioteca Vaticana, MS. gr. 1162, fol. 3. Ornamental headpiece.

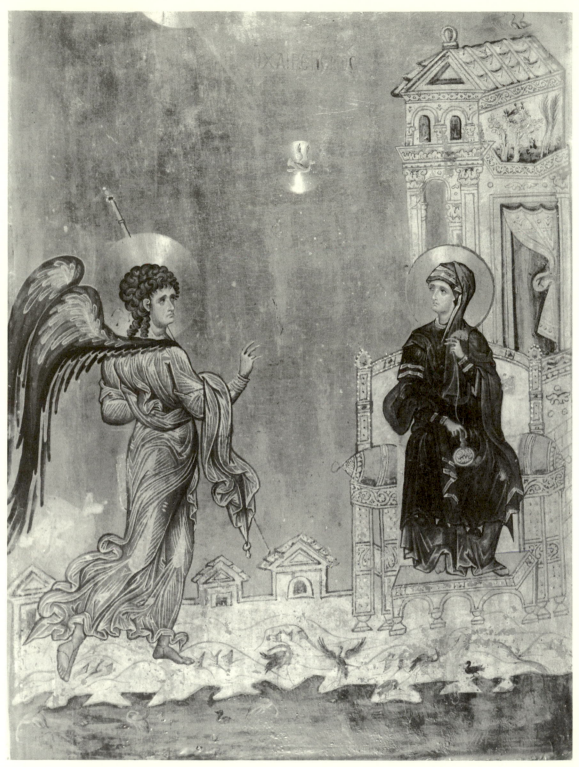

42. *Mount Sinai, icon. The Annunciation.*

43. Rome, S. Costanza, mosaics in the dome (water-color copy by F. d'Ollanda).

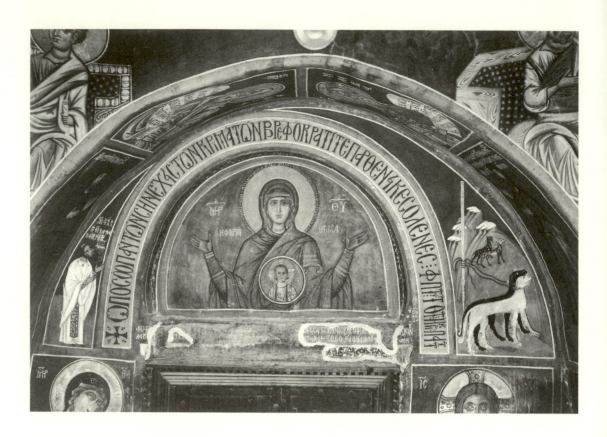

44. *Asinou, Panagia Phorbiotissa,
fresco. The Virgin and Child.*

46. *Salonika, Holy Apostles, fresco.
The Virgin and Child with the Ab-
bot Paul.*

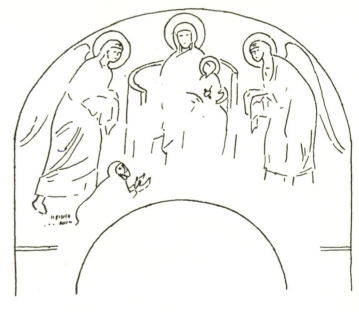

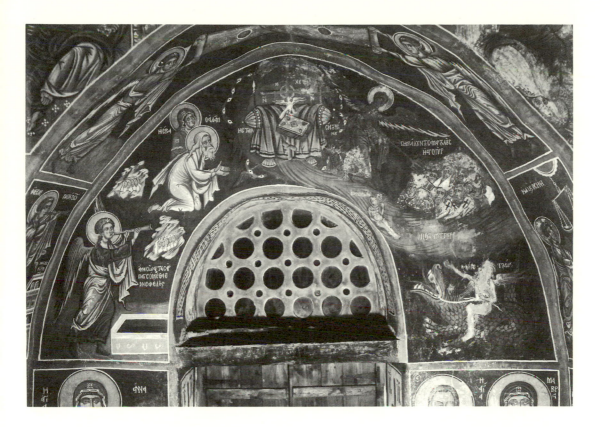

45. *Asinou, Panagia Phorbiotissa, fresco. Last Judgment Scenes.*

47. *Salonika, Holy Apostles, fresco. The Souls of the Righteous in the Hand of God.*

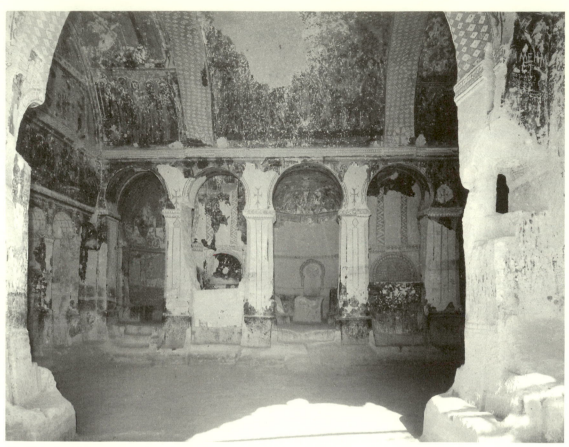

48. *Tokalı Kilise, New Church. View towards the East Wall.*

49. *Tokalı Kilise, New Church, fresco. The Dormition of the Virgin.*

50. *Tokalı Kilise, New Church, fresco. The Virgin and Child.*

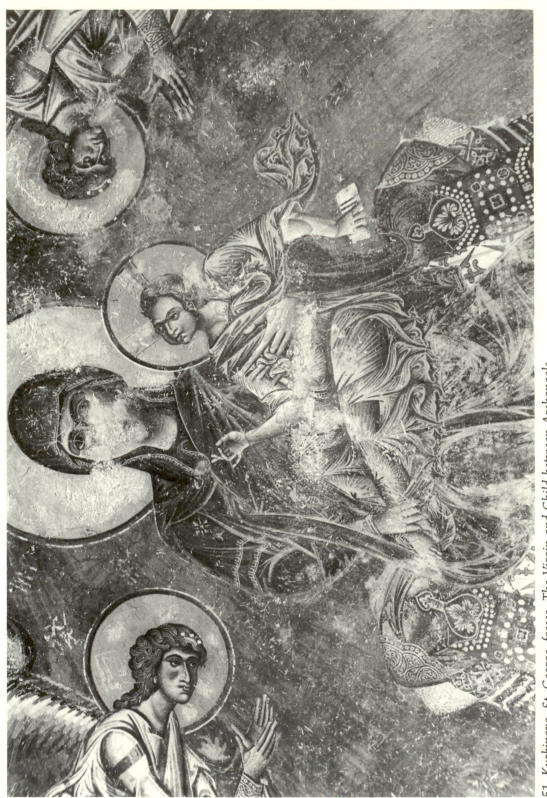

51. Kurbinovo, St. George, fresco. The Virgin and Child between Archangels.

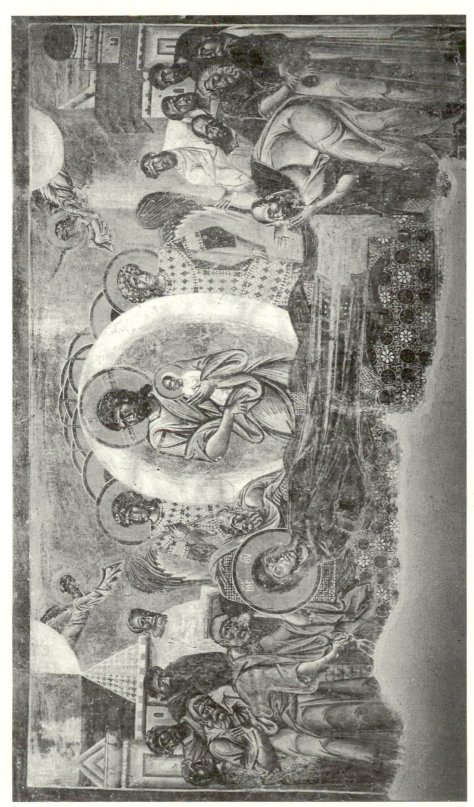

52. *Kurbinovo, St. George, fresco. The Dormition of the Virgin.*

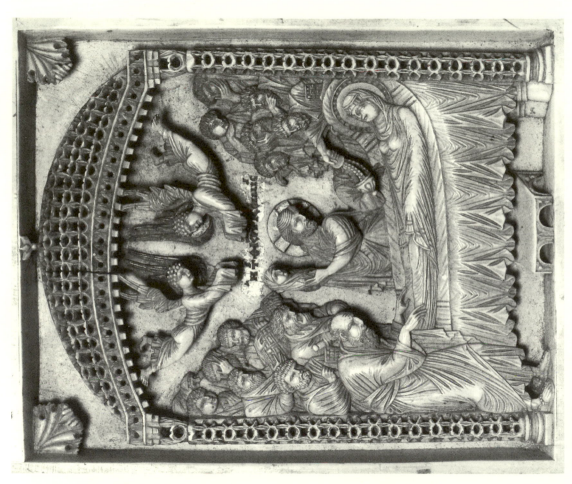

53. Munich, Staatsbibliothek, ivory. The Dormition of the Virgin.

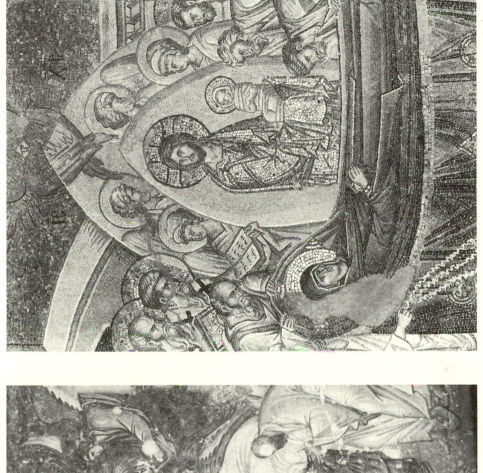

54. Sopoćani, Church of the Trinity, fresco. The Dormition of the Virgin, detail.

55. Istanbul, Kariye Camii, mosaic. The Dormition of the Virgin, detail.

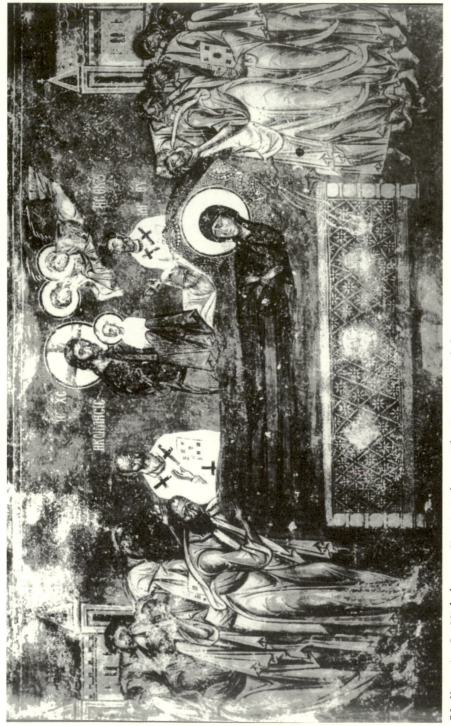

56. Kastoria, St. Nicholas tou Kasnitzē, fresco. The Dormition of the Virgin.

57. Florence, Museo dell' Opera
del Duomo, mosaic icon, detail.
The Dormition of the Virgin.

58. Istanbul, Kariye Camii, mo-
saic. The Virgin and Child.

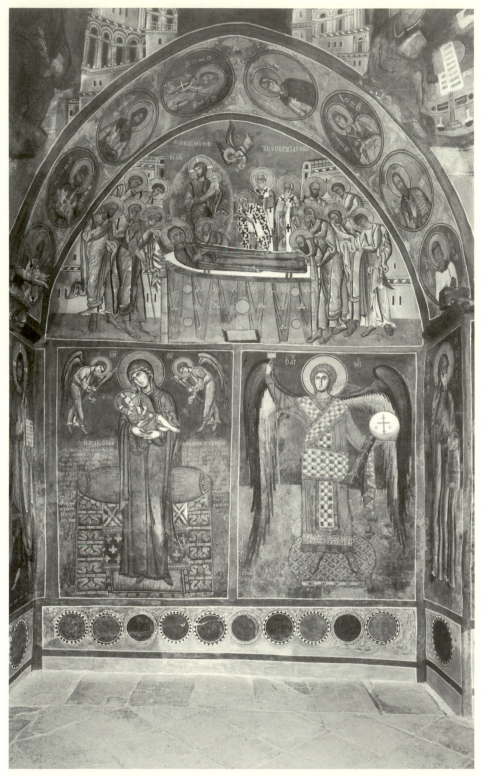

59. *Lagoudera, Panagia tou Arakou, frescoes. The Dormition of the Virgin; the Virgin and Child; St. Michael.*

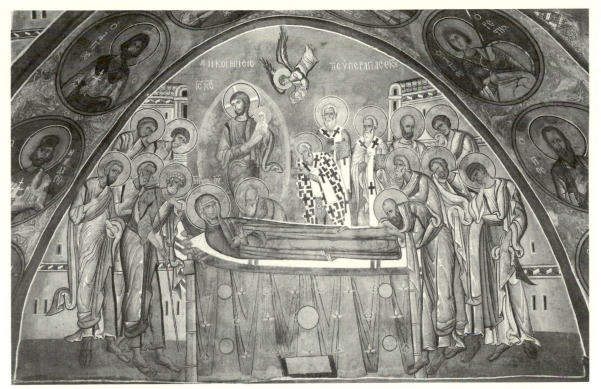

60. *Lagoudera, Panagia tou Arakou, fresco. The Dormition of the Virgin.*

61. *Kılıçlar Kuşluk, cave church, fresco. The Nativity of Christ.*

63. *Saklı Kilise, fresco. The Nativity of Christ.*

62. *Kılıçlar Kuşluk, cave church, fresco. The Dormition of the Virgin.*

64. *Saklı Kilise, fresco. The Dormition of the Virgin.*

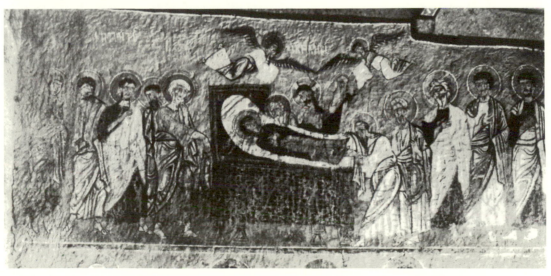

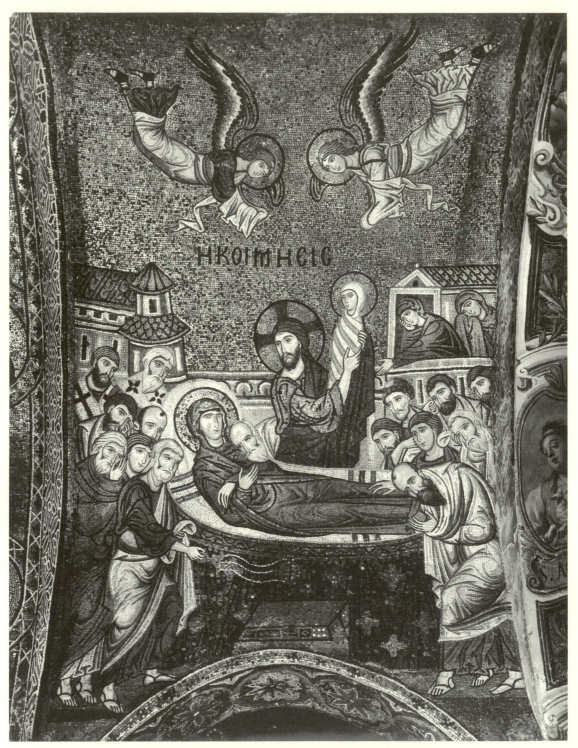

65. *Palermo, Church of the Martorana, mosaic. The Dormition of the Virgin.*

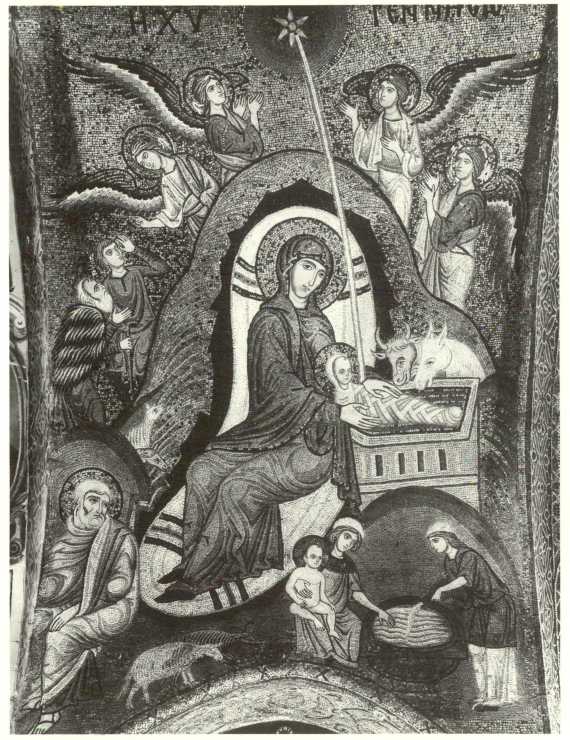

66. Palermo, Church of the Martorana, mosaic. The Nativity of Christ.

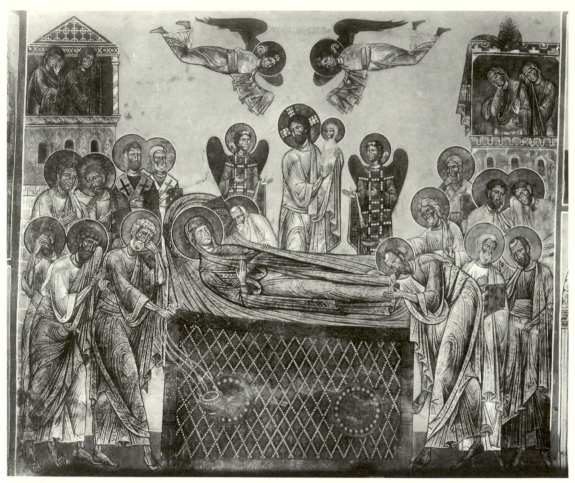

67. Pskov, Mirož Monastery, fresco. The Dormition of the Virgin.

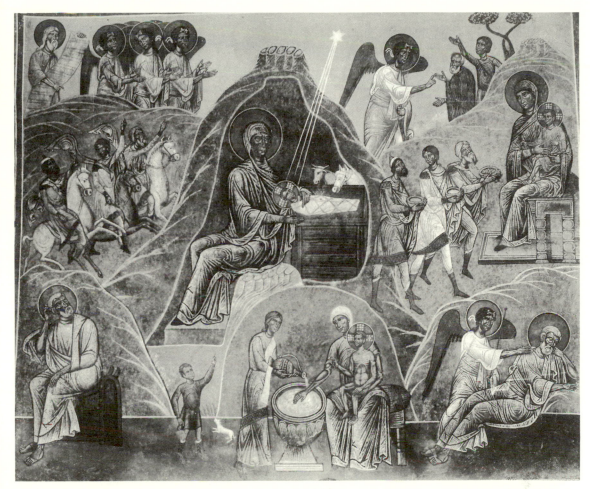

68. Pskov, Mirož Monastery, fresco. The Nativity of Christ.

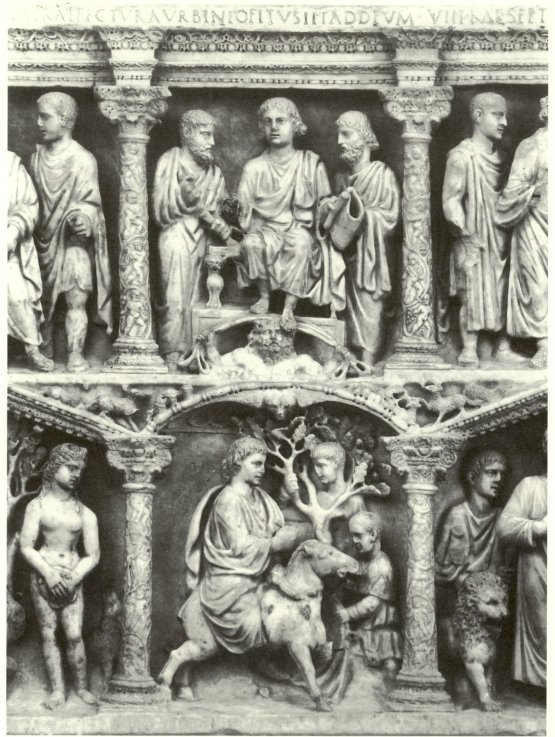

69. Vatican, Grottoes of St. Peter, Sarcophagus of Junius Bassus, detail. Christ Enthroned above the Heavens; Christ's Entry into Jerusalem.

70. *Mount Sinai, painted beam, detail. Christ Enthroned between the Virgin and St. John the Baptist (Deesis).*

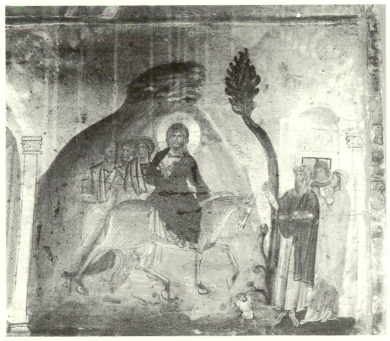

71. *Mount Sinai, painted beam, detail. Christ's Entry into Jerusalem.*

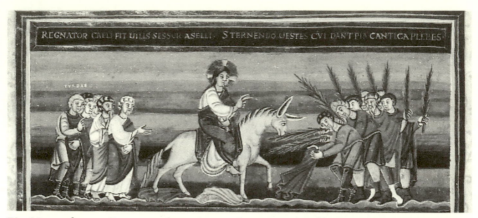

72. Nuremberg, Germanisches Nationalmuseum, Golden Gospels, fol. 110v,
detail. Christ's Entry into Jerusalem.

73. Kurbinovo, St. George, frescoes on the west wall.

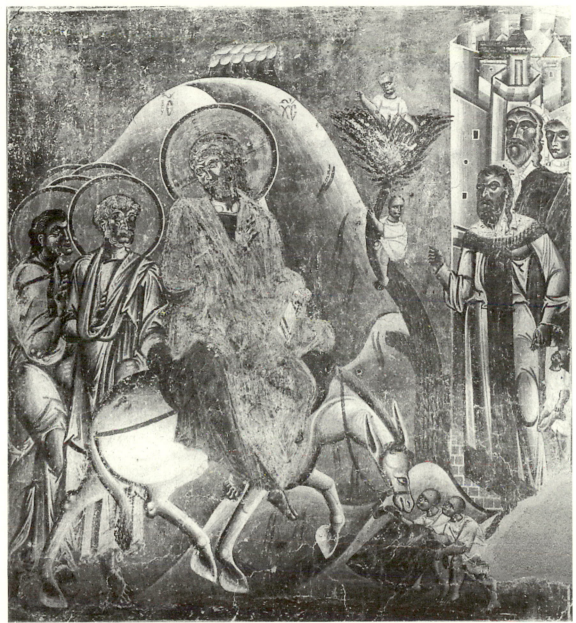

74. *Kurbinovo, St. George, fresco. Christ's Entry into Jerusalem.*

75. *Paris, Bibliothèque Nationale, MS. gr. 923, fol. 167. The Canaanite Woman Describes the Madness of Her Daughter.*

76. *Paris, Bibliothèque Nationale, MS. gr. 923, fol. 167v. Christ's Rebuff to the Canaanite Woman.*

77. *Paris, Bibliothèque Nationale, MS. gr. 923, fol. 170. Christ Grants the Canaanite Woman's Request.*

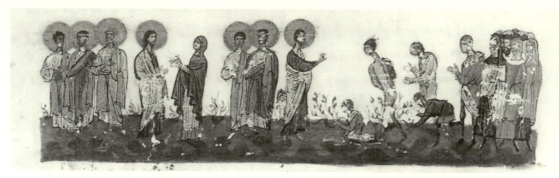

78. Paris, Bibliothèque Nationale, MS. gr. 74, fol. 31v. Christ Rebuffs the Canaanite Woman.

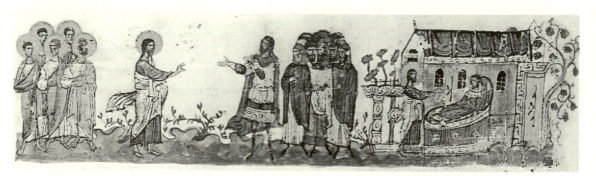

79. Paris, Bibliothèque Nationale, MS. gr. 74, fol. 14v. Christ Heals the Centurion's Son.

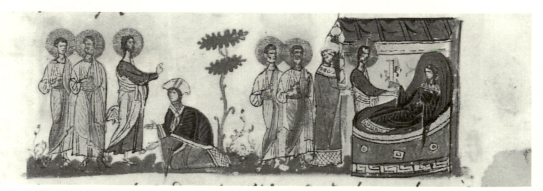

80. Paris, Bibliothèque Nationale, MS. gr. 74, fol. 79. Christ Heals the Phoenician Woman's Daughter.

81. Florence, Biblioteca Laurenziana, MS. VI. 23, fol. 32. Christ Rebuffs the Canaanite Woman.

82. Florence, Biblioteca Laurenziana, MS. VI. 23, fol. 77. Christ Heals the Phoenician Woman's Daughter.

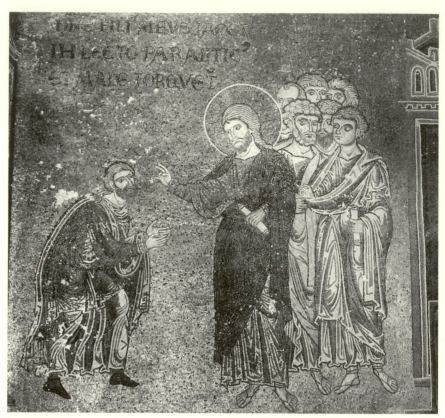

83. Monreale, Cathedral, mosaic. Christ Heals the Centurion's Son.

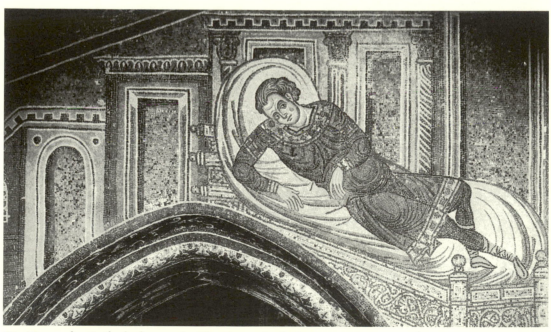

84. Monreale, Cathedral, mosaic. The Centurion's Son.

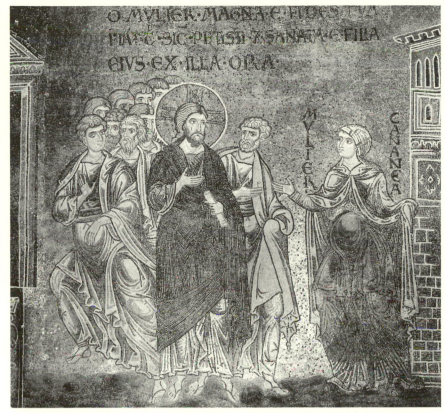

O·MVLIER·MAGNA·C·FIDRS·TVA
FIAT·SIC·PFTISTI·7·SANATA·C·FILA
EIVS·EX·ILLA·ORA·

85. *Monreale, Cathedral, mosaic. Christ Rebuffs the Canaanite Woman.*

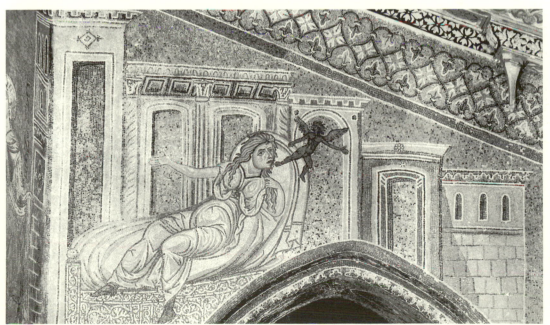

86. *Monreale, Cathedral, mosaic. The Canaanite Woman's Daughter.*

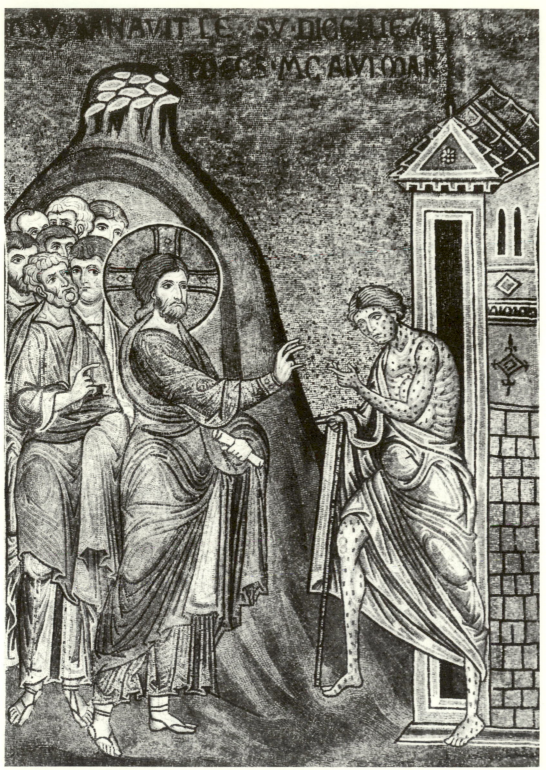

87. Monreale, Cathedral, mosaic. Christ Heals the Leper.

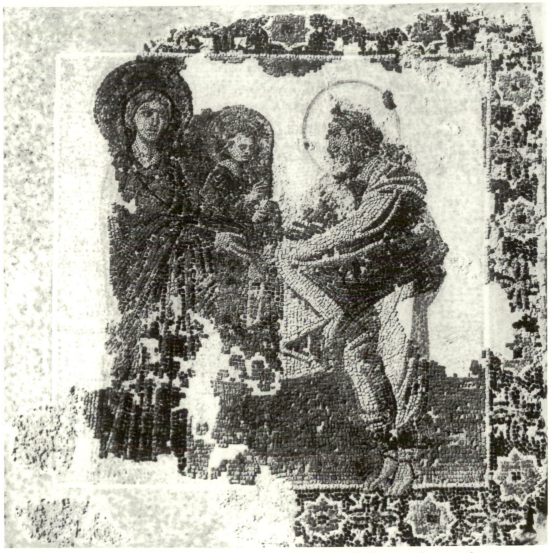

88. Istanbul, Kalenderhane Camii, mosaic. The Presentation of Christ in the Temple.

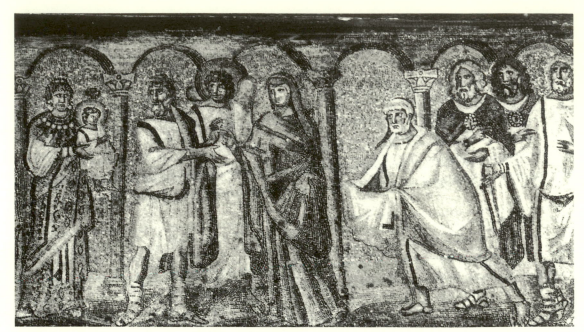

89. Rome, S. Maria Maggiore, mosaic. The Presentation of Christ in the Temple, detail.

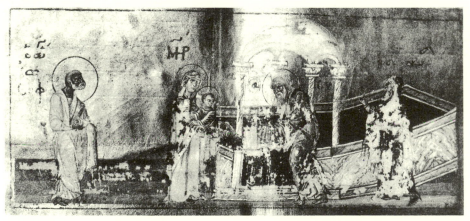

90. Moscow, Historical Museum, MS. gr. 183, page 8. The Presentation of Christ in the Temple.

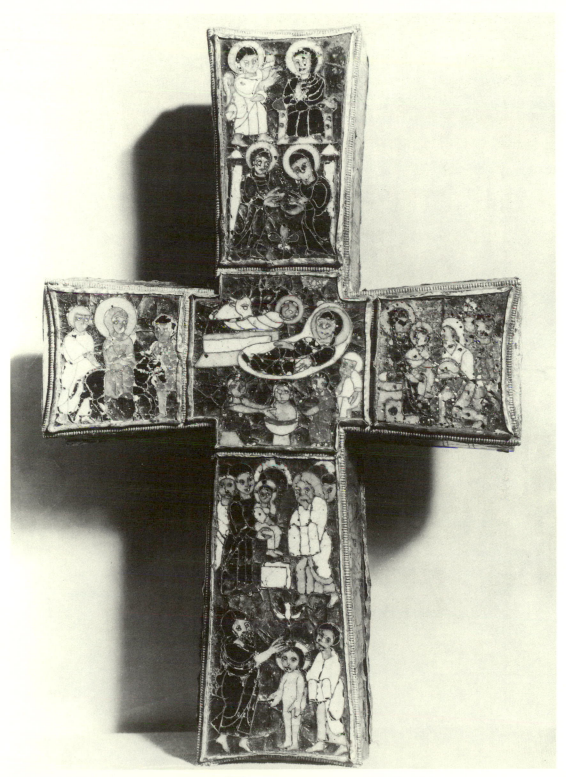

91. Vatican, Museo Cristiano, enamelled cross.

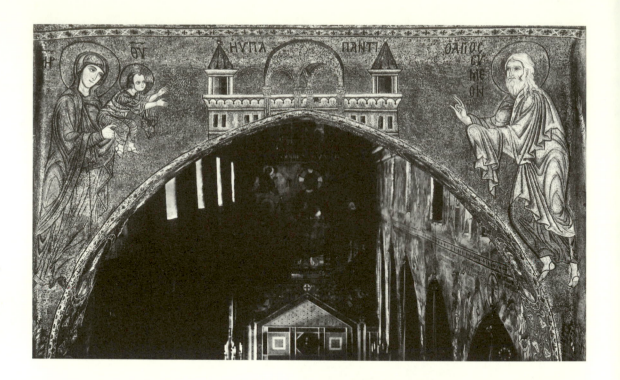

92. *Palermo, Palace Chapel, mosaic. The Presentation of Christ in the Temple.*

94a. *Palermo, Church of the Martorana, mosaic. The Presentation of Christ in the Temple (Virgin and Child).*

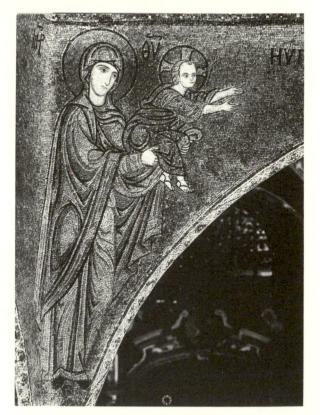

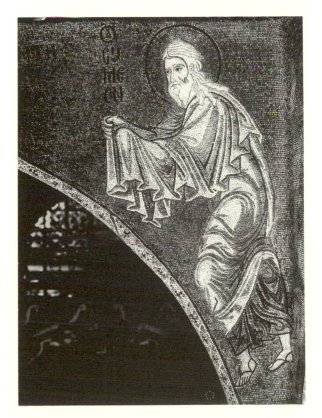

93. *Palermo, Palace Chapel, mosaic. The Annunciation.*

94b. *Palermo, Church of the Martorana, mosaic. The Presentation of Christ in the Temple (Symeon).*

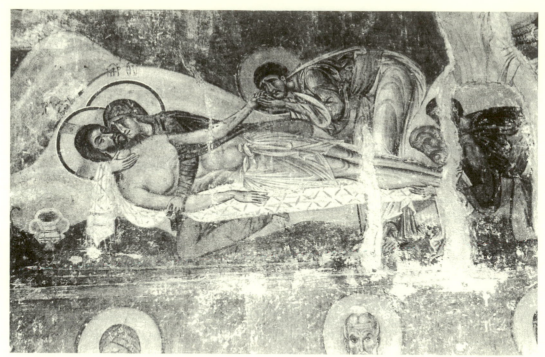

95. *Nerezi, St. Panteleimon, fresco. The Lamentation over Christ's Body.*

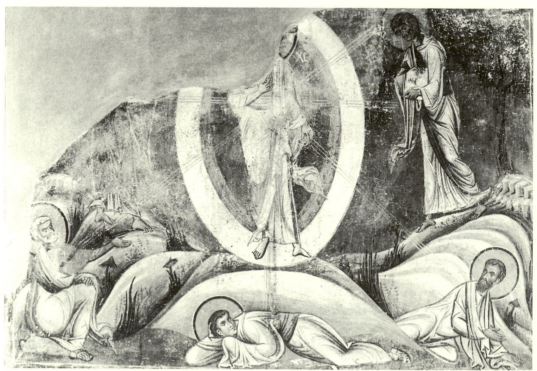

96. *Nerezi, St. Panteleimon, fresco. The Transfiguration of Christ.*

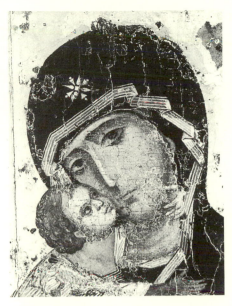

97. Moscow, Tretyakov Gallery, icon. The Virgin and Child, detail ("Our Lady of Vladimir").

98. Kurbinovo, St. George, frescoes on the south wall.

99. Kurbinovo, St. George, frescoes on the north and east walls.

100. Kurbinovo, St. George, frescoes on the east and south walls.

102. Kurbinovo, St. George, fresco. The Holy Women at Christ's Tomb.

101. Kurbinovo, St. George, fresco. The Lamentation over Christ's Body.

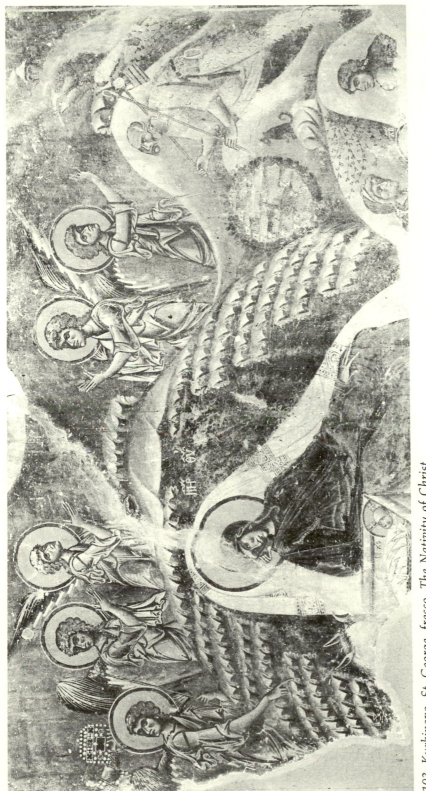

103. *Kurbinovo, St. George, fresco. The Nativity of Christ.*

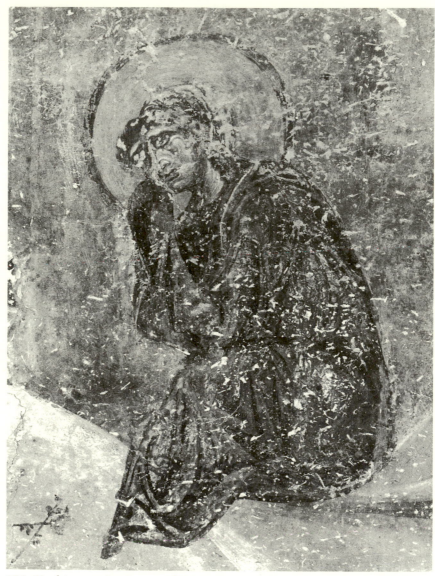

104. *Kurbinovo, St. George, fresco. The Lamentation over Christ's Body, detail.*

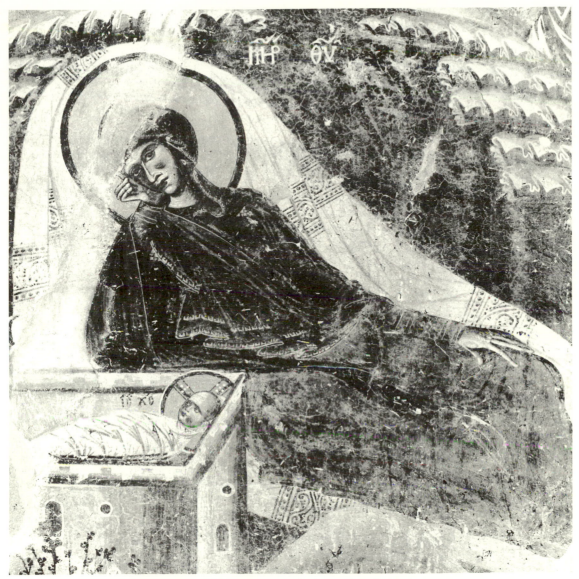

105. *Kurbinovo, St. George, fresco. The Nativity of Christ, detail.*

106. Ohrid, St. Clement, frescoes on the north wall.

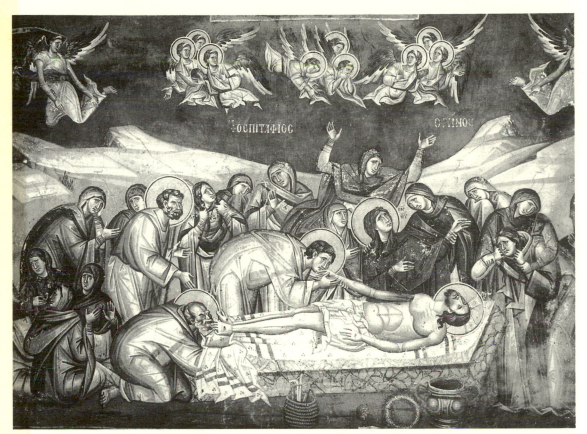

107. Ohrid, St. Clement, fresco. *The Lamentation over Christ's Body.*

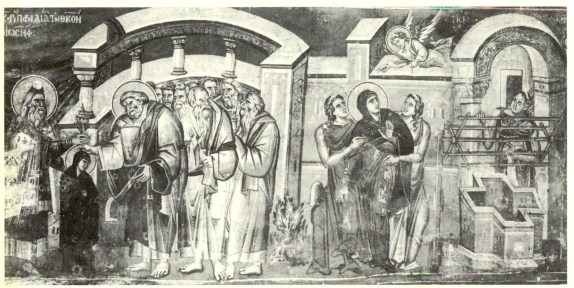

108. Ohrid, St. Clement, fresco. *The Virgin Entrusted to Joseph and the Annunciation by the Well.*

109. *Staro Nagoričino, St. George, fresco. The Annunciation by the Well.*

110. *Moscow, Historical Museum, MS. Add. gr. 129, fol. 87. The Entombment of Christ.*

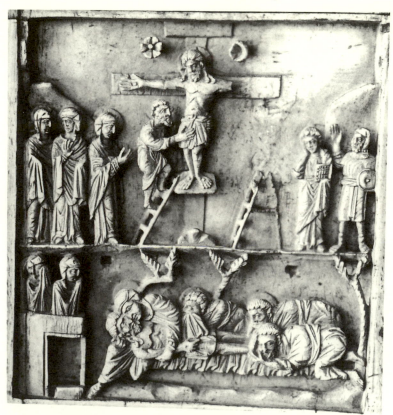

111. *Berlin/DDR, Deutsche Staatsbibliothek, ivory, detail. The Deposition and the Lamentation.*